Resistance!

Resi

stance!

Inaugural Exhibition of the **NATIONAL MUSEUM OF AFRICAN AMERICAN HISTORY AND CULTURE**

In collaboration with the NATIONAL PORTRAIT GALLERY

and the INTERNATIONAL CENTER OF PHOTOGRAPHY

DEBORAH WILLIS

Introduction LONNIE G. BUNCH III
Afterword MARC PACHTER

Let Your Motto Be Resistance

AFRICAN AMERICAN PORTRAITS

Essays	Biographies	Commentaries
CHERYL FINLEY	FRANK H. GOODYEAR III	KIRSTEN P. BUICK
SARAH ELIZABETH LEWIS	ANN M. SHUMARD	DAVID C. LEVY
	FREDERICK S. VOSS	WILLIAM C. RHODEN
Poems		P. STERLING STUCKEY
ELIZABETH ALEXANDER		

9

Foreword: A Collaboration

Lonnie G. Bunch III

Willis E. Hartshorn

Marc Pachter

11

Introduction

Lonnie G. Bunch III

14

The Photographic Portrait:
Constructing an Ideal

Deborah Willis

150

American Idols

Sarah Elizabeth Lewis

154

Postscript: M is for Memory

Cheryl Finley

158

Biographies

Ann M. Shumard

Frank H. Goodyear III

Frederick S. Voss

181

Afterword

Marc Pachter

182

Index of Photographers

29

Portraits

Poems *by Elizabeth Alexander*

56 *Carver's Song*

64 *Toomer*

84 *The Black Woman Speaks*

110 *Abuela Watches Television*

124 *Stokely and Adam*

145 *Jazz Funeral, New Orleans*

FOREWORD: A COLLABORATION

A great thinker once said, "Politeness is the poison of collaboration." On the contrary, the three-way collaboration between the National Museum of African American History and Culture (NMAAHC), the National Portrait Gallery (NPG), and the International Center of Photography (ICP) has been not only polite but warm and collegial. Early in 2006, as its inaugural exhibition, NMAAHC proposed a show consisting of African American portraits to NPG, with MacArthur Fellow and noted photography historian Deborah Willis as guest curator. Impressed by the groundbreaking photography program at ICP, both Smithsonian museums solicited the Center's participation in shaping the project for presentation at its venue in New York City. *Let Your Motto Be Resistance: African American Portraits,* a show of one hundred photographs selected from the collection of NPG, is the result. The exhibition and accompanying publication span a century and a half of both the photographic medium and the history of the United States as seen through an African American lens.

A project of this scale requires more than politeness and goodwill. Many individuals from the three institutions contributed their expertise, hard work, and enthusiasm to make the exhibition and catalogue a reality, and they did so within a very compressed period of time. An endeavor that might easily have taken several years came to fruition in eighteen months. Only a strong belief in the project, and a determination to see it happen in record time, could have brought us to this moment of satisfaction, as the exhibition opens at ICP. The ICP staff—especially deputy director and chief curator Brian Wallis, deputy director for external affairs Evan Kingsley, and deputy director for programs Philip S. Block—were champions of the exhibition from the earliest discussions, and made certain its New York debut would be a success. ICP publications editor Karen Hansgen provided advice on the catalogue, and manager of events and corporate relations Dionne Thornton made sure that all the special occasions in connection with the exhibition unfolded flawlessly.

In realizing this project, NMAAHC benefited from NPG's long experience in organizing Smithsonian exhibitions. The generosity and flexibility of the NPG staff in working with its newest sister institution, NMAAHC, insured a smooth process. Director of exhibitions Beverly Cox coordinated NPG's interactions with NMAAHC and ICP. At the outset NPG generously opened the collection to guest curator Deborah Willis, offering her information and suggestions about individual images as she made her selection. When the timeline changed, NPG graciously rearranged its schedule to accommodate the exhibition. Curators Ann M. Shumard, Frank H. Goodyear III, and former NPG historian Frederick S. Voss, with the research assistance of Amy Baskette, wrote the biographical labels on a very tight schedule, relying on the expert assistance of head of publications Dru Dowdy. Alex Jamison and Mark Gulezian are responsible for the exquisite photography used in the catalogue. Lizanne Garrett coordinated the copy photography, and Kristin Smith handled the myriad logistical details associated with the conservation, matting, and framing of the works. Sarah Wagner performed the conservation treatments. Molly Grimsley supervised the crating and shipping to and from New York City.

The small staff at NMAAHC stayed in close touch with both ICP and NPG all along the way. Deputy director Kinshasha Holman Conwill served as the principal liaison with ICP and NPG as the collaboration took shape, bringing to bear the breadth of her museum experience. Chief curator Jacquelyn Serwer coordinated the production of the catalogue, working with Deborah Willis and the other authors to produce an insightful and memorable publication. Fleur Paysour managed the press and public affairs aspects of the project. Collections curator Michèle Gates Moresi provided her expertise as both a historian and proofreader, while education director Esther Washington worked with ICP and NPG educators Jewell Robinson, Geri Provost, Briana Zavadil White, and Ian Cooke to adapt the catalogue material for families, teachers, and students. Carla Borden, a longtime editor at the Smithsonian, fine-tuned the essays.

Publisher Ed Marquand and designer Jeff Wincapaw brought great care and enormous imagination to the production of the book. The publication serves as the perfect accompaniment and keepsake for this exhibition. Caroline Newman, executive editor at Smithsonian Books, arranged distribution of the catalogue, and recommended the cover image.

The New York and Washington, D.C., venues result from the three-way collaboration. However, the exhibition will enjoy a subsequent tour, featuring modern rather than vintage prints of the photographs, to other distinguished museums and educational venues across the country. The Smithsonian Institution Traveling Exhibition Service (SITES) will travel this modified version of the show beginning in summer 2008, thanks to the cooperation of SITES director Anna Cohn, who enthusiastically supported the project from the beginning, as well as exhibits director Frederica Adelman, and staff professionals Deborah Macanic, Laurie Trippett, Josette Cole, and research assistant Mary Battle. We have enjoyed the strong support of Smithsonian Secretary Lawrence M. Small and Deputy Secretary Sheila Burke in all phases of this project. They have been especially pleased with the arrangements for the national tour involving the Smithsonian's NPG, SITES, and NMAAHC.

We are grateful to MetLife Foundation, the lead sponsor of the exhibition, the catalogue, and the national tour of the exhibition. Special thanks go to Sibyl Jacobson, president and chief executive officer of MetLife Foundation, for her leadership and to Rohit Burman, manager, culture and public broadcasting, whose assistance and advice throughout this endeavor were invaluable.

We must devote a final word to our dear colleague, Deborah Willis. When the NMAAHC sought to present itself to the world years prior to a completed building, Deborah Willis offered her skill, her expertise, her friendship, and her curatorial creativity. Ultimately, she brought a unifying vision, one that has engaged and inspired all three collaborating museums in realizing this worthwhile project.

LONNIE G. BUNCH III
FOUNDING DIRECTOR
NATIONAL MUSEUM OF AFRICAN AMERICAN HISTORY AND CULTURE, SMITHSONIAN INSTITUTION

WILLIS E. HARTSHORN
EHRENKRANZ DIRECTOR
INTERNATIONAL CENTER OF PHOTOGRAPHY

MARC PACHTER
DIRECTOR
NATIONAL PORTRAIT GALLERY, SMITHSONIAN INSTITUTION

INTRODUCTION

In August 1843, nearly one hundred black men arrived in Buffalo, New York, for a national convention of clergymen, lawyers, and other leaders of the small but growing community of Northern free blacks, to discuss the status and future prospects of black America. Though the overwhelming percentage of African Americans was enslaved, thousands were living as free men and women in the Northern states. Some of this latter group had been born free or had purchased their freedom, while others were fugitive slaves who had escaped from their owners' plantations or farms in search of the hope and possibility of liberty. Yet the free black community often found itself in a limbo between citizenship and slavery. Though they were without owners, they were not completely free. Almost every Northern state passed laws to limit the rights and the presence of free blacks.

So on those hot August days, the conventioneers, well aware of the tenuousness of their condition, wrestled with ways to combat the segregation that kept many African Americans from finding food, lodging, and seats on public conveyances; debated the impact of the lack of black suffrage; and examined the central and perennial struggle to abolish slavery. On August 16, the second day of the convention, the principal speaker was Henry Highland Garnet, a clergyman whose determination to end slavery was shaped by the fact that he had escaped from bondage in Maryland as a child in 1824. As Garnet, just beginning what would be a forty-year tenure as the minister of Shiloh Presbyterian Church in New York City, rose to speak, he initially struggled to express his frustration that blacks had already waited long enough for justice and liberty. "We have hoped in vain. . . . Years have rolled on," Garnet began. But now, he exhorted his audience with the following words:

> *Brethren arise, arise! Strike for your lives and liberties. Now is the day and the hour. Let every slave throughout the land do this and the days of slavery are numbered.* . . . Rather die freemen than live to be slaves. *Remember that you are three* millions!

Garnet's call for slaves to actively and violently resist their enslavement—a statement that went far beyond what most black abolitionists were willing to express publicly—reverberated throughout the convention as a bold, controversial, and, some would say, a foolhardy proposal. He reminded his fellow freemen that their fate was tied to the slaves by saying, "nor can we be free while [others] are enslaved." But Garnet was not yet through. He concluded with the thundering words:

> *Let your motto be Resistance!* Resistance! *RESISTANCE! No oppressed people have ever secured their liberty without resistance. What kind of resistance you . . . make you must decide by the circumstances that surround you. . . .*

Garnet's call, his challenge to America, resounded throughout the nation. And for the next forty years, Garnet retained this commitment to racial justice by ministering to his church; engaging in the debates and struggles of abolitionism and civil war; and boldly and forcefully expressing his views until his death in 1881. In many

respects, however, his articulation of a people's frustration and his prophetic call for action on that August day in 1843 is his most lasting and important legacy.

Throughout the nineteenth and twentieth centuries, almost all of black America embraced Garnet's plea to "let your motto be resistance," based on "the circumstances that surround you." As we examined the photographs that comprise this exhibition, it was clear that they revealed, reflected, and illuminated the variety of creative and courageous ways that African Americans resisted, accommodated, redefined, and struggled in an America that needed but rarely embraced and accepted its black citizens. Thus the exhibition title, *Let Your Motto Be Resistance: African American Portraits*.

To some black Americans, the profound and fundamental lack of racial justice and civic fairness needed to be challenged by any means necessary, including violence. The notion once expressed by the 1960s activist H. Rap Brown that "violence is as American as cherry pie" suggests that change might come only if violence is one of the weapons used. Individuals as diverse as the enslaved Nat Turner and the abolitionist David Walker as well have embraced the notion that America must be forced into granting equality and human rights for its darker citizens. Stokely Carmichael and Angela Davis, whose portraits are featured in this exhibition, are part of the African American community who came to believe, like Garnet, that one must strike for liberty. For others, just surviving and refusing to be destroyed was a strong form of resistance. The wonderfully powerful image of Gordon, a former slave whose whipped, scarred back dominates the photograph, speaks volumes about the strength needed to survive. In many ways, Gordon represents the thousands who endured slavery, the humiliations of segregation, the terrorism of the Ku Klux Klan, and who suffered the losses and costs of racial violence.

Other black Americans felt that the best form of resistance was to confront discrimination whenever and wherever possible. The long history of the black experience in America is replete with examples of groups and individuals who organized protests and sit-ins, who demanded justice and equality through the courts, or who illuminated all the darker corners of racism through the use of weekly newspapers or secondhand cameras. There is rich imagery in this show that captures Martin Luther King Jr., A. Philip Randolph, Robert Moses, Rosa Parks, and many others who believed that resistance could be the highest form of patriotism.

But this material also reveals that celebrating, expressing, and recapturing African American culture in a manner that was untainted by the myopic and the racist is an important form of resistance. The cultural expressions of Langston Hughes, Cab Calloway, Edmonia Lewis, Ntozake Shange, and Wynton Marsalis—all of whose photographs appear in this exhibition—help to define a culture and capture its essence in ways familiar, comforting, and inspirational. Tapping one's toes to Sidney Bechet or Duke Ellington, humming along with Billie Holiday or Hazel Scott, or smiling with Richard Pryor all call into question notions of supposed racial inferiority and enable the community to resist them. And the sheer beauty of many of these images—from the haunting presence of Jessye Norman to the almost heroic framing of Muhammad Ali—destroys many of the stereotypic depictions that populated much of America's culture in the nineteenth and twentieth centuries.

The National Museum of African American History and Culture is quite proud that *Let Your Motto Be Resistance: African American Portraits* is our inaugural exhibition. We are proud because these stunning portraits will help us rethink and reposition our notions of resistance; and proud because these images of individuals from Frederick

Douglass to Malcolm X; from Edward Bannister to Toni Morrison; and from Father Divine to Jimi Hendrix help us to remember the richness and diversity of African American life in the nineteenth and twentieth centuries. The challenge of remembering the African American experience is at the heart of the National Museum of African American History and Culture. For nearly one hundred years, African Americans have struggled to create a national institution that would help all Americans to remember the lessons, the contributions, the importance, and the place of black Americans within the context of the American experience. This museum is dedicated to the idea that there are few things more powerful than a people, than a nation that is steeped in its history. And there is nothing nobler than honoring all of our ancestors by remembering.

Let Your Motto Be Resistance: African American Portraits is the first of many exhibitions, programs, web-based learning opportunities, and educational activities that will allow the National Museum of African American History and Culture to serve its audience even before a building on the National Mall is erected. *Let Your Motto Be Resistance: African American Portraits* offers an introduction to this new Smithsonian museum for visitors across the country. As the founding director of the museum, it is my fond hope that the exhibition and catalogue will inspire Americans of all backgrounds to embrace the rich history we share.

LONNIE G. BUNCH III
FOUNDING DIRECTOR
NATIONAL MUSEUM OF AFRICAN AMERICAN HISTORY AND CULTURE, SMITHSONIAN INSTITUTION

Note

Garnet quotations taken from H. H. Garnet, "An Address to the Slaves of the United States of America," in *Lift Every Voice and Sing: African American Oratory, 1787–1900,* ed. Philip S. Foner and Robert James Branham, Tuscaloosa and London: The University of Alabama Press, 1998.

THE PHOTOGRAPHIC PORTRAIT **Constructing an Ideal**

Man is the only picture-making animal in the world. He alone of all the inhabitants of the earth has the capacity and passion for pictures. . . . Poets, prophets, and reformers are all picture-makers, and this ability is the secret of their power and achievements: they see what ought to be by the reflection of what is, and endeavor to remove the contradiction.[1]

FREDERICK DOUGLASS

Regardless of the medium used to facilitate it, portraiture is the pictorial representation of an individual and it can be challenging, interesting and historically significant—capable of embracing an era and the people who exist within it.[2]

GORDON PARKS

I have used the words of two significant individuals whose portraits are included in this exhibition to introduce my essay—abolitionist Frederick Douglass and photojournalist-writer Gordon Parks. Each conveys the importance of the portrait in his own time. Photography has served as a space to perform or imagine since the medium's invention in the mid-nineteenth century. Many African Americans, in particular, used photography to focus on the goal of racial uplift and the notion of being seen as they desired to be seen. They recognized immediately that they could communicate a sense of self-worth and counter prevailing stereotypes with photographs that celebrated their dignity and achievements. Alternative and self-created images of the African American experience, especially those related to the arts, education, and family life, publicly challenged the predominantly negative representations circulating in American mainstream culture.

Douglass summed up his views in the following statement from 1849:

We shall venture one remark, which we have never heard before, and which will, perhaps, be set down to the account of our negro vanity, and it may be, not unjustly so, but we have presented it for what it may be worth. It is this: negroes can never have impartial portraits at the hands of white artists. . . . We have heard many white persons say that "negroes look all alike," and that they . . . associate with the negro face, high cheek bones, distended nostril, depressed nose, thick lips and retreating forehead. This theory, impresed [sic] strongly on the mind of an artist, exercises a powerful influence over his pencil, and very naturally leads him to distort and exaggerate those peculiarities, even when they scarcely exist in the original. [But t]here is the greatest variety of form and feature among us, and there is seldom one face to be found which has all the features usually attributed to the negro; . . . Perhaps we should not be more impartial than our white brothers, should we attempt to picture them. We should be as likely to get their lips too thin, noses too sharp and pinched up, their hair too lank and lifeless, and their faces altogether too cadaverous.[3]

Although ostensibly about painters and draftsmen, Douglass's "reading" of the white artist's inability to portray African Americans raises critical questions about photographic objectivity and challenges conventional perspectives on racial identity, beauty, and community.

Cultural historian Alan Trachtenberg argues that elevating photography to a position of social commentary is a significant aspect of reading images. In his opinion, there are many factors to be considered:

> *American photographs are not simple depictions but constructions[, and] the history they show is inseparable from the history they enact: a history of photographers employing their medium to make sense of their society. It is also a history of photographers seeking to define themselves, to create a role for photography as an American art. . . . Consisting of images rather than words, photography places its own constraints on interpretation, requiring that photographers invent new forms of presentation, of collaboration between images and text, between artist and audience.*[4]

Photography is empowering for both those in front of and those behind the camera, and the photographic image represents a transformative experience: the ordinary and ephemeral becomes exceptional and permanent. One portrait subject in this exhibition was not a celebrity or well-known figure in his lifetime but became one as a result of the act of being photographed. In the portrait from the Mathew Brady Studio, possibly taken in New Orleans, Gordon is seated sideways on a wooden chair with his hand placed delicately on his hip and his back rather than his face the focus of the image.

Known as "Gordon," the portrait has another title as well, "The Scourged Back." Gordon's partially nude body makes visible the memory of frequent, bloody whippings, which caused the formation of thick-skinned (keloid) scars on his back. Nicholas Mirzoeff describes two opposing perspectives on the photograph:

> *It was intended to highlight the evils of enforced labor and human bondage, made visible as the scars of whipping(s) inflicted by a cruel slave-owner. In the plantation world-view, The Scourged Back was simply evidence of a crime committed and properly punished.*[5]

This politically charged *carte-de-visite* was reproduced frequently in 1863 by commercial photographic agencies such as McAllister & Brothers, Philadelphia, and McPherson & Oliver, Baton Rouge. The scarification, for the abolitionists who sold the image, served as evidence of slavery's cruelties. Other types of albumen prints of Gordon, a little larger than the *carte-de-visite,* were also used to foment resistance to slavery.

Since the mid-nineteenth century, photographic studios owned by both white and black Americans have recorded social and political events, families, and leaders in their respective communities. By the 1860s photography was big business: more than 3,000 Americans were working as photographers. Within the nineteenth-century photographic studio, artists captured a wide range of sitters whose portraits reflected racial consciousness, class attitudes, gender roles, and personal achievement.

In the twentieth century, Parks concluded that "good portraiture requires ample research, for without it there exists an easily detected thinness in the finished work."[6] He went on to describe the most common procedure in photographic portraiture:

Usually the subject and photographer meet for the first time during the sitting. When this is the case the photographer should have some pre-knowledge of his sitter, for this knowledge will most immediately direct the approach. Research includes the subject's profession, achievements, avocations, moods, personality, and, most important, his significance in relation to the era he represents.[7]

Many photographers used composition and studio setups to establish spaces where African Americans could express themselves visually, intellectually, spiritually, and emotionally. Some photographers—often in collaboration with their subjects—created idealized poses, while others demonstrated the sitters' confidence through style and dress. In the nineteenth and twentieth centuries, for white and black sitters alike, props such as drapery, classical columns, and parlor furniture offered a class-based and gendered reading of an individual subject and were used as signifiers of achievement. Such props served as symbols of social status, wealth, intellect, and empowerment: a lectern suggested an orator; a pillar, respectability; books, intellect; a framed photograph linked the generations; drapery indicated prosperity and gentility.

Similarly, photographic portraits of black women, in particular, challenged conventional images. Around the turn of the century, black women used these self-consciously constructed photographs to promote themselves—in their businesses and their social and civic activities. Portraits of women became an important political force, and the photographic image was a vehicle for exhibiting their collective power. Later, black women entertainers used portraits on record covers, on sheet music, and as advertising materials. Over the decades photographs of black women became symbolic vehicles of personal and public reinvention.

Zora Neale Hurston's revealing response to Carl Van Vechten's portraits of her suggests the participatory nature of the photographic process. In her 1934 letter to Van Vechten, she wrote the following words:

Carl Darling, Send the pictures here. I am so excited about them I can hardly wait. Frankly I feel flattered that you wanted to photograph me. I am conscious of the honor you do me.[8]

After viewing the portraits, she expressed her approval. "The pictures are swell! I love myself when I am laughing. And then again when I am looking mean and impressive."[9]

In the 1950s, Philippe Halsman's portraits of glamorous actresses Dorothy Dandridge, Eartha Kitt, and Lena Horne constructed a radically different vision of black women's sexuality, previously exemplified perhaps only by Josephine Baker. The beautiful screen star Dandridge's portrait is a splendid example. Halsman photographed her in 1953, the year she acted in the low-budget movie *Bright Road*. She smiles, looking up into the lens with an expression of innocence. Donald Bogle describes her as "pert, pretty and warm . . . lovely to look at, refreshing, and clear-eyed,"[10] and Halsman's photograph captures these qualities effectively. In contrast, Halsman's Eartha Kitt is more seductively posed, while Lena Horne, as "the first black woman in American films to be fully glamorized, publicized, and promoted by her studio [MGM],"[11] received more ethereal treatment.

While the role of portraiture has evolved since photography's beginnings, many aspects remain the same. Portraits reflect individual and community concerns, and the photograph continues to be a metaphor for people's ideals and their desire to improve their lives. As photography historian Graham Clarke remarks, "[T]he portrait is . . . a sign whose purpose is both the description of an individual and the inscription of social identity."[12]

Photography and Fame

Photography has always enjoyed an undeniable relationship with fame. Unlike the once-commissioned studio portraits familiar to many of us, the images in this exhibition are all of subjects whose social or political significance resonates with a contemporary audience. It is important to recognize, however, that some of these people were not famous when they were photographed. In fact, they may have consciously used the medium—by having themselves photographed in a particular pose or by a particular photographer—as the means to achieve fame and thereby further their purpose or cause. Collectively, these major figures exemplify the construction of power through the photographic portrait. They acquired this power by providing a visual equivalent—the portrait—to symbolize their resistance to the limitations set by the larger society. Since all conform to ideals of worthiness or excellence in their various spheres, they are able to represent their communities as well as themselves in the quest to improve the social and political standing of African Americans over the course of American history. As photographic historian Colin Westerbeck writes, "[Frederick] Douglass's portrait still has a powerful and unsettling effect on us today because he really became the prophet of his people that he felt destiny had chosen him to be."[13] Henry Highland Garnet's statement, which provides the context for this exhibition, reflected the combative attitude of many educated free blacks of the period:

> Let your motto be Resistance! Resistance! RESISTANCE! No oppressed people have ever secured their liberty without resistance. What kind of resistance you had better make you must decide by the circumstances that surround you, and according to the suggestion of expediency.[14]

Notions of resistance and expediency are explored in the medium of photography. Nineteenth-century sitters like Garnet presented themselves to the camera in a manner that projects a higher social status or position of authority than their everyday life might suggest. Photography provided them with a safe and effective way to counter the negative paradigm associated with the black community that was commonly accepted among the majority of white Americans. During a time in American history when a significant number of photographs depicted black Americans as subordinate to the dominant culture, some subjects used portraiture to defy or challenge their assigned status as inferior members of society.

However, fame did not necessarily result simply from the act of being photographed. Photographic portraits had to be disseminated to their audiences. Prior to the development of photomechanical reproduction in the latter half of the nineteenth century, consumers purchased, collected, and coveted original photographic prints as a way of demonstrating their social and cultural sophistication.

Frederick Douglass's ambrotype of 1856 is one that celebrates the notion of dandyism found in early photography. His expressive gaze communicates confidence. His hair is well coiffed; his suit jacket, glossy vest, and wide black bowtie suggest his public status as an orator. Art historian Richard J. Powell describes Douglass as a black activist dandy of the antebellum period:

> A man of imposing height (over six feet), strong, masculine features, and wavy, mane-like black hair, Douglass often wore the most elegant suits, vests and neckties. His impressive attire, combined with his handsome features, deep, rousing voice, and dramatic delivery, converted the susceptible and startled the unassuming.[15]

Some imagery of this type appeared as *cartes-de-visite,* or calling cards, which were about 4 × 2 inches, only slightly larger than modern-day business cards. *Cartes-de-visite,* usually albumen prints mounted on board, were introduced in 1854, and millions were made, purchased, and traded through the late 1870s. They "normally bore carefully posed full-length studio portraits, often of celebrities,"[16] and people collected them in albums in which they were as coveted as any family photograph. Graham Clarke comments on the self-conscious character of the nineteenth-century photographic portrait:

> [A]ny portrait is a construction, an advertisement of the self—so obviously underlined by the way in which the cartes-
> de-visite *became so fashionable in nineteenth-century Paris as the mark of identity and social significance.*[17]

Some examples include Henry Rocher's portrait of sculptor Edmonia Lewis (c. 1870), James U. Stead's portrait of Henry Highland Garnet (c. 1881), and George Kendall Warren's portrait of pianist "Blind Tom" (Thomas Bethune, also known as Thomas Greene Wiggins, c. 1882). Individuals often commissioned such portraits in this intimate and mass-produced format for the purpose of advertising or self-promotion. To the public they became treasured likenesses of greatness that inspired and invited emulation.

Cartes-de-visite of celebrities, artists, religious leaders, and abolitionists circulated widely in the small towns and larger cities where their subjects lived, lectured, exhibited, and performed. When artist Edmonia Lewis sat for Henry Rocher (born 1824),[18] possibly in his Chicago studio, she was a highly respected sculptor. She had already completed work on major pieces such as *Forever Free* and *Hagar.* "Lewis sat for a series of at least six formal portraits," writes art historian Gwendolyn DuBois Shaw:

> *The resulting images of the twenty-six-year-old artist were printed as* cartes-de-visite *and used as promotional tools*
> *for her work and were distributed to potential patrons and admirers.*[19]

In the serene portrait in this exhibition, Lewis is seated in a chair with fringe bordering the armrest. She wears a ribbon tied around her neck, a skirt bordered with pleated ribbon, and a velvet shawl over her shoulder. Under her small, tasseled hat, her cropped, curly hair is styled in the manner of a modern-day woman. DuBois Shaw comments on another photograph in the series:

> *[It] embodies what philosopher Walter Benjamin has called a "spell of personality" with its presentation of Lewis as*
> *a worldly woman, independent and liberated, artistic and original. From her cropped hair, cut short to stay out of her*
> *way while at work . . . [and] the exquisitely trimmed jacket and the unrestricted cut of her clothes all serve to identify*
> *her as a bohemian and an artist. Her clothing depicts the dominant and the avant-garde cultural ideologies of*
> *feminine and artistic dress as well as the artist's own relationship to these discourses.*[20]

The portrait of Henry Highland Garnet (1815–82) also demonstrates a careful and conscious construction of the image. He was born into slavery in New Market, Maryland, but his father escaped with the entire family and moved to New York City. Garnet grew up to become a Presbyterian minister who fought aggressively against slavery. An outspoken abolitionist and orator, Garnet urged slaves to take action to gain their own freedom in his "Address to the Slaves of the United States of America," causing a split within the abolitionist movement. The portrait of the anti-slavery advocate presents a composed leader and encourages the viewer to take stock of

this significant figure. The oval framing provides an opportunity to gaze at Garnet, to look closer at the details, such as his salt-and-pepper beard and his up-to-date and fashionable turn-down collar and tie.

Conversely, the significance of the portrait of "Blind Tom"—Thomas Bethune, also known as Thomas Greene Wiggins (1849–1908)—derives from the context in which it was made. He is pictured sitting at a piano, but was he a willing subject? Is this a celebrity portrait? Do his mood and dress represent pride or resignation? Born blind and in slavery, Wiggins was purchased, along with his family, by a lawyer-politician from Columbus, Georgia, named Colonel James N. Bethune. "Blind Tom's" musical interest and talent were recognized early, and he was later "hired out" to perform and be exhibited as a slave prodigy touring around Georgia and other slave-holding states. Ironically, during the Civil War, Colonel Bethune used Wiggins's performances to raise money for the Confederacy. Wiggins subsequently performed in Europe and throughout the United States until the vaudeville era began in 1905. Unlike the portraits of Garnet, Douglass, and Lewis, Wiggins's portrait was not used primarily to enhance his social status. Rather, it was used to bolster the status of Colonel Bethune's family; they exploited Wiggins's musical gifts and his portrait for their benefit. While this portrait signals one person's control over another's life, Wiggins's pose and expression may convey a pride in his own talent despite the demeaning circumstances.

Cabinet cards, popular from the 1860s through the 1890s, were 6½ × 4¼ inch photographs mounted on sturdy board. In the nineteenth century the best-known photographic image of a black woman was probably a cabinet card of Sojourner Truth (1797–1883), a former slave turned abolitionist and orator. Truth was remarkably savvy about the photographic medium and its powers of communication. After initially earning money to support her abolitionist activities by selling the narrative of her life story, Truth sold *cartes-de-visite* and cabinet card portraits for thirty-three and fifty cents each, respectively. "I am living on my shadow,"[21] she wrote, and eventually the images were distributed with the now-famous caption "I sell the shadow to support the substance."[22] Her Randall Studio portrait, taken in Detroit, Michigan, around 1870, is a cabinet card of a seated Truth, her hands crossed in her lap, offering a look of feminine humility as she gazes directly at the camera. Historian Nell Painter takes special note of her clothing: "[S]he is dressed in the Quaker-style clothing that feminists and anti-slavery lecturers wore to distinguish themselves from showily dressed actresses, their less reputable colleagues in female public performance."[23] Painter also notes that "the larger format of the cabinet card allowed for additional background images, further locating Truth within a realm of middle-class sophistication and refinement."[24]

Art historian Gwendolyn DuBois Shaw reminds us that, in addition to Truth's image, her name also held significance.

> *Africans that arrived on slave ships in the eighteenth and nineteenth centuries were given new names as they were sold into slavery. It was not until a slave was freed that he/she was able to name him/her-self. This practice of self-naming may be found in the case of Isabella Dumont, who as a free woman became Sojourner Truth. . . . Truth was able to sell a reproduction of her body in order to sustain its source. In this manner the formerly enslaved woman was able to achieve an ironic sort of control over the sale of the representation of her selfhood.*[25]

Truth's image has been engraved on our public conscience since the 1860s. She used photography to construct an audacious but respectable new image of herself. The popularity in the nineteenth century of *cartes-de-visite*

and cabinet cards such as the type presented in this exhibition encouraged her to pose for at least fourteen portraits in seven sittings.[26] Truth never portrayed herself as a slave. Instead, her dignity belied the injustices of slavery. A similar notion of selfhood marks all the portraits in this exhibition.

John Roy Lynch, whose c. 1883 portrait is by Charles Milton Bell, had grown up enslaved in Natchez, Mississippi. In the 1870s he found a job in a portrait studio in Vicksburg, Mississippi, and in 1881 he became a member of Congress. His portrait depicts a serene and confident gentleman, an impressive image of black achievement during the Reconstruction era.

In the early twentieth century, African American studio photographers such as Addison N. Scurlock in Washington, D.C., and James VanDerZee in Harlem had an impact on both their immediate communities and the broader African American population. Through the force of their talents, assisted by word-of-mouth recommendations, theirs became the studios to visit. Their images created a fashionable new world of middle-class African Americans who proclaimed their sophistication and social status. Everyone who was anyone—whether a local resident or a visiting dignitary—had his or her portrait taken by the preeminent local photographer. The photographers would then make multiple prints of these significant subjects that they could sell to the black press or to discerning collectors, thus creating and reinforcing their subject's place of importance among the public.

Addison N. Scurlock (1883–1964) was born in Fayetteville, North Carolina, and spent his entire professional career in Washington, D.C. He served as Howard University's official photographer from the early 1900s until his death. Following a four-year apprenticeship with Moses P. Rice, he opened the Scurlock Studio in 1911 and operated it with his wife and sons. Portraits were their specialty.

Historian Jane Freundel Levey gives a good description of the Washington, D.C., that Scurlock called home:

> [It] had a large black community—one-third of the total population—with strong institutions and long-held traditions. This community included people who had resided in the capital area for several generations and whose ancestors had lived as free people in the years before the Civil War. While the dominant spirit of the city was that of the segregated South, and segregated schools, hospitals, and institutions prevailed, turn-of-the-century Washington offered black Americans the economic and social opportunities of urban life.[27]

During the 1920s and 1930s, Scurlock Studio worked diligently to increase the visibility of black intellectuals, artists, musicians, and politicians in Washington, D.C., and the surrounding areas. The studio also documented community life: activities at Howard University, conventions and banquets, sorority and social club events, dances, weddings, cotillions, and local business affairs. Scurlock portraits, for the most part, were images of self-empowerment and self-determination. The studio's clients included leaders and brides, high school and college graduates, and entertainers.

Looking at Scurlock's photographs and others from this period, one can see an African American community that is intellectually and artistically productive. Levey notes that the Scurlock photographs are readily identifiable:

> Perhaps the most distinctive hallmark of the Scurlock photograph is the dignity, the uplifting quality, of the demeanor of every subject, captured by photographers who clearly saw each one as above the ordinary.[28]

There is a Scurlock "look," Levey continues, a highly technical quality in which light plays evenly and attractively across the features of the subjects.[29]

Scurlock's portrait of sociologist W. E. B. Du Bois (1911), then editor of the new *Crisis* magazine, shows Du Bois as a reflective leader through the sitter's constructed pose and style of dress, and the photographer's strategic use of light. Here the Scurlock look is self-assured and formal, befitting a leader of Du Bois's exalted status. Just as the easy portability of the *carte-de-visite* and cabinet card made them ideal for proliferation and distribution, the larger scale of the aesthetic print appealed to the fine art photographer. Scurlock's portrait of Du Bois is just over 13 × 16 inches, its size appropriate to its celebrated subject. Such an enlargement was intended to be framed and hung on a wall. Although in 1911 there were few exhibition opportunities for African American artists, Scurlock could market such images to a discriminating clientele who would have enjoyed both the means and the wherewithal to proudly hang them in homes and classrooms. During the 1920s, Du Bois's *Crisis* published photographs documenting the achievements of black men and women, often featuring portraits on the journal's cover. These portraits were consciously selected for their depiction of racial progress and positive impact on perceptions of the black middle class.

James VanDerZee was both a participant in and a recorder of the Harlem Renaissance, the flowering of African American art and culture in Harlem during the 1920s and 1930s. VanDerZee's 1925 portrait of Reverend Adam Clayton Powell Sr. (1865–1953) with his Sunday school class firmly locates the reverend within his Harlem community and demonstrates his popular appeal.

Powell was born in Franklin County, Virginia. He was named pastor of New York's Abyssinian Baptist Church in 1908 and moved it to Harlem in 1923, buying land on West 138th Street. Powell raised enough money to pay off the loan for the church, and five years later was able to stage a public mortgage-burning bonfire. He remained an important force in the community, and became a national leader with tremendous influence.

Gordon Parks's own writings address the notion of a celebrity photographing a celebrity. Parks (1912–2006) spent seven decades observing, writing, documenting, photographing, and interpreting a wide range of life experiences. His biography includes several remarkable "firsts"—first black photographer hired by the Farm Security Administration, first black photographer for *Life* magazine, and first black director to make a movie for a major Hollywood studio (*The Learning Tree,* Warner Bros., 1969). Arnold Eagle's 1945 portrait of Parks shows the handsome young man with the tools of his trade, photographed from slightly below to aggrandize him, his gaze cast out of the frame and metaphorically toward his future career.

The political climate of America in the 1960s informed much of Parks's work. In 1966, for *Life* magazine, Parks photographed firebrand athlete and activist Muhammad Ali in training, his poised body emblematic of his power and seemingly unstoppable force. As an African American, Parks was often part of his subjects' milieu, allowing him access that other *Life* photographers did not have. As Parks explained, Malcolm X and the Muslims were careful about publicity and were especially leery of white photographers.[30]

Among the powerful *Life* photo-essays published by Parks was one about the young Student Nonviolent Coordinating Committee (SNCC) coordinator and orator Stokely Carmichael.[31] In 1967 the photographer interviewed

and photographed Carmichael as he addressed a rapt crowd at a demonstration against the Vietnam War. Parks wrote, "Stokely Carmichael screamed 'Black Power' until he was hoarse. . . . Carmichael had been propelled to the center of the black revolution by racism. . . . It was his strident call for Black Power that set off a chain of reaction hardly to be equaled in our time."[32]

George Tames's photograph shows Carmichael in conversation. It captures a light moment in an office corridor between the young firebrand and the politician Adam Clayton Powell Jr. (namesake of his father, the founder of Harlem's Abyssinian Baptist Church) and freezes this informal meeting of emerging power and established power for all time. Parks describes Powell in 1948 as "glamorous, flamboyant."[33] Tames's photograph of Powell in a light-colored suit exaggerates the notion of "flamboyant." Parks went on to describe Powell's magic:

> He [Powell] is an eloquent spokesman. He brings tears to the stout-of-heart, and with perspiration flying from his flopping hair, he transforms a complacent audience into one of electrified frenzy. He gestures, points his fingers and dramatically beats his message home with clenched fist up on the speaker's rostrum. Then suddenly, and with great finesse, he leans forward, surveys his spellbound audience and delivers the coup de grace.[34]

Such a depiction of a celebrated speaker at the podium before a large crowd harkens back to Arthur Bedou's powerful portrait (1915) of a poised and smiling Booker T. Washington addressing an audience in Shreveport, Louisiana, during his last Southern tour. Arthur P. Bedou (1882–1966), a journalistic and portrait photographer, was born in New Orleans. When Booker T. Washington was president of Tuskegee Institute, he hired Bedou to document his public life and personal moments. Washington knew that photographs promoting his work at Tuskegee Institute and his public lectures around the country could be used to inform black and white Americans of his accomplishments. Art historian Richard Powell comments on Washington's understanding of photography's power:

> School administrators like . . . Tuskegee Institute's Booker T. Washington knew how effective documentary photography was in elevating the public profiles of their schools. . . . Pictures . . . were understood by one and all to be ammunition against those in society who would deny African Americans their rights and privileges as full citizens, not to mention a visual contestation against the legion of racist images that proliferated throughout America during the same period.[35]

Bedou's photograph helps the modern viewer to imagine how Washington's audiences must have viewed him. The photograph conveys all those qualities that made Washington such a powerful orator, as noted in this contemporary description:

> There was a remarkable figure, tall, bony . . . and [with a] strong determined mouth . . . piercing eyes, and a commanding manner. The sinews stood out on his bronzed neck, and his muscular right arm swung high in the air. . . . His voice rang out clear and true, and he paused impressively as he made each point. Within ten minutes the multitude was in an uproar of enthusiasm—handkerchiefs were waved, canes were flourished, hats were tossed in the air. The fairest women . . . stood up and cheered. It was as if the orator had bewitched them.[36]

Bedou's picture draws the viewer to the orator's imposing physical presence, while the smiling faces of the audience make the perfect backdrop.

Photography and the "Performance Portrait"

The major categories of cultural production in the United States—music, dance, writing, the spoken word, and the visual arts—are represented in this exhibition through a range of environmental and performance portraits. These portraits provide a context that enhances the viewer's understanding of the subject's particular genius. They often suggest the notion of a sophisticated and cool pose that became immortal only because of the photographic image. In a 1933 portrait of Cab Calloway, Carl Van Vechten placed the bandleader in the foreground, motionless, against a backdrop of painted, slightly abstracted performing bodies. Similarly, in a 1959 study of Jacob Lawrence, Arnold Newman positioned the painter on the same plane as one of his paintings, neatly balancing the composition between the artist and his work.

Alfredo Valente's dramatic photograph of Ethel Waters (c. 1939) depicts the emotive actress in character, thus obfuscating the individual and elevating her craft. Stanislaus J. Walery's Josephine Baker (1926) is posed in a glamorous showgirl costume, likewise favoring the persona over the person. After moving to Paris in 1925, Baker was photographed by Walery in different poses, from seductress to comedian to cultured lady.

George Hurrell's 1935 photograph of noted dancer Bill "Bojangles" Robinson, popularly known as the "Honorary Mayor of Harlem," presents him in full dance mode. Robinson's fans favored this classic stair dance image—the fashionably dressed, charismatic entertainer tapping his way down the steps. Robinson played supporting roles in a number of movies in the 1930s, but he is widely known for this famous dance movement. The portrait focuses on Robinson's talent, relying for its impact upon his then-universal renown.

Other portraits are significant because of their reference to racial dynamics. In Ruth Orkin's powerful portrait, composer Leonard Bernstein assumes a subordinate posture to soloist Marian Anderson; she stands in the foreground at the microphone, rehearsing in New York's Lewisohn Stadium, which makes her appear larger and more imposing than the seated Bernstein. In Sid Avery's 1954 portrait, singer Nat King Cole is the embodiment of respectability in his pose and dress. At one of Cole's nightclub performances the photographer frames spectators Gig Young and Jack Palance as ordinary members of his admiring audience. Cole is not only the center of attention, he becomes the paragon of poise and charismatic talent, "looked up to" even by his white peers. Film historian Donald Bogle describes Cole's short-lived television program, *The Nat "King" Cole Show* (1956–57), as "mainstream pop rather than ethnic rhythm and blues, . . . [that] had already won him a large national following."[37] Avery's adulatory treatment reinforces that assessment. Bogle observes that "Cole himself came across as a model gentleman: smooth, polished, soft-spoken, debonair, easy-going, urbane."[38]

Context is an important element in photography. Images of musicians performing in a nightclub, studio, or on stage can create a strikingly different reading of the subject than a conventional portrait would allow. Gjon Mili's remarkable 1943 portrait of Mary Lou Williams seated at the piano is much more than a study of the musician performing; it is a collaboration with her musicians and the photographer. Gesture and style determine the effect of this expressive portrait.

The striking 1958 portrait of Sarah Vaughan by Josef Breitenbach, taken while in performance, creates an image infused with expressive beauty and sexuality. Her well-manicured hands are raised as she belts out a song. Breitenbach's use of available light silhouettes Vaughn's sophisticated evening dress that reveals a bare shoulder, catching this much-admired performer in an unguarded moment.

Lisette Model's Ella Fitzgerald photograph from 1954 shows the singer in a dramatic pose shot from below. Model is known for her unusual framing of her subjects. Herschel Levit's approach is similar. His portrait of singer Harry Belafonte (c. 1968) frames the subject close up and mid-song, capturing the riveting emotional intensity of the performance as well as the human drama behind the performer.

Photographs of boxers reveal both the beauty and the pain of the sport. The defiant portrait of boxer Jack (John Arthur) Johnson (c. 1910) is both titillating and ironic, since his triumph was marred by the overt hostility of white boxing fans. His profiled pose emphasizes his strength; it is a celebratory pose. In 1908, as the first black heavyweight champion of the world, Johnson caused an international furor and great excitement in both black and white communities. He lost the title in 1915, but continued to fight exhibition bouts until his death in 1946.

Charles Hoff's 1952 photograph of heavyweight Rocky Marciano and Jersey Joe Walcott at Philadelphia's Municipal Stadium emphasizes their muscular bodies in the ring. Marciano was knocked down for the first time in his career during the opening round; this photograph captures the pain and grace of the hit. Walcott was knocked out in the thirteenth round. The photograph of lightweight boxers Jimmy Carter and George Araujo (1953) also shows the dominance and power that are integral to the sport. Araujo only had nine losses in his long career—one being to Carter in this bout in the thirteenth round at New York's Madison Square Garden.

In 1975, Anthony Barboza began a series of portraits in context, and for the next ten years photographed close friends and admired artists, intellectuals, models, sports figures, and actors. But in Barboza's case, it is the photographer who provides the context. In describing his work, Barboza recalls that "when I shoot a portrait, I meet another person's space. I interpret and define it."[39] Like many of the photographers in this exhibition, Barboza enhances his subject's personality through lighting and studio backdrop paper. He wrote in 1980:

> *I am not showing them at their work, but showing their faces and bodies and other elements that indicate what their work might look like—to catch not the outward appearances, but the essences of their work. . . .*[40]

To further enhance the portraits, Barboza prefers to create the backdrop for his subject. The backdrop papers in his portraits have been sliced, stapled, taped, and/or sprayed with metallic paint, transforming what started as a void into a distinctly personalized environment.

Sometimes photographers also used technical means to achieve particular effects to suit a subject. In the case of Paul Robeson's portrait, photography historian Merry Foresta notes the painstaking ritual Doris Ulmann followed to create an image of unusual beauty and sensitivity that enhances our understanding of the personality depicted:

Long after more advanced equipment was available, Ulmann worked with a view camera and soft-focus lens without a shutter. For each exposure she manually removed and replaced her lens cap; her subjects had to be carefully—and self-consciously—posed. Printed, like most self-consciously Pictorialist works of art, in the luxuriously rich tones of platinum, the images are equally ideal and romantic.[41]

Her portrait of Paul Robeson depicts a smiling figure, self-confident and self-defined.

Many other photographers in this exhibition played an important role in constructing their subjects' identities. They devised ways to use composition and props, manipulate images, and stage studio scenes to establish a space in which their subjects could reinvent themselves symbolically.

Conclusion: The Legacy

In his introduction to *12 Million Black Voices,* novelist Richard Wright suggests that those outside the black community often "take us for granted" and think that they know "us." But, he goes on to say, "we are not what we seem." He elaborates further:

Our outward guise still carries the old family aspect which three hundred years of oppression in America have given us, but beneath the garb of the black laborer, the black cook, and the black elevator operator lies an uneasily tied knot of pain and hope whose snarled strands converge from many points of time and space.[42]

Wright's haunting words, "we are not what we seem," reinforce the idea that photographic portraits operate on several levels. Many of the people represented in this exhibition held conflicting views about their own status as well as about each other. The resulting photographs, though resolved as works of art, often mask the complex narrative behind the images.

Photographs did much more than record the presence of black men and women in America. Images of race leaders and society or celebrity portraits acknowledged the importance of the sitters, and that pride—in portraits of Nat King Cole on stage, Joe Louis with his trainer, Judith Jamison performing *Cry,* or Sarah Vaughan in performance—was transferred to other blacks, creating a communal portrait of prestige and power that resisted the stereotypes of the time.

Today, as they were in the past, photographs are considered visual testimony of our collective memory. Even now, notions of race and power guide our visual reading of the medium. What we imagine and know about these subjects through the visual image is mediated through the insight of the photographers and framed within our own experience with portrait photography. The National Portrait Gallery's collection includes photographs of African Americans of note that can be read in a variety of illuminating ways.

DEBORAH WILLIS
GUEST CURATOR
PROFESSOR OF PHOTOGRAPHY AND IMAGING
TISCH SCHOOL OF THE ARTS
NEW YORK UNIVERSITY

Notes

1. As quoted in Gregory Fried, "True Pictures: Frederick Douglass on Race in Early American Photography," *Common Place* 2, no. 2, (January 2002), part I, at www.common-place.org (accessed 31 January 2007).

2. Gordon Parks, *Camera Portraits: The Techniques and Principles of Documentary Portraiture,* New York: Watts, 1948, 5.

3. Frederick Douglass, "Negro Portraits," *The Liberator* 19, no. 16, 20 April 1849: 62.

4. Alan Trachtenberg, *Reading American Photographs: Images as History, Mathew Brady to Walker Evans,* New York: Noonday, 1989, xvi.

5. Nicholas Mirzoeff, "The Shadow and the Substance: Race, Photography and the Index," in *Only Skin Deep: Changing Visions of the American Self,* ed. Coco Fusco and Brian Wallis, New York: International Center of Photography / Harry N. Abrams, Inc. Publishers, 2003, 111–27, 116.

6. Parks, *Camera Portraits,* 5.

7. Ibid.

8. Carla Kaplan, ed., *Zora Neale Hurston: A Life in Letters,* New York: Doubleday, 2002, 323.

9. Ibid., 324.

10. Donald Bogle, *Blacks in American Films and Television: An Encyclopedia,* New York: Garland Publishing, Inc., 1988, 36.

11. Ibid., 404.

12. Graham Clarke, *The Photograph,* New York: Oxford University Press, 1997, 112.

13. Colin L. Westerbeck, "Frederick Douglass Chooses His Moment," in *African Americans in Art: Selections from the Art Institute of Chicago,* ed. Art Institute of Chicago, Chicago: The Art Institute, 1999, 25.

14. Henry Highland Garnet, "An Address to the Slaves of the United States of America," in *Lift Every Voice: African American Oratory, 1787–1900,* ed. Philip S. Foner and Robert James Branham, Tuscaloosa and London: University of Alabama Press, 1998, 198–205, 205.

15. Richard J. Powell, "Sartor Africanus," in *Dandies: Fashion and Finesse in Art and Culture,* ed. Susan Fillin-Yeh, New York: New York University Press, 2001, 224.

16. Clarke, *The Photograph,* 106.

17. Ibid.

18. Romare Bearden and Harry Henderson, *A History of African-American Artists from 1792 to the Present,* New York: Pantheon Books, 1992, 77.

19. Gwendolyn DuBois Shaw, *Portraits of a People: Picturing African Americans in the Nineteenth Century,* Andover, Mass.: Addison Gallery of American Art, Phillips Academy, 2006, 170.

20. Ibid., 170–72.

21. Nell Irvin Painter, *Sojourner Truth: A Life, A Symbol,* New York: W. W. Norton, 1996, 197.

22. Ibid., 197–98.

23. Ibid., 187.

24. Ibid., 195.

25. Dubois Shaw, *Portraits of a People,* 48.

26. Painter, *Sojourner Truth,* 198.

27. Jane Freundel Levey, "The Scurlock Studio," in *Visual Journal: Harlem and D.C. in the Thirties and Forties,* ed. Deborah Willis and Jane Lusaka, Washington, D.C.: Smithsonian Institution Press, 1996, 150.

28. Ibid., 154.

29. Ibid., 153.

30. Gordon Parks, *Half Past Autumn: A Retrospective,* Boston: Bulfinch, 1997, 240–43.

31. See "Stokely Carmichael: Young Man Behind an Angry Message," *Life* 62, no. 20 (19 May 1967), 76A–78, 80, 82.

32. Gordon Parks, *Voices in the Mirror: An Autobiography,* New York: Doubleday, 1990, 238.

33. Parks, *Camera Portraits,* 62.

34. Ibid.

35. Richard J. Powell and Jock Reynolds, *To Conserve A Legacy: American Art from Historically Black Colleges and Universities,* Andover, Mass.: Addison Gallery of American Art; New York: The Studio Museum in Harlem; Cambridge, Mass.: Distributed by MIT Press, 1999, 112.

36. A description of Washington delivering his speech at the 1895 Atlanta Exposition is given by James Creelman in the *New York World,* 18 September 1895, and quoted in Washington's autobiography, *Up From Slavery,* in *Three Negro Classics,* New York: Avon Books, 1965, 24–205, 158–59.

37. Bogle, *Blacks in American Film and Television,* 240.

38. Ibid.

39. *Introspect: The Photography of Anthony Barboza,* New York: Studio Museum in Harlem, 1982, 12.

40. Ibid., 13.

41. Merry A. Foresta, *American Photographs: The First Century from the Isaacs Collection in the National Museum of American Art,* Washington, D.C.: National Museum of American Art, Smithsonian Institution; Smithsonian Institution Press, 1996, 26.

42. Richard Wright and Edwin Rosskam, *12 Million Black Voices: A Folk History of the Negro in the United States,* New York: Viking, 1941, 10.

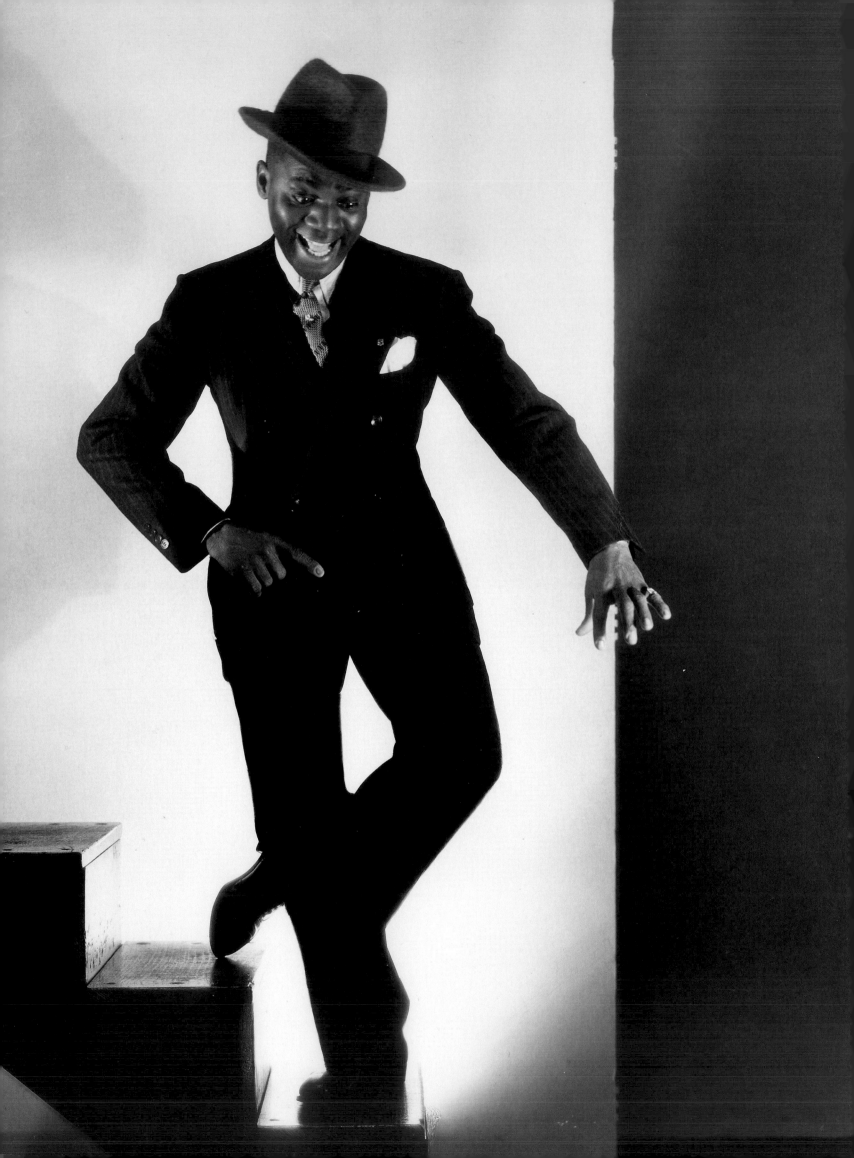

PORTRAITS

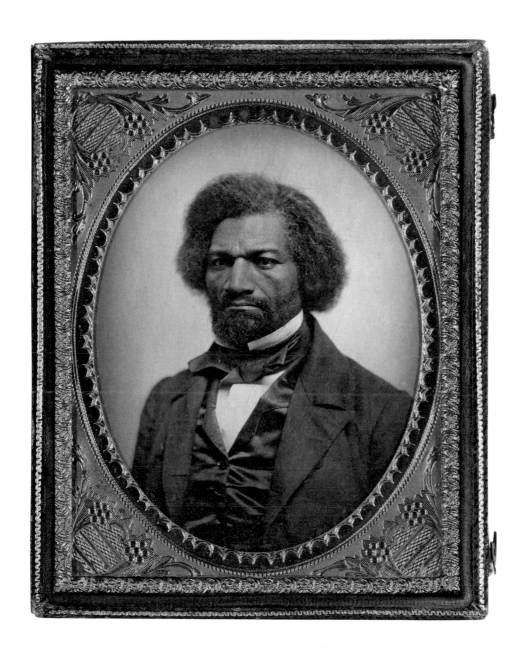

PLATE 1 | **Frederick Douglass** UNIDENTIFIED PHOTOGRAPHER 1856

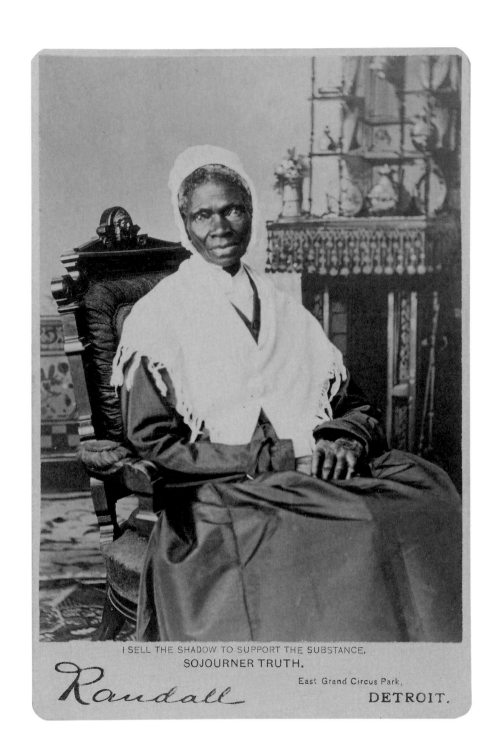

I SELL THE SHADOW TO SUPPORT THE SUBSTANCE.
SOJOURNER TRUTH.

Randall

East Grand Circus Park,
DETROIT.

PLATE 2 | **Sojourner Truth** RANDALL STUDIO C. 1870

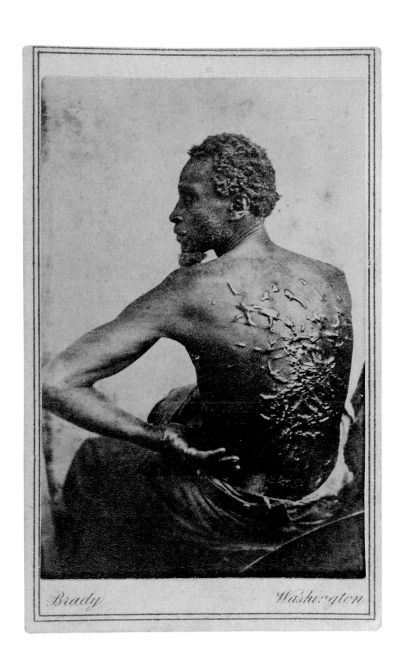

PLATE 3 | **Gordon** MATHEW BRADY STUDIO 1863

EDMONIA LEWIS

The *carte-de-visite* of Edmonia Lewis represents an element of risk—risk because Lewis's image is one that rests in tension between her status as celebrity and her status as specimen. Her status as "celebrity" was determined by her career as an artist living and working as part of an expatriate community of American sculptors in Italy. These artists were responsible for linking the United States to a long history of European creativity; simultaneously, as Americans they would be credited by homegrown theorists with improving upon the art of antiquity and the Renaissance because of the superior moral condition of the American Republic. Lewis's status as "specimen" was determined by how race and gender shaded and nuanced her career. The dissonance between being "black" and an "artist" made her an anomaly, but it was an anomaly easily accommodated to an age in which human beings were exhibited as curiosities.

Lewis's appearance was an obsession with her reviewers and interviewers. In the nineteenth century, appearance was an index of "blood," which was thought to carry racial characteristics that were then made manifest on the body. The fixation on "blood" and its relative "purity" reflected American society's need to maintain and police the boundaries of racial difference. Lewis's contemporaries used the intersection of science and aesthetics to register her appearance, and those descriptions became part of the larger explanation of her "identity," read narrowly as "race." Nevertheless, conflicting descriptions of Lewis abound, and, although one can reasonably speculate that Lewis hoped her *cartes-de-visite* would represent a moment of stability amid the conflicting accounts of her appearance-qua-identity, this is not the case. This *carte-de-visite,* part of the only known set to have been commissioned by Lewis, is but one of a myriad of ways the artist both represents her "self" and was represented by others.

What then can we say about this image? By comparing it to the *cartes-de-visite* of other people, we can identify options not taken by Lewis. For example, she easily could have posed as the "Indian Princess" complete with costume and studio props; instead, she dresses modestly and not at all "boyishly" (as many written descriptions would have her). Ultimately, she does not use the photographer's studio as a space in which to "play" with identity in any obvious manner. As Shawn Michelle Smith writes in *American Archives,* "Identity is not fixed in the body but in representation itself" and therefore "one might begin to think of the body as a product, not a producer of identity." Accordingly, Lewis's *carte-de-visite* is no more "true" or "real" than the many other representations of the artist. It, too, is a construction, strategically inserted into the field of representations of Lewis and thus holding no absolute authority over her. Even

so, the photograph may constitute a conscious choice on the part of the artist to construct an image that denies the exotic interpretations favored by the biases of the time.

Kirsten P. Buick
Assistant Professor
Department of Art and Art History
The University of New Mexico

NOTE

Michelle Shawn Smith, *American Archives: Gender, Race, and Class in Visual Culture,* Princeton, N.J.: Princeton University Press, 1999, 104.

SELECTED BIBLIOGRAPHY

Bogdan, Robert. "The Social Construction of Freaks." In *Freakery: Cultural Spectacles of the Extraordinary Body,* edited by Rosemarie Garland Thomson, 23–37. New York and London: New York University Press, 1996.

Buick, Kirsten Pai. *Child of the Fire: Mary Edmonia Lewis and the Problem of Art History's Black and Indian Subject.* Durham: Duke University Press, forthcoming 2007.

Frizot, Michel. *A New History of Photography.* Köln: Könemann, 1998.

Richardson, Marilyn. "Hiawatha in Rome: Edmonia Lewis and Figures from Longfellow." *Antiques and Fine Art* (Spring 2002): 198–203.

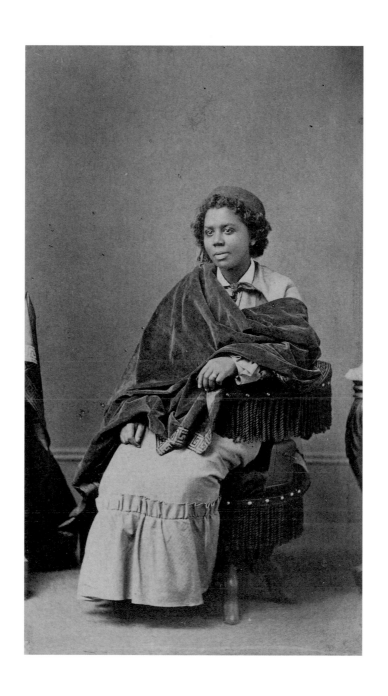

PLATE 4 | **Edmonia Lewis** HENRY ROCHER C. 1870

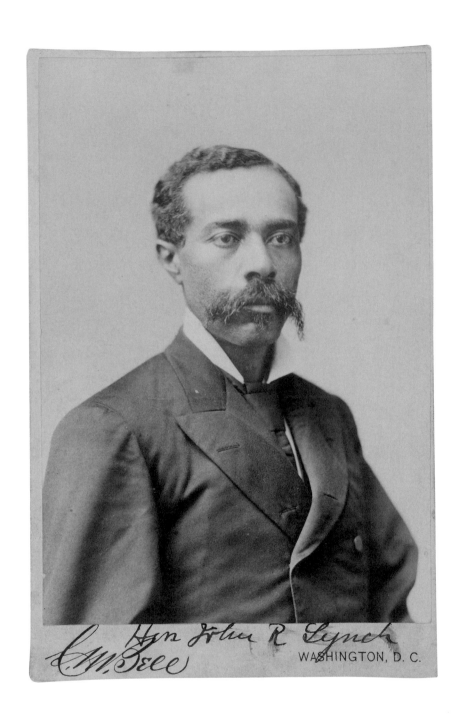

PLATE 5 | **John Roy Lynch** CHARLES MILTON BELL C. 1883

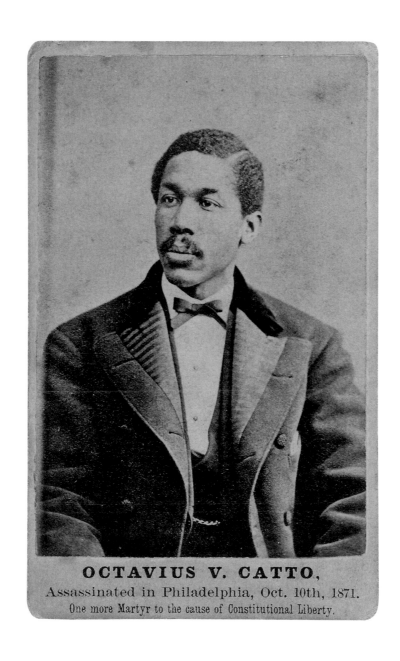

OCTAVIUS V. CATTO,
Assassinated in Philadelphia, Oct. 10th, 1871.
One more Martyr to the cause of Constitutional Liberty.

PLATE 6 | **Octavius V. Catto** BROADBENT AND PHILLIPS C. 1871

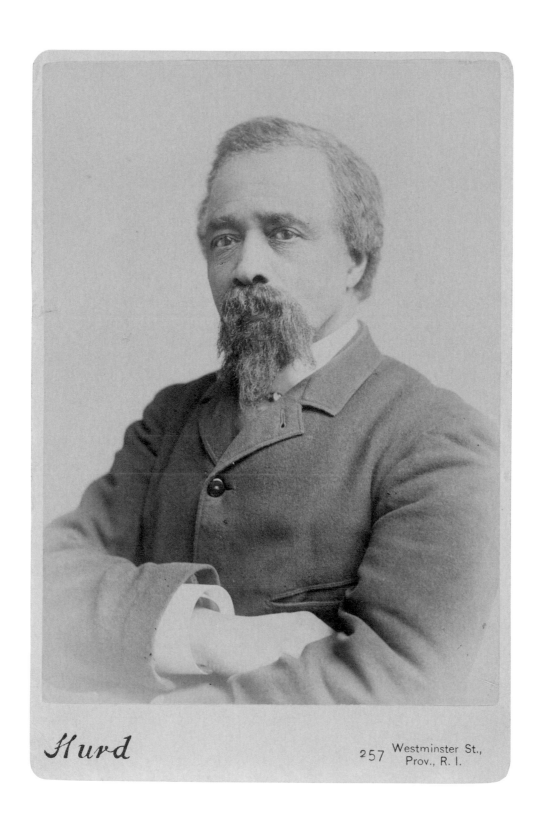

Hurd

257 Westminster St.,
Prov., R. I.

PLATE 7 | **Edward Mitchell Bannister** GUSTINE L. HURD C. 1880

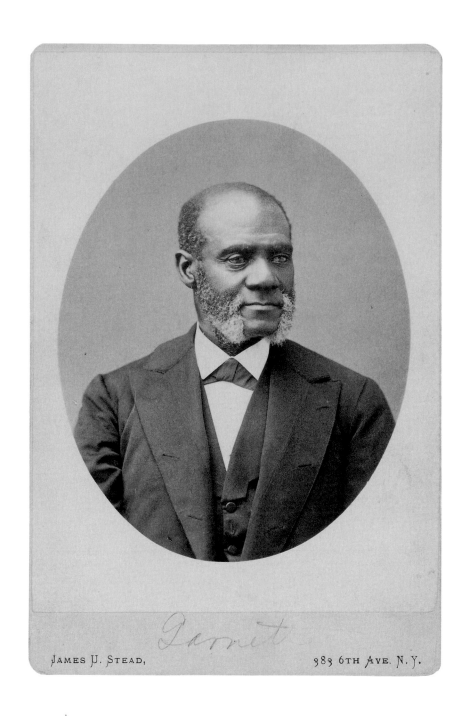

JAMES U. STEAD, 983 6TH AVE. N.Y.

PLATE 8 **Henry Highland Garnet** JAMES U. STEAD C. 1881

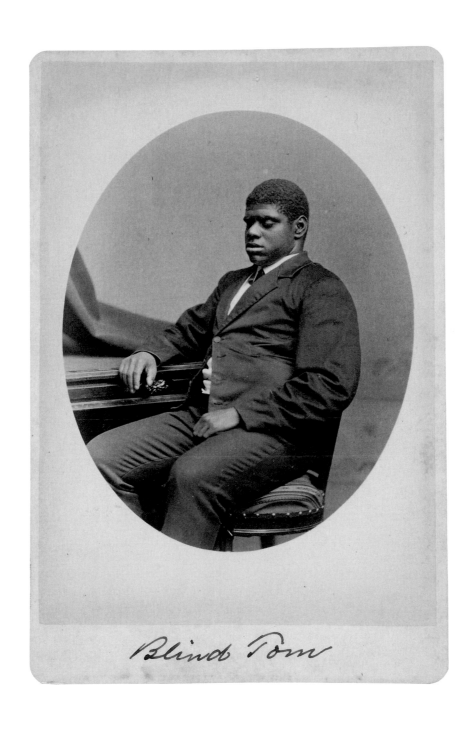

Blind Tom

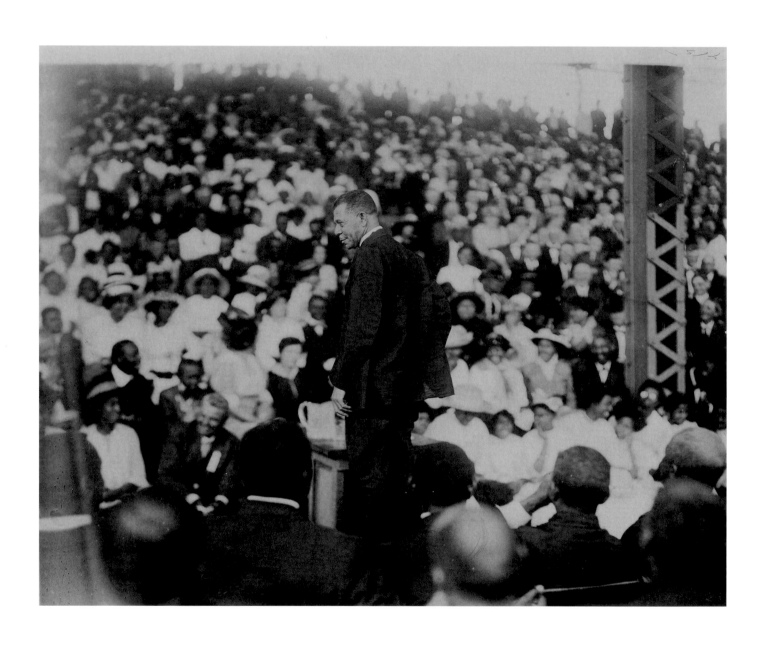

PLATE 10 | **Booker T. Washington** ARTHUR P. BEDOU 1915

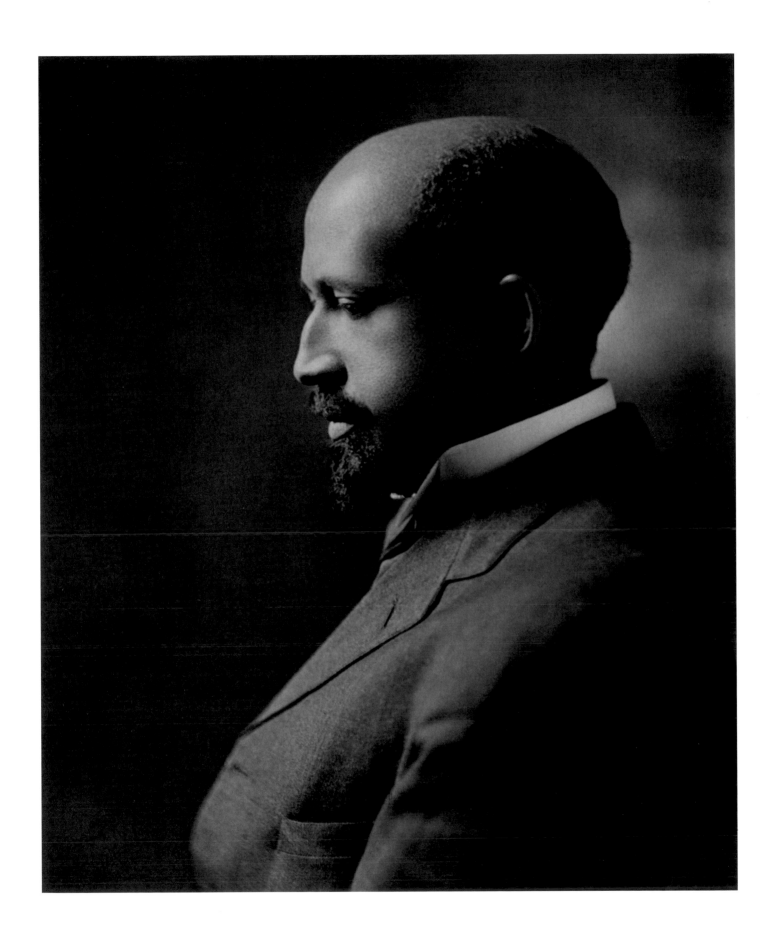

PLATE 11 | **W. E. B. Du Bois** ADDISON N. SCURLOCK C. 1911

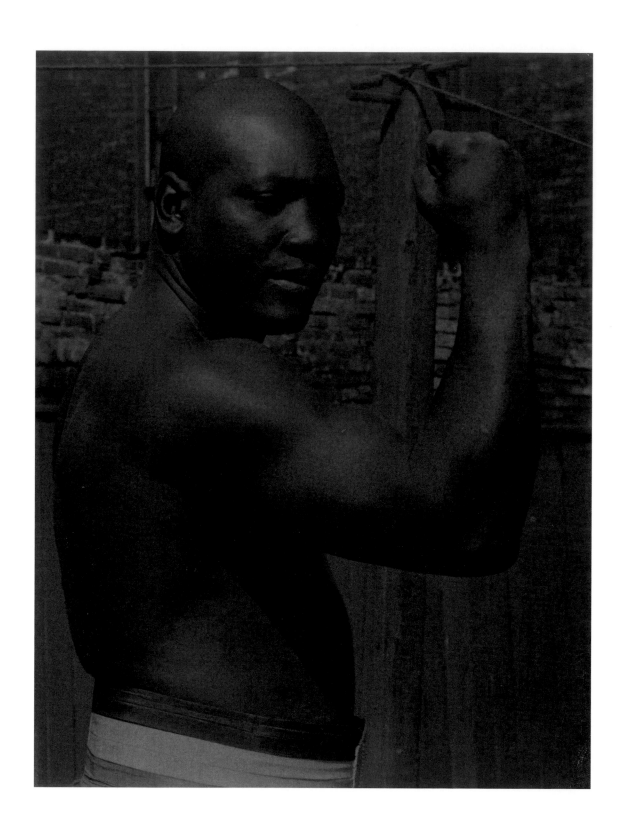

PLATE 12 | **Jack Johnson** PAUL THOMPSON C. 1910

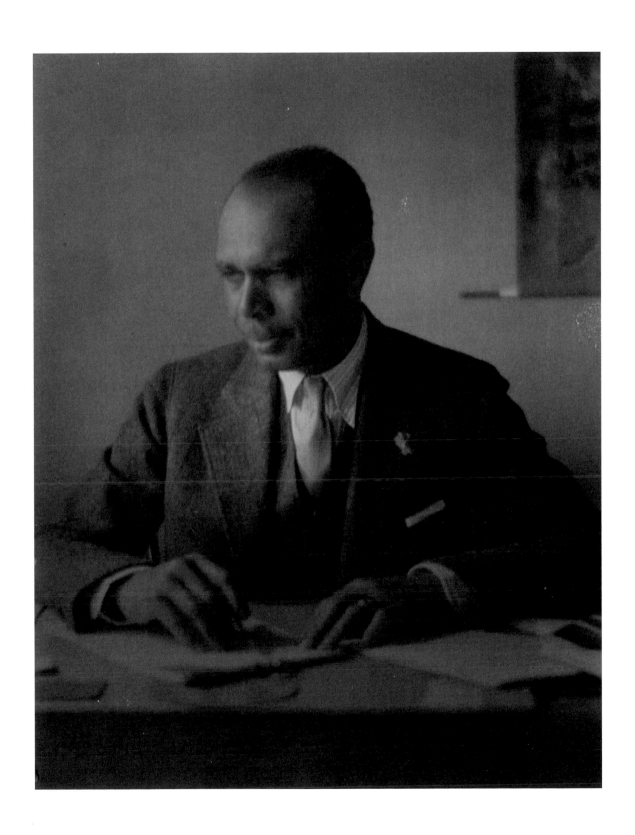

PLATE 13 | **James Weldon Johnson** DORIS ULMANN C. 1925

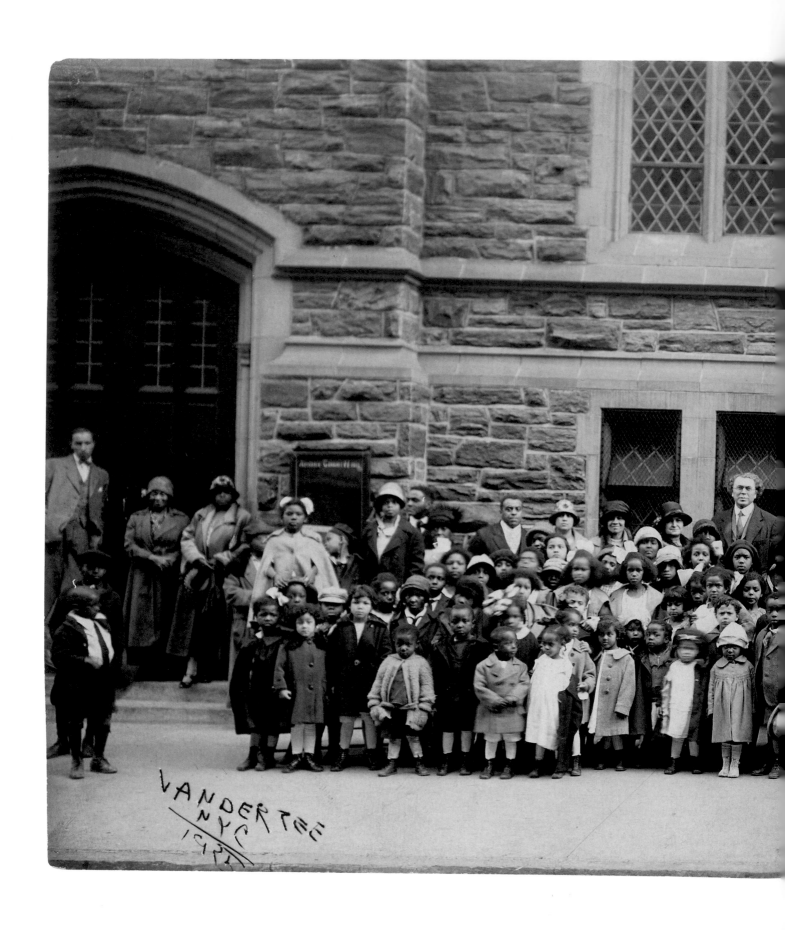

PLATE 14 | **Adam Clayton Powell Sr. (center) with his Abyssinian Baptist Church Sunday school class** JAMES VANDERZEE 1925

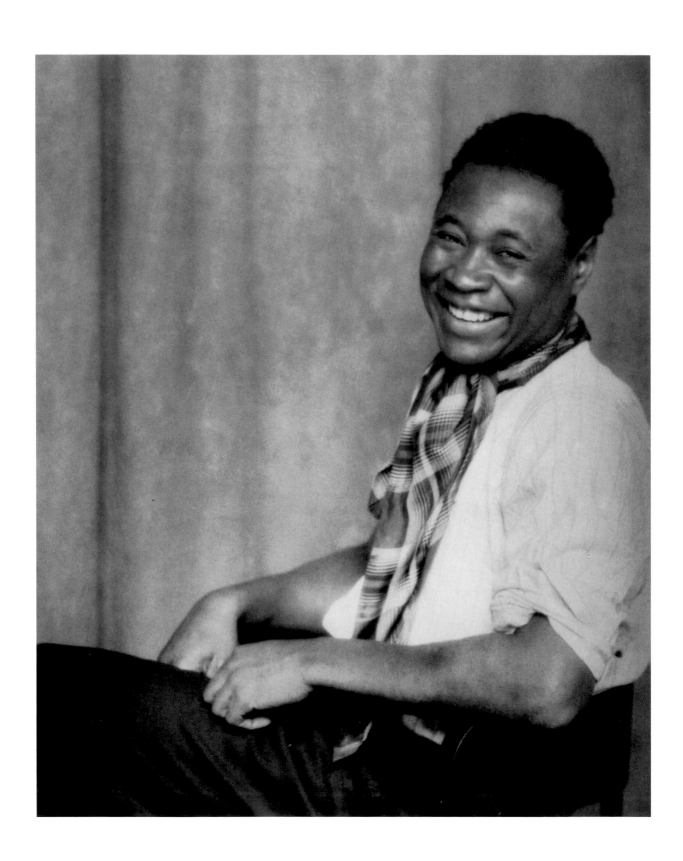

PLATE 15 | **Claude McKay** BERENICE ABBOTT 1926

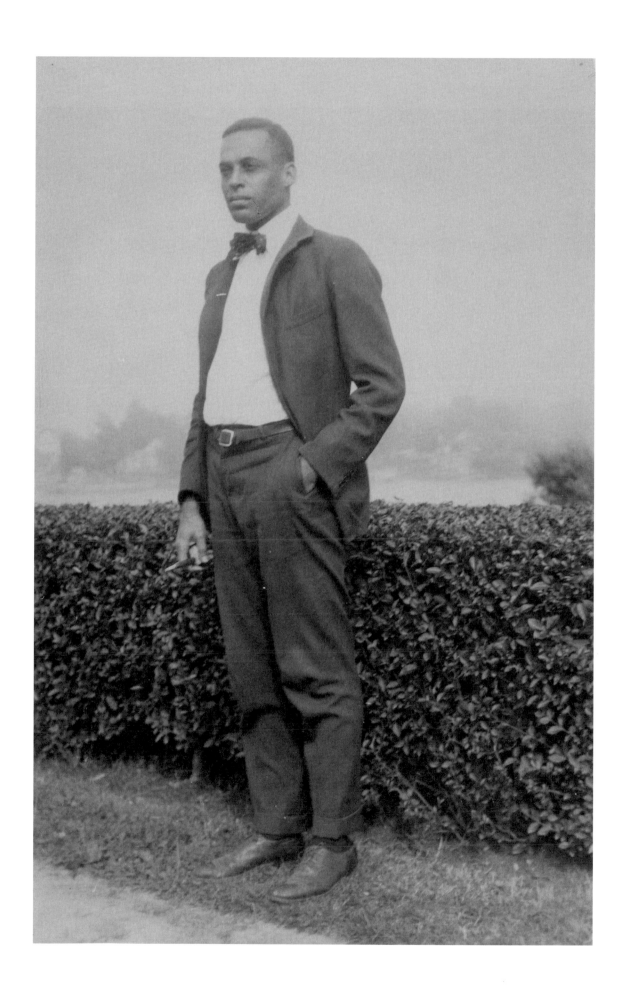

PLATE 16 | **Ernest Everett Just** UNIDENTIFIED PHOTOGRAPHER C. 1920

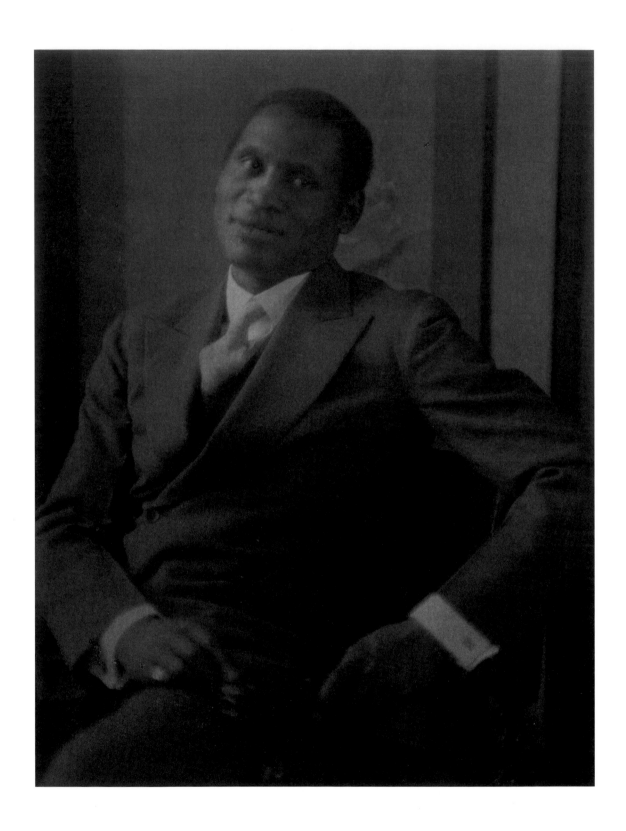

PLATE 17 | **Paul Robeson** DORIS ULMANN C. 1924

PAUL ROBESON

Paul Robeson was born in Princeton, New Jersey, on April 9, 1898, the son of William Drew Robeson, who had escaped from slavery, and Maria Louisa Robeson, a former school teacher. Robeson studied at Rutgers and won All-American football honors despite brutal efforts by his own teammates to keep him off the team. Elected to Phi Beta Kappa, he gave the commencement address, calling for a new idealism.

After graduating from Columbia University Law School, Robeson decided to become an artist rather than a lawyer. In 1925, not long after Ulmann's photograph, he gave a stunning performance as the lead in Eugene O'Neill's *The Emperor Jones* and sang a concert consisting overwhelmingly of slave music, a revolutionary development in the arts. Within months, some critics were hailing him as the world's greatest singer.

In the late 1920s, Robeson lived in England, concertizing, acting, and making films. In the 1930s, he studied at the London School of Oriental Languages. Brilliance in Chinese, Russian, and several African languages, among others, allowed him to enlarge his repertoire of folk music and to discern cultural links among the world's people irrespective of color. He visited the Soviet Union and discovered that in that nation his color was not held against him.

No other artist engendered love or elicited awe in equal measure. Whether acting in Shakespeare or singing Mussorgsky, Robeson's voice ranged in color from the gold of sunlight to the dark thunder of the storm. For his work in *Othello,* he received the Donaldson Award in 1944 as the best actor and the American Academy of Arts and Sciences Gold Medal for the best diction in the American theater. In the same year, composer and director Walter Damrosch said Robeson was "gifted by the gods as musician and actor," and cultural historian Van Wyck Brooks wrote the following: "Everyone knows that this great artist is a great man as well. I doubt if there is another American living of whom this can be said as surely as one says it of Paul Robeson."

At that rare pinnacle of success, Robeson's respect for Negro dialect, in which he sang magnificently, contrasted with the shame most black intellectuals felt for the speech of their slave ancestors. He refused to sing before segregated audiences and championed the emancipation of Africa from colonialism, which he thought necessary to freedom for blacks everywhere. Sadly, many blacks could not understand why one so gifted was willing to sacrifice so much, but Robeson never forgot that his father had been a slave.

In 1946, Robeson led a delegation to the White House to discuss lynching with President Truman; at one point the exchanges grew heated. In subsequent years, as fear of Communism swept the country, resentment over his still-cordial relationship with the Soviet Union served as an excuse to deny him access to the theater and concert hall and to remove his passport. For nearly a decade, his salary, once more than $150,000 a year, was less than $3,000. In Peekskill, New York, in 1949, as state troopers looked on, an attempt was made to kill him.

Though Robeson regained his passport in 1958, his poor health soon led to prolonged retirement. In a recorded final statement to those gathered at Carnegie Hall to celebrate his seventy-fifth birthday, he made the following remarks: "I want you to know that I am the same Paul, dedicated as ever to the worldwide cause of humanity for freedom, peace, and brotherhood. My heart is with the continuing struggle of my own people . . . for not only equal rights but an equal share." Paul Robeson died of a stroke in Philadelphia on January 23, 1976, at the age of seventy-seven.

P. Sterling Stuckey
Professor of History
University of California, Riverside

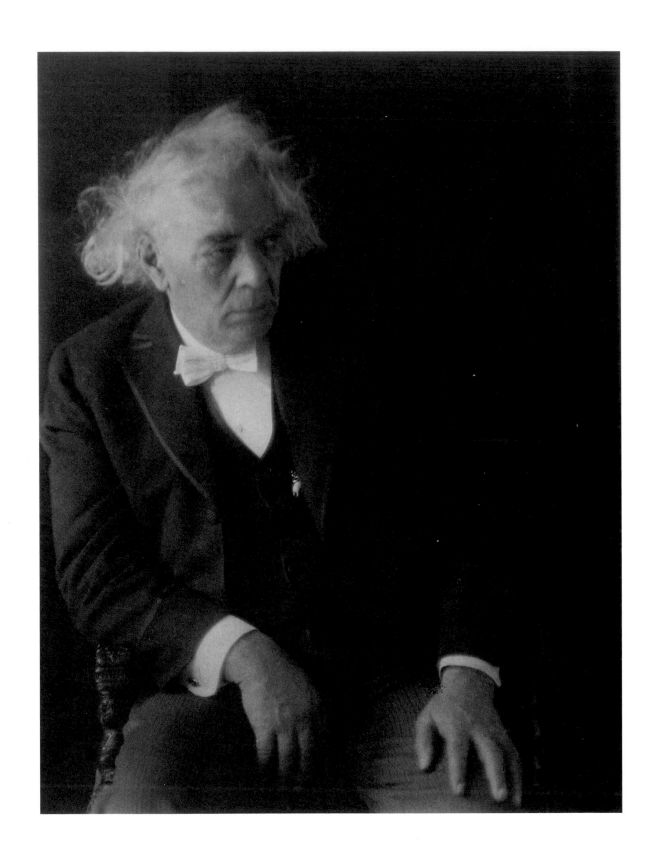

PLATE 18 | **Richard B. Harrison** DORIS ULMANN C. 1932

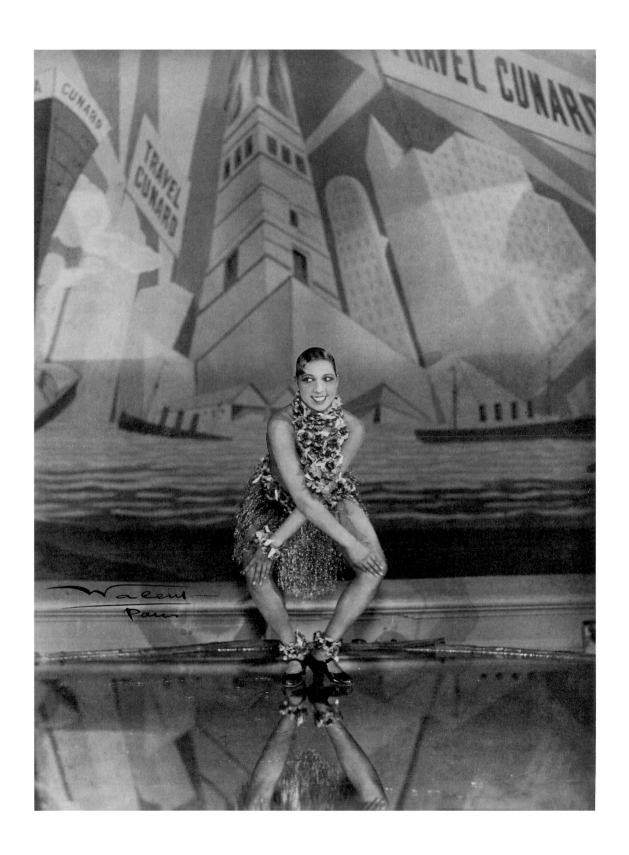

PLATE 19 | **Josephine Baker** STANISLAUS J. WALERY 1926

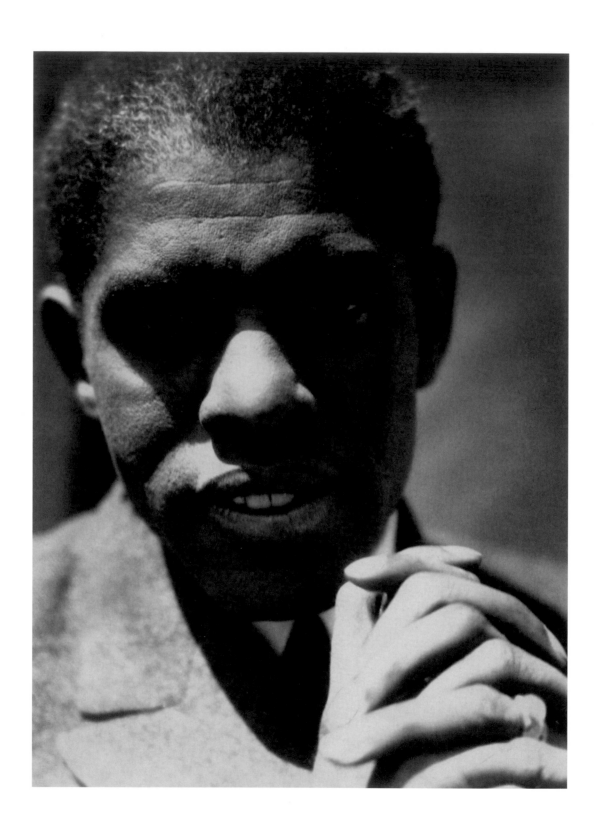

PLATE 20 | **Roland Hayes** ATTRIBUTED TO JOHAN HAGEMEYER 1934

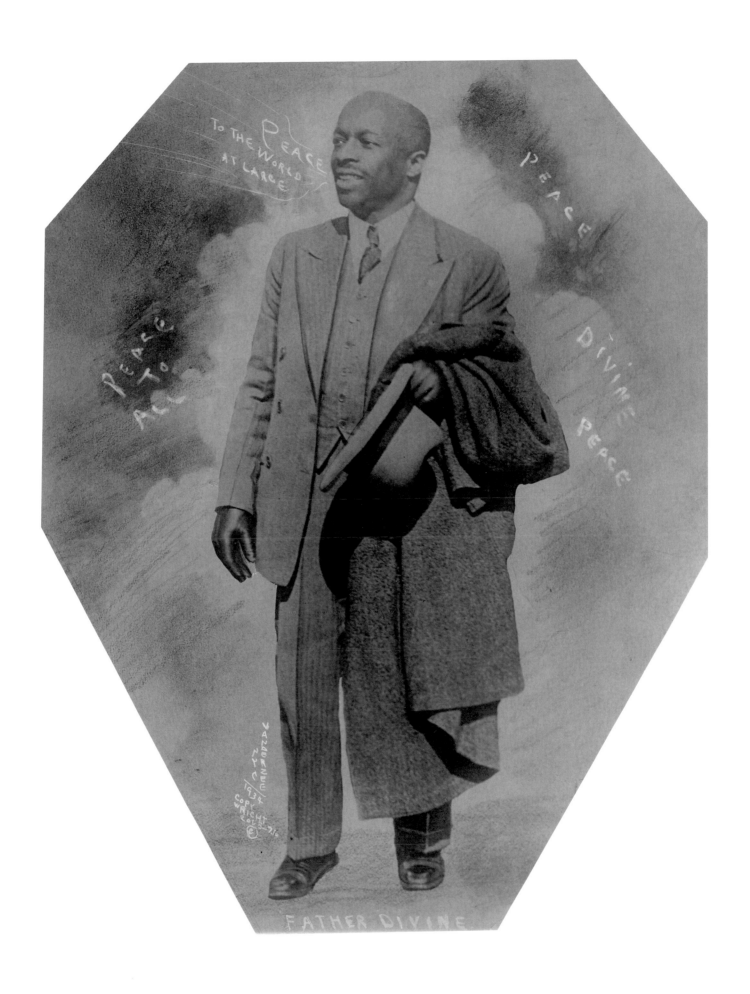

PLATE 21 | **Father Divine** JAMES VANDERZEE 1934

CARVER'S SONG

Pour liquid from a cruet to a test-tube
and wait. Glassy music as the vessels clink.
Will it fizzle? Change colors? Congeal? Dissolve? Wait.

Oh peanut, oh sweet potato,
What I will do with you?
What I will find in you?

What is contained in you?
What is derived from you?
You are humble and magnificent, infinite.

Conjugate conditional,
What could be?
I dream the periodic table spinning:

What will happen, what could.

(George Washington Carver)

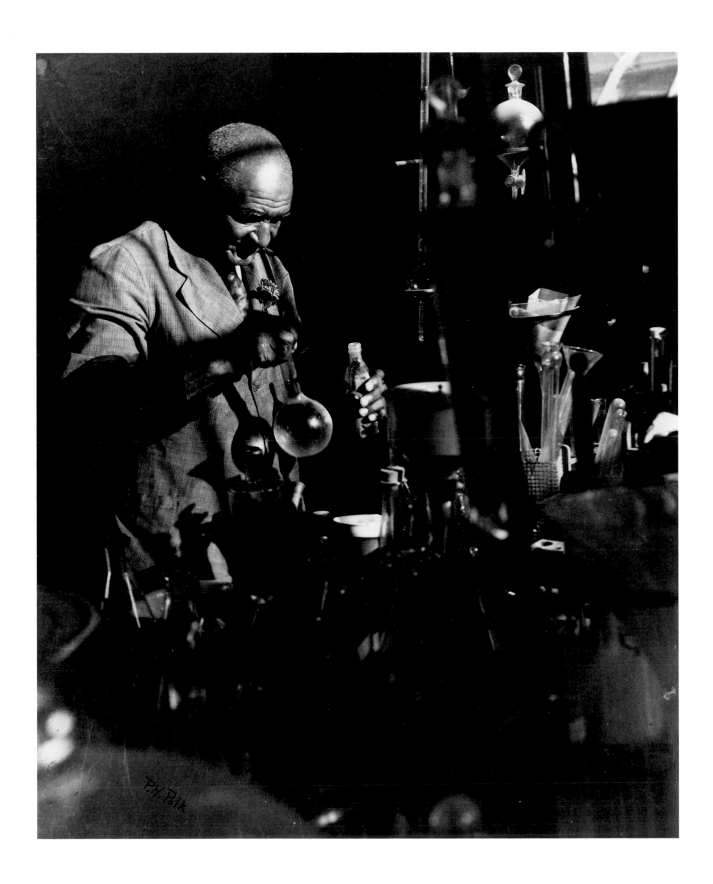

PLATE 22 | **George Washingon Carver** PRENTICE H. POLK C. 1930

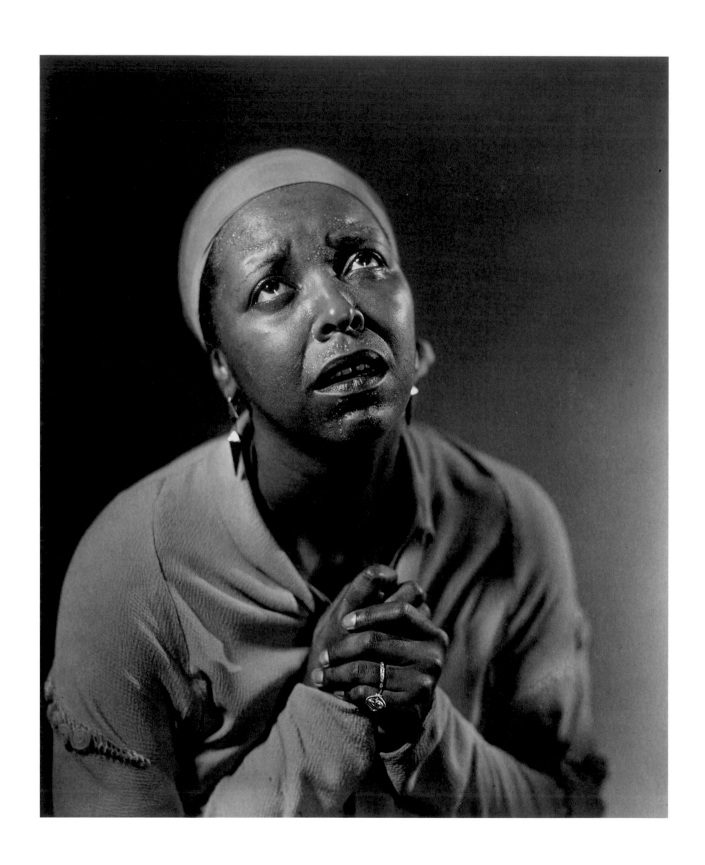

PLATE 23 | **Ethel Waters** ALFREDO VALENTE C. 1939

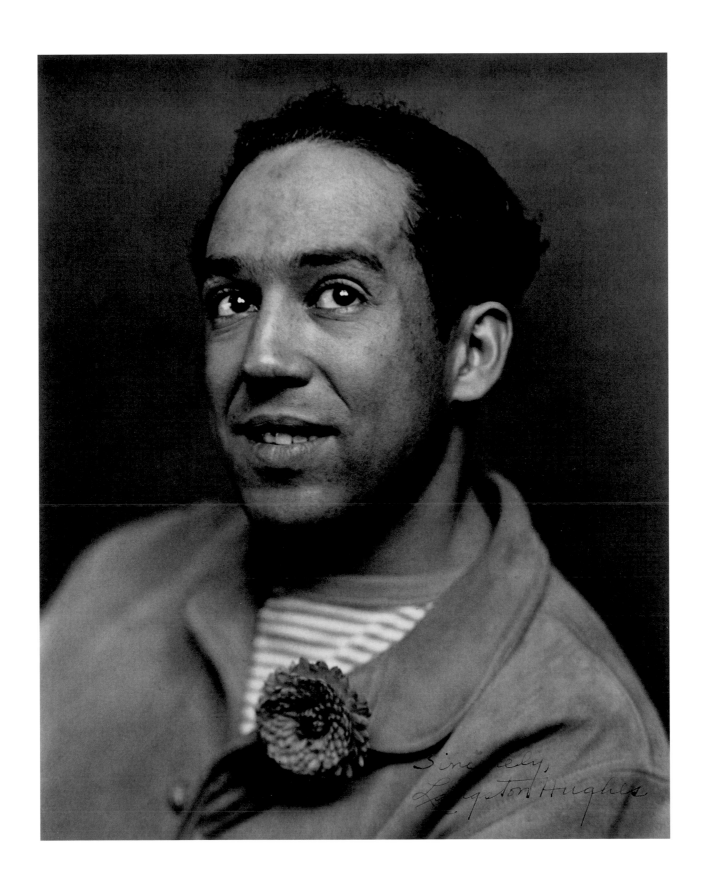

PLATE 24 | **Langston Hughes** EDWARD WESTON 1932

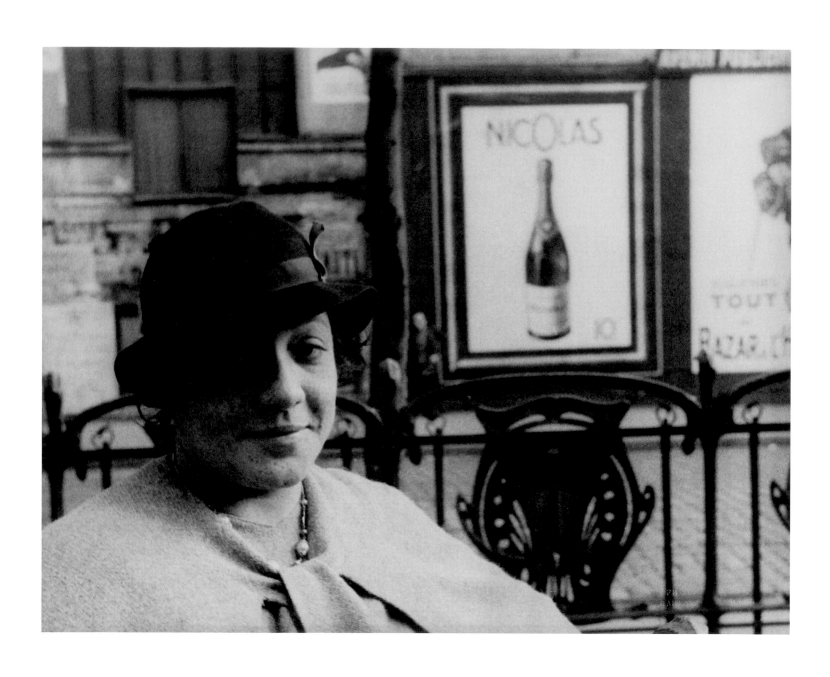

PLATE 25 | **Ada "Bricktop" Smith** CARL VAN VECHTEN 1934

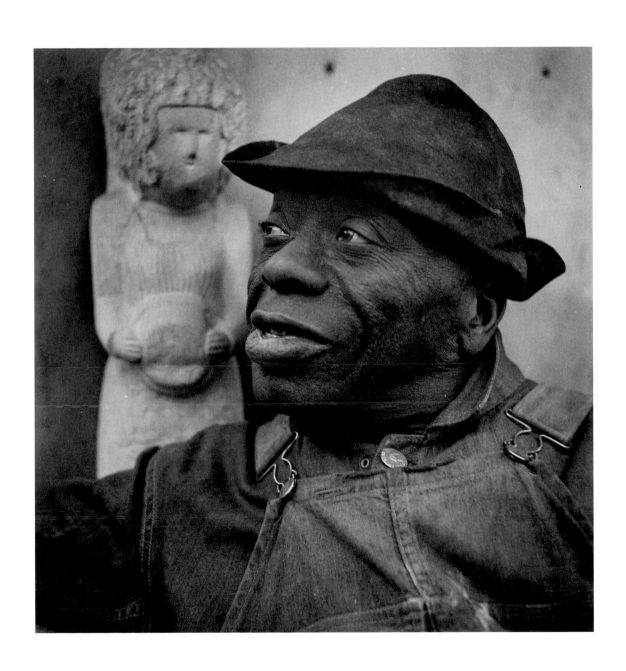

PLATE 26 | **William Edmondson** LOUISE DAHL-WOLFE C. 1933–36

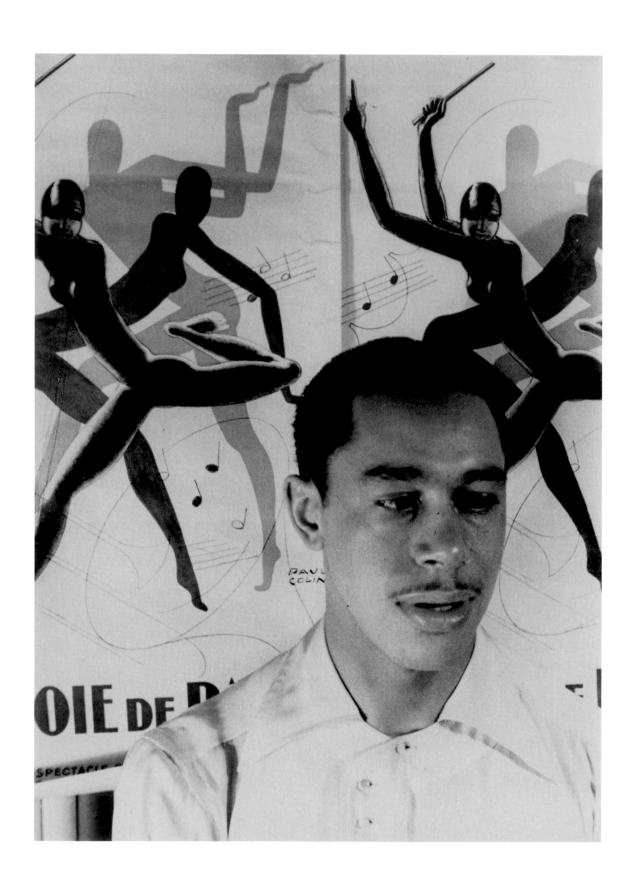

PLATE 27 | **Cab Calloway** CARL VAN VECHTEN 1933

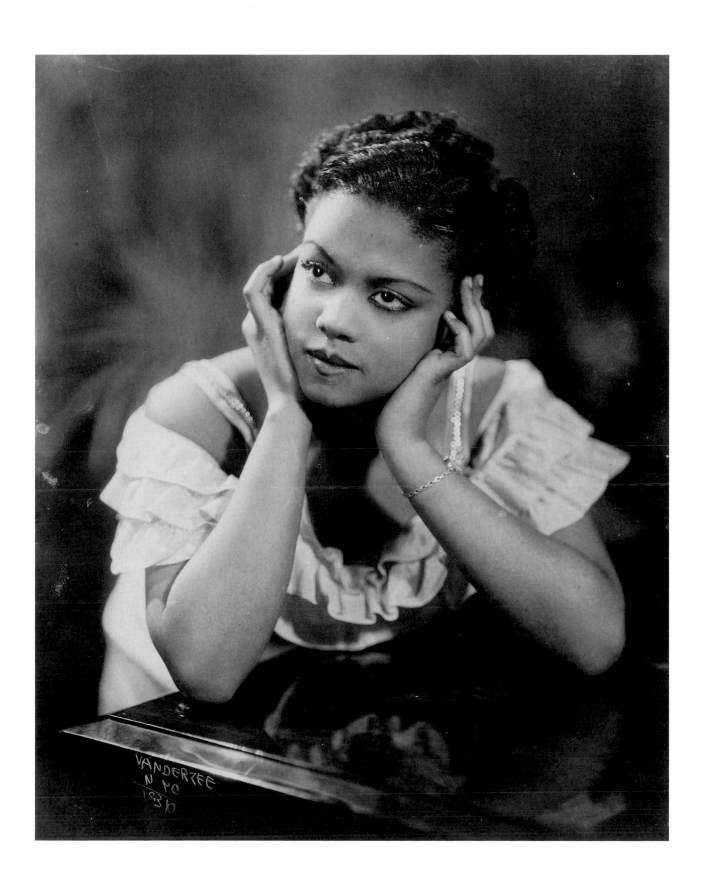

PLATE 28 | **Hazel Scott** JAMES VANDERZEE 1936

I did not wish to "rise above"
or "move beyond" my race. I wished

to contemplate who I was beyond
my body, this container of flesh.

I made up a language in which to exist.
I wondered what God breathed into me.

I wondered who I was beyond
this complicated, milk-skinned, genital-ed body.

I exercised it, watched it change and grow.
I spun like a dervish to see what would happen. Oh,

to be a Negro is—is?—
to be a Negro, is. To be.

(Jean Toomer)

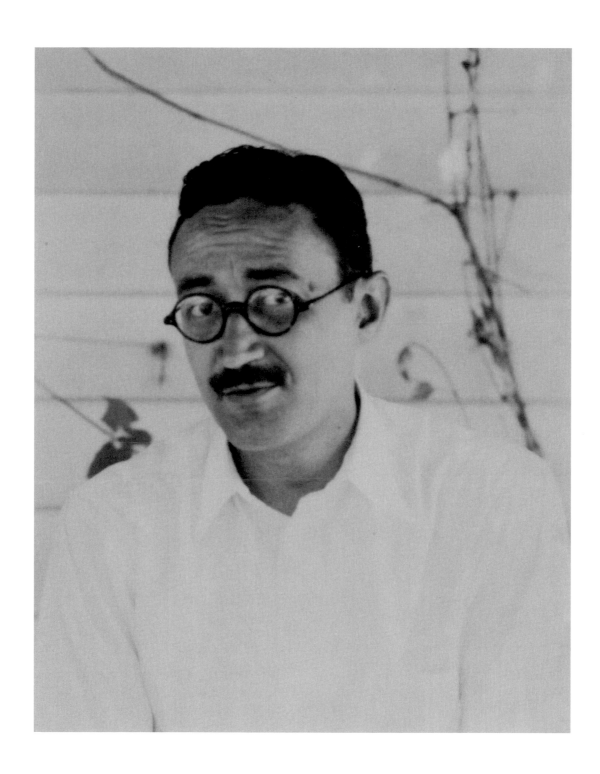

PLATE 29 | **Jean Toomer** MARJORIE CONTENT C. 1934

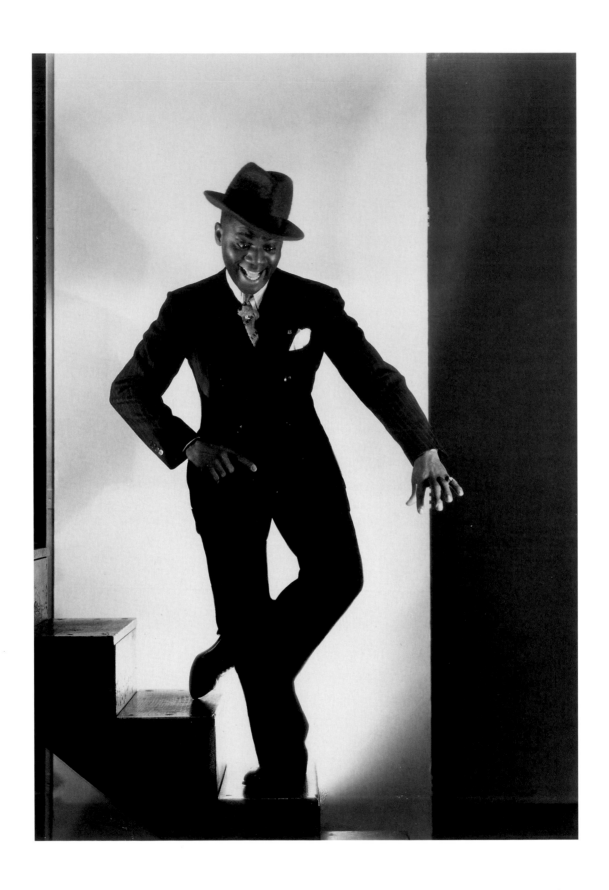

PLATE 30 | **Bill "Bojangles" Robinson** GEORGE HURRELL 1935

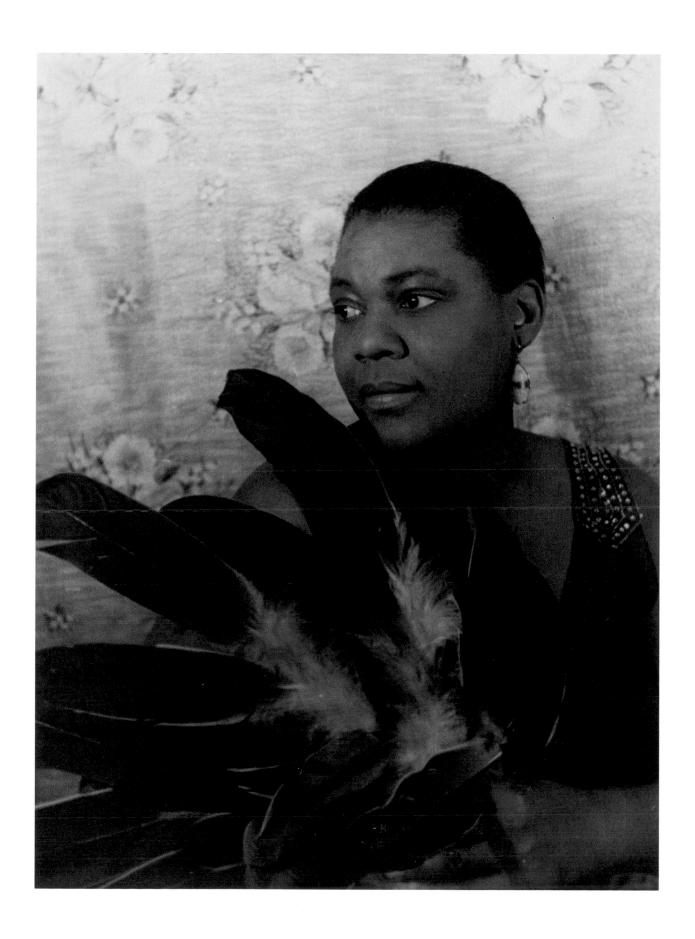

PLATE 31 | **Bessie Smith** CARL VAN VECHTEN 1936

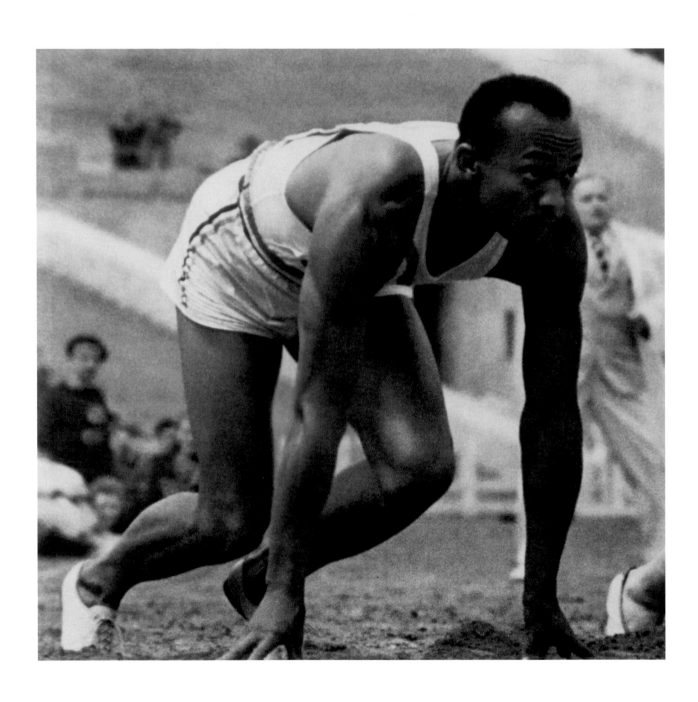

PLATE 32 | **Jesse Owens** LENI RIEFENSTAHL 1936

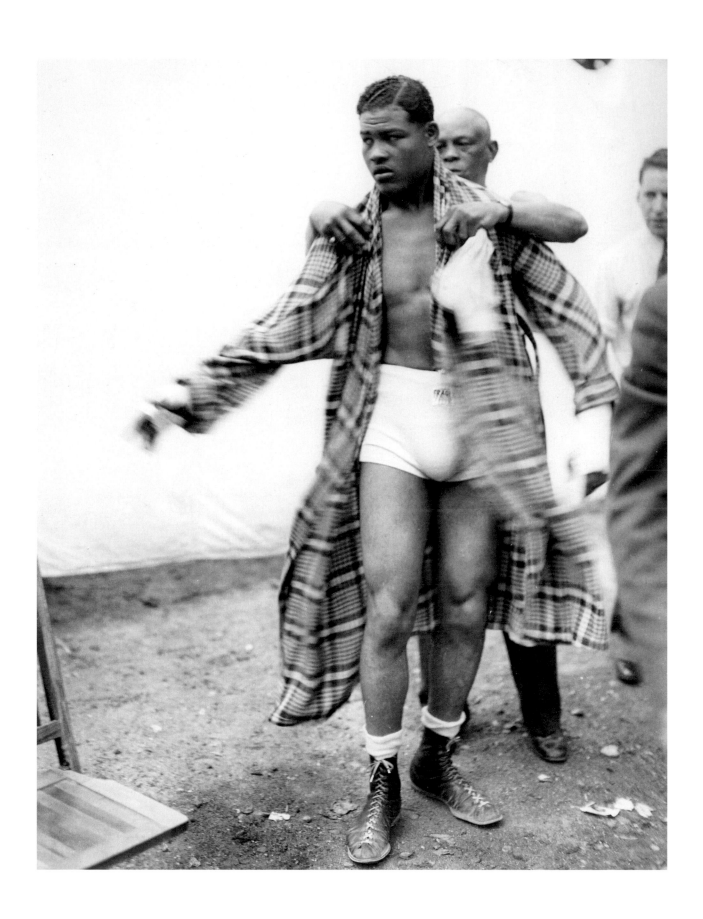

PLATE 33 | **Joe Louis** UNDERWOOD & UNDERWOOD C. 1935

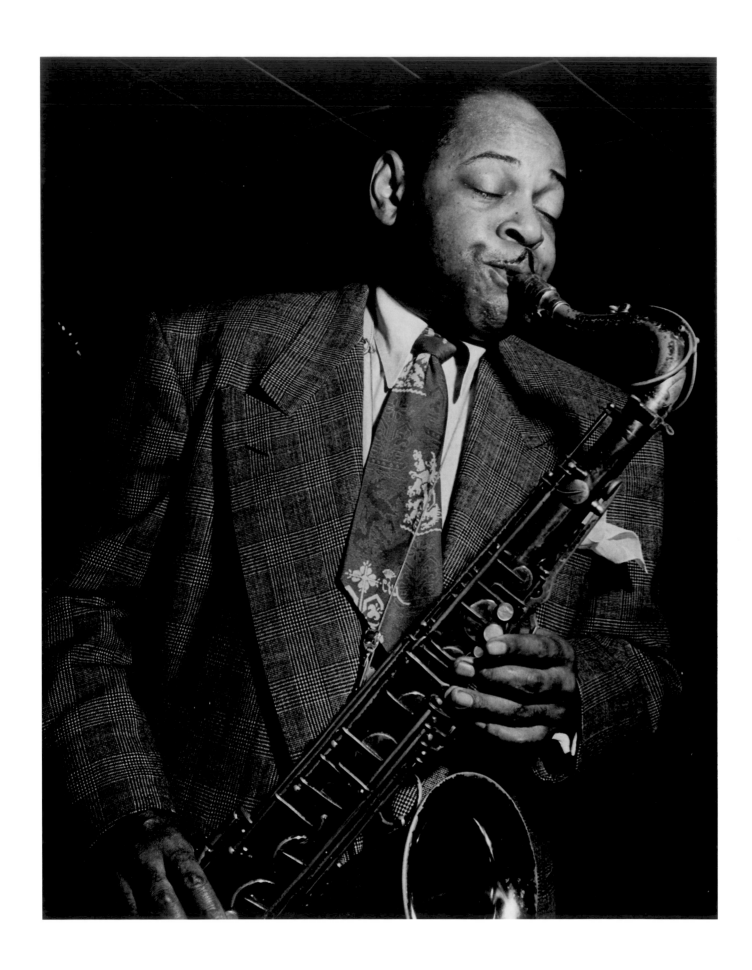

PLATE 34 | **Coleman Hawkins** RONNY JAQUES C. 1942

COLEMAN HAWKINS

Jazz was probably the last thing on the mind of Freud's erst-while disciple Otto Rank when, in 1909, he wrote his famous monograph *The Myth of the Birth of the Hero*. But Rank's thesis, that heroic archetypes are constant across diverse cultures and societies, sheds a revealing light on the puzzling and century-long struggle for legitimacy by jazz music—arguably America's most original contribution to world culture.

Although jazz blends many musical traditions and owes much of its vitality to the multi-cultural mix of artists who conceived and shaped it, its African and African American roots are dominant, both in fact and in the public imagination. So in an America where civil rights for blacks was still a distant dream, it is understandable (though not excusable) that for at least the first three-quarters of the twentieth century the brilliant originality of jazz's creators was marginalized by the American cultural mainstream, while the importance of the music itself was simply rejected out of hand.

Like Rank's mythic figures, stereotypes of our society's cultural heroes had been very rigidly formulated. "Serious" music belonged in red plush concert halls, was composed by the likes of Mozart and Brahms, and was performed by musicians from Central Casting. Leonard Bernstein and Van Cliburn fit the model. Charlie Parker, Bessie Smith, and Coleman Hawkins did not.

Simply put, Americans were unwilling to acknowledge the validity of an art whose origin was in the streets, speakeasies, and brothels of the American ghetto. Embracing the greatness of music largely created by people whom it had first enslaved, then relegated to second-class citizenship, was too great a stretch. So it is no coincidence that the mainstream acceptance of jazz as "America's Classical Music" did not occur until civil rights in America had begun to cross a significant threshold, in the late 1980s and early 1990s.

It is unlikely that the creators of jazz consciously regarded their art as a social or political tool, but it is equally unlikely that they were not intuitively aware of its power. The emergence of an art form based on the freedom and challenge of improvisation was, in fact, a revolutionary idea, and jazz became part of the cultural and political voice that underlay much of the social change in America during the second half of the twentieth century. Simultaneously, in the Soviet Bloc, jazz was viewed as so powerful a symbol of free expression that it was vigorously suppressed by the totalitarian establishment.

Against this background we should not be surprised by the irony that Coleman Hawkins, a dominant figure in the creation and shaping of jazz from the late 1920s through the 1950s, is principally remembered for a three-minute recording of the song, "Body and Soul"—an event that he himself found unremarkable. Of course it *was* remarkable because, like all of Hawkins's mature work, the recording demonstrates a degree of harmonic subtlety that rivals any music written or played at any time. "Body and Soul" is, however, only a fragment of an oeuvre that is infinitely greater than three minutes of vinyl. Symbolizing Hawkins's career through this one recording trivializes the depth and originality of his contribution to the evolution of jazz and thus to modern music.

"Classically" trained on a variety of instruments, including the cello, and with college studies in music theory and composition, Hawkins differed from the majority of more-or-less self-taught black players in the formative years of jazz. His harmonic command is immediately apparent in the subtlety of his improvisation, though Hawkins remained rhythmically committed to the vertical chord structure of the music. His extraordinary lyricism is inevitably coupled with the complexity of his departures from the melodic line and reveals the workings of an exceptionally adept musical mind.

Hawkins's five-year retreat to Europe, from 1934 to 1939, was symptomatic of the need by black American artists and intellectuals to find an environment that was receptive both to them and their art. Possibly it was also an expression of the frustration black jazz artists felt at the beginning of the "swing era"—the one time in American musical history when jazz and popular music coincided—in seeing "their" music become the province of white bands under leaders like Glenn Miller and the Dorsey Brothers.

Upon his return to the United States, Hawkins, at the height of his powers, remained a dominant force in the jazz scene. He continued to play and record until the mid-1960s. Along with his sometime rival, Lester Young, Hawkins defined tenor saxophone playing for generations of jazz musicians. Today his work stands as a testament to the enduring power of jazz, for like all great art, it remains as vital and exciting as it was in those seminal years when this giant of American music added his lyrical voice to our cultural history.

David C. Levy
President
Education Division
Cambridge Information Group

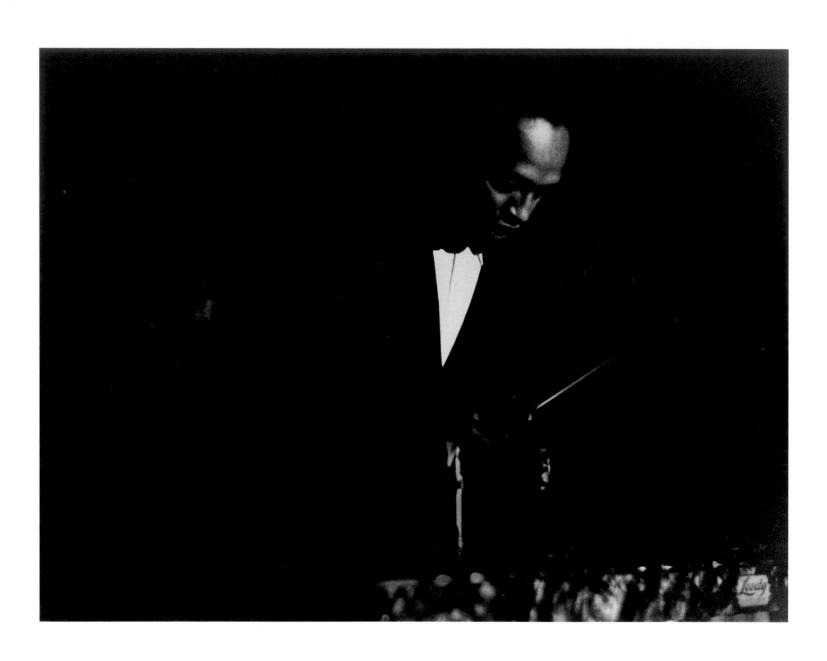

PLATE 35 | **Lionel Hampton** ANDRÉ DA MIANO 1937

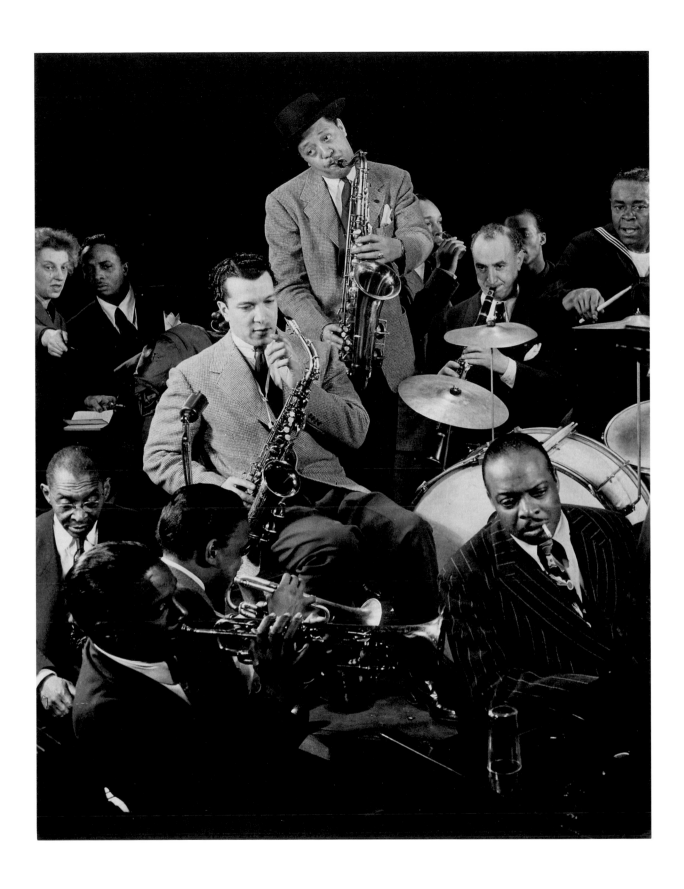

PLATE 36 | **Count Basie** GJON MILI 1944

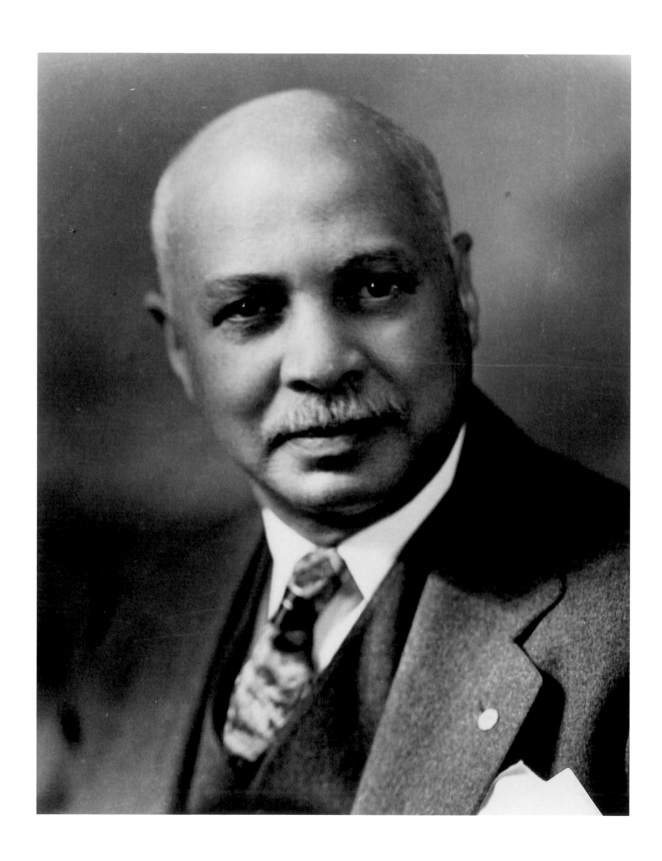

PLATE 37 | **W. C. Handy** PRENTICE H. POLK 1942

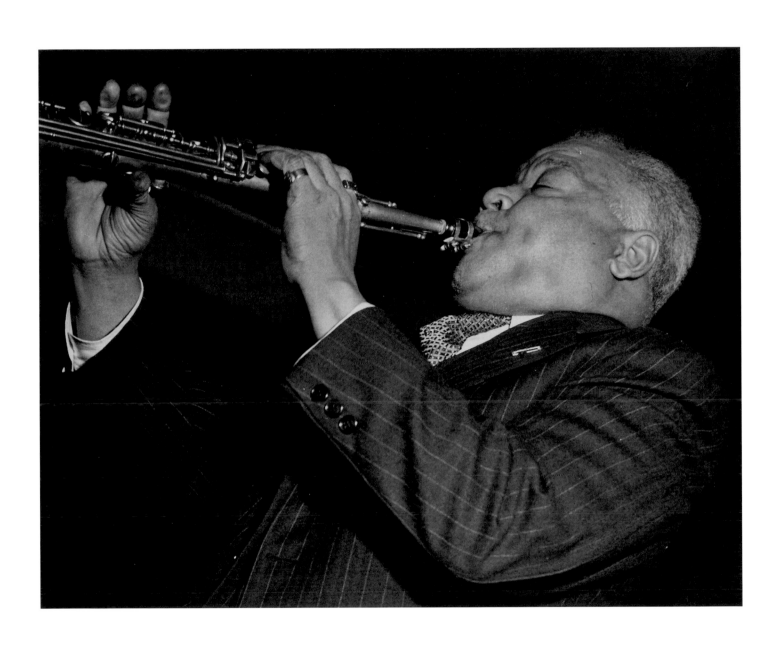

PLATE 38 | **Sidney Bechet** ARTHUR LEIPZIG 1945

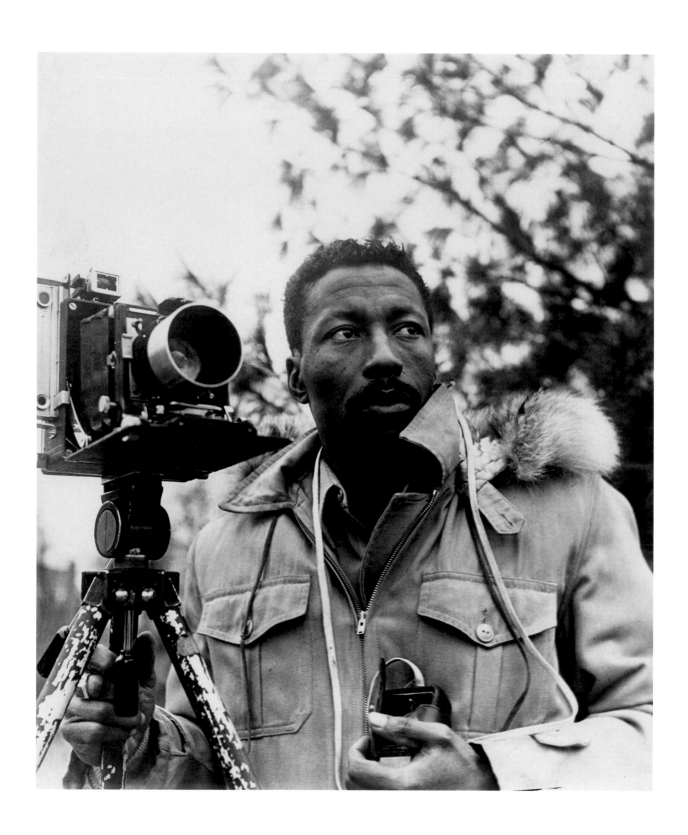

PLATE 39 | **Gordon Parks** ARNOLD EAGLE 1945

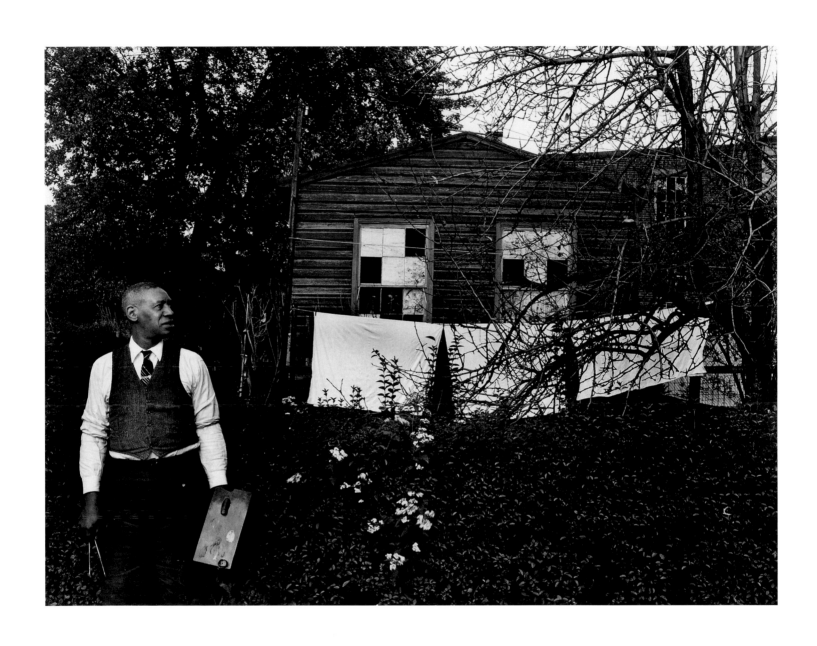

PLATE 40 | **Horace Pippin** ARNOLD NEWMAN 1945

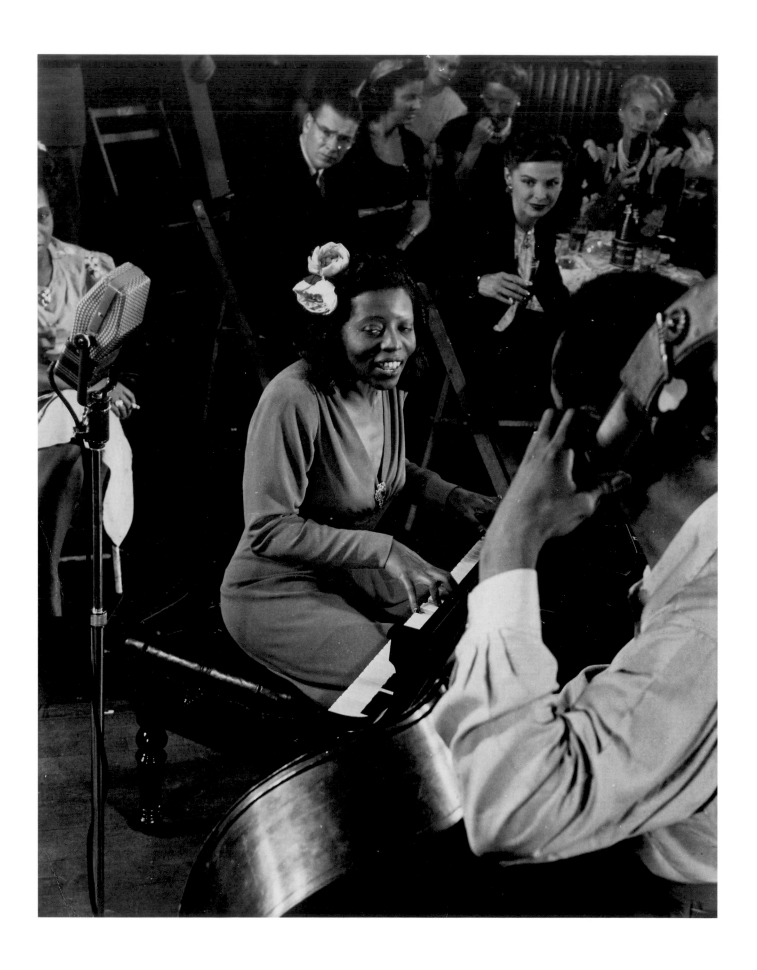

PLATE 41 | **Mary Lou Williams** GJON MILI 1943

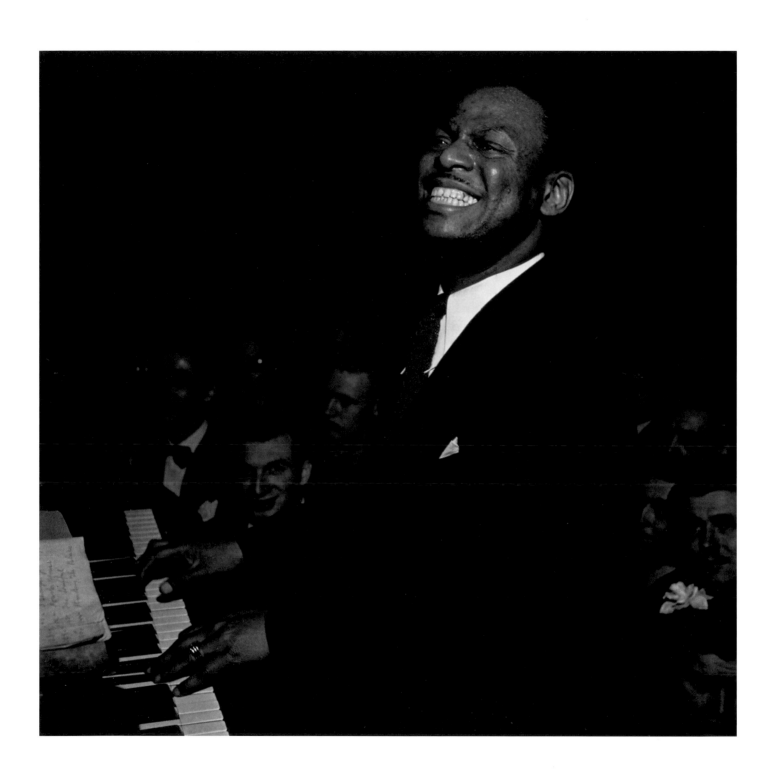

PLATE 42 | **Earl "Fatha" Hines** RONNY JAQUES C. 1942

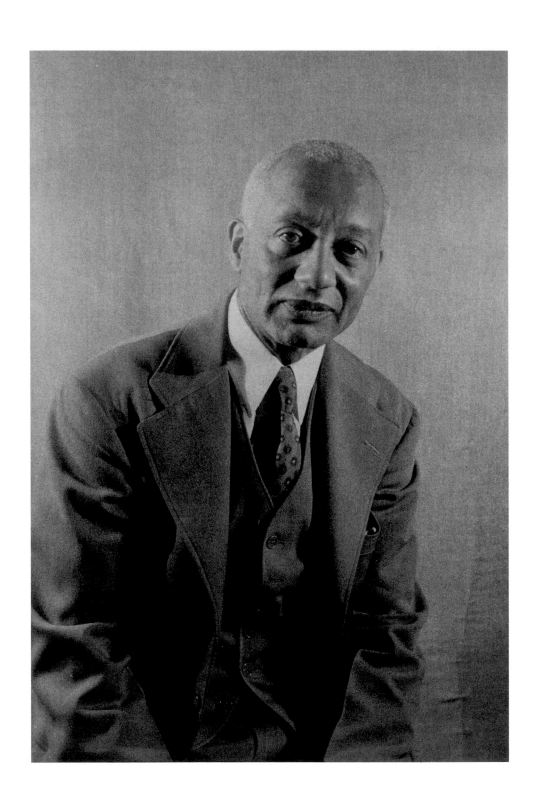

PLATE 43 | **Alain Locke** CARL VAN VECHTEN 1941

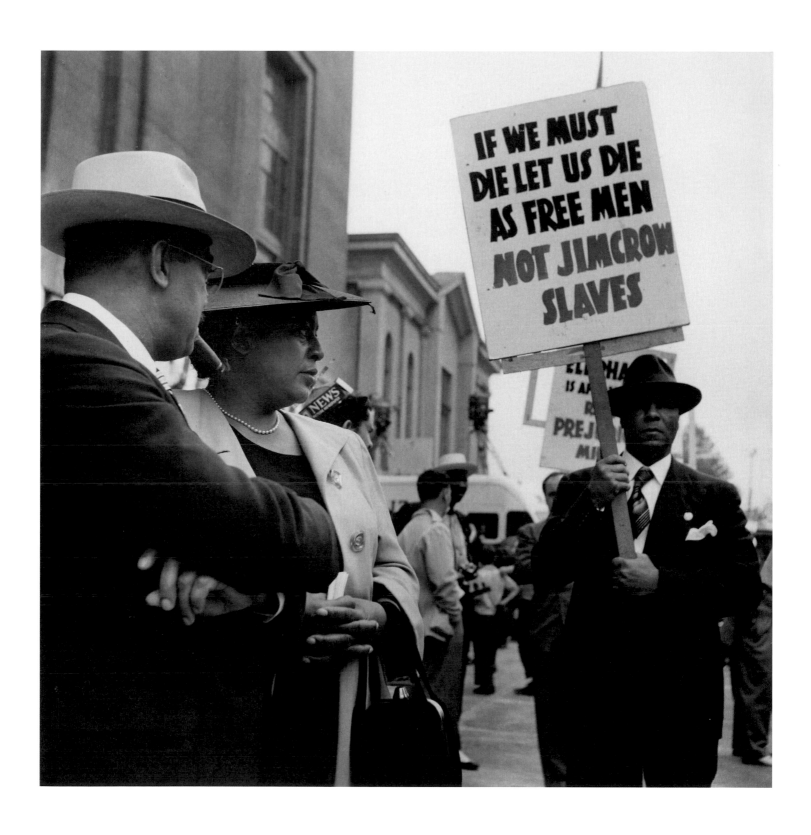

The sign reads:

IF WE MUST
DIE LET US DIE
AS FREE MEN
NOT JIMCROW
SLAVES

PLATE 44 | **A. Philip Randolph** SY KATTELSON 1948

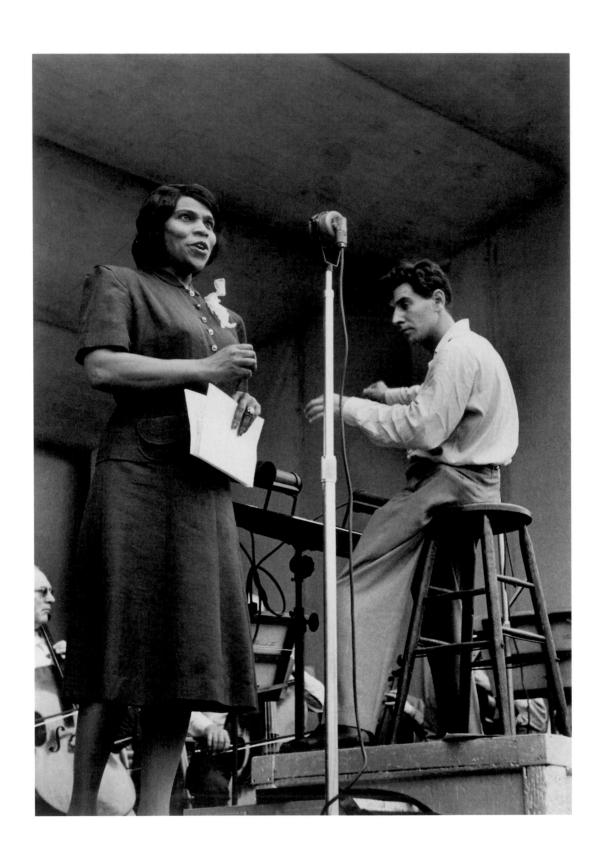

PLATE 45 | **Marian Anderson with Leonard Bernstein** RUTH ORKIN 1947

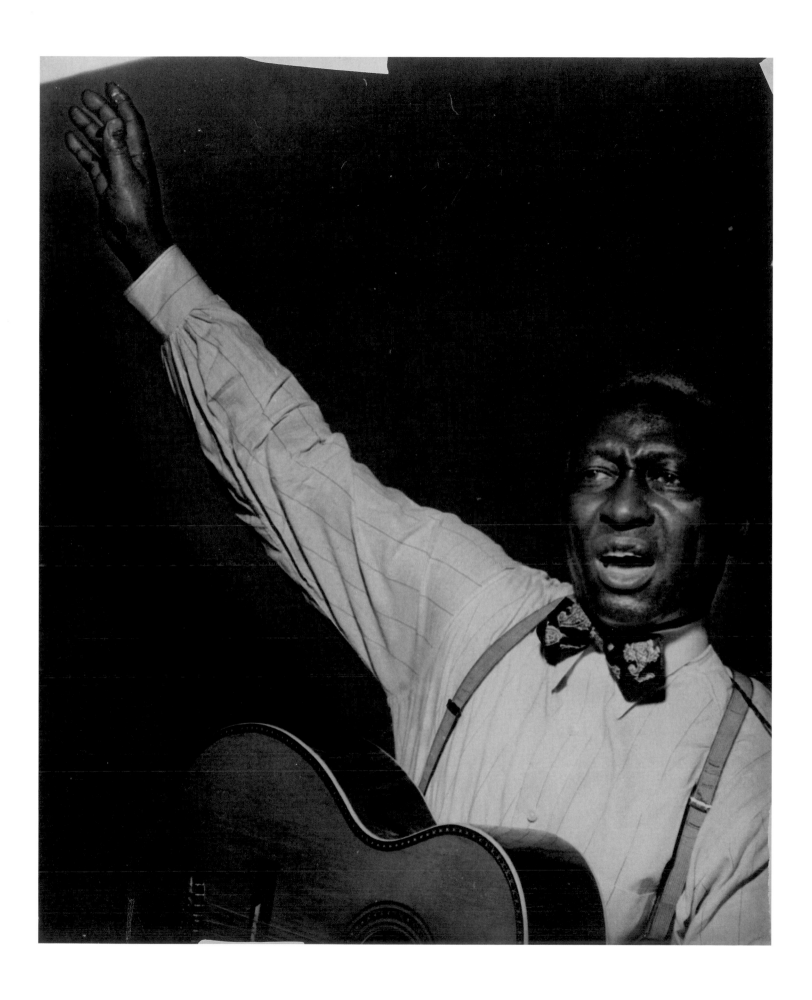

PLATE 46 | **Huddie Ledbetter** SID GROSSMAN C. 1946–48

I am thirty-five and the love of my life,
and my great work, and my three sons,

and my new nation are ahead of me. Good-bye, Chicago.
About to set out for the territory, Mexico,

for the rest of the century and into the next.
My sense of my people will strengthen and shift.

But first I had to leave D.C. You have to leave D.C.,
lovely colored town that will make a colored girl smile

but not stretch or growl or frown
with the exertion of thinking, WORK.

Yet there I made my first carving
from a cake of Ivory soap, at Dunbar High School.

There I was taught. There I stood
in front of the United States Supreme Court

with a noose around my neck, protesting lynching.
There I realized I had a debt I had not paid.

I am black because my great-great-grandmother
was kidnapped on a beach in Madagascar.

In Mexico, I will carve black women's bodies and heads
from reddish stone and black stone.

Some will be massive and the work will make me sweat.
The black woman's head is a massive weight.

The black woman's head holds the black woman's brain.
The black woman's body supports the black woman's head.

The black woman's work is the work of this world.

(Elizabeth Catlett)

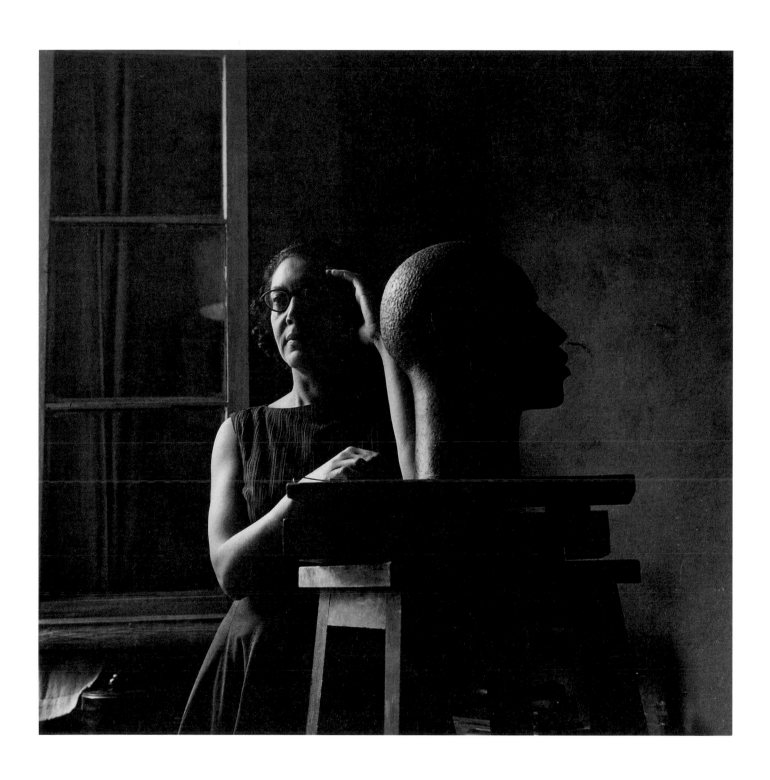

PLATE 47 | **Elizabeth Catlett** MARIANA YAMPOLSKY C. 1949

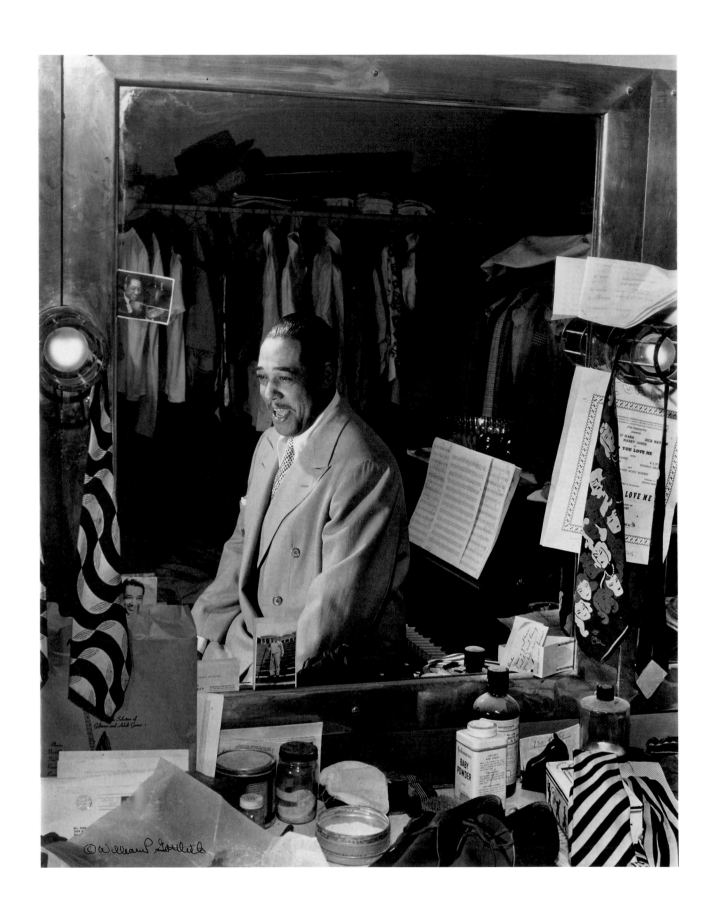

PLATE 48 | **Duke Ellington** WILLIAM P. GOTTLIEB C. 1946

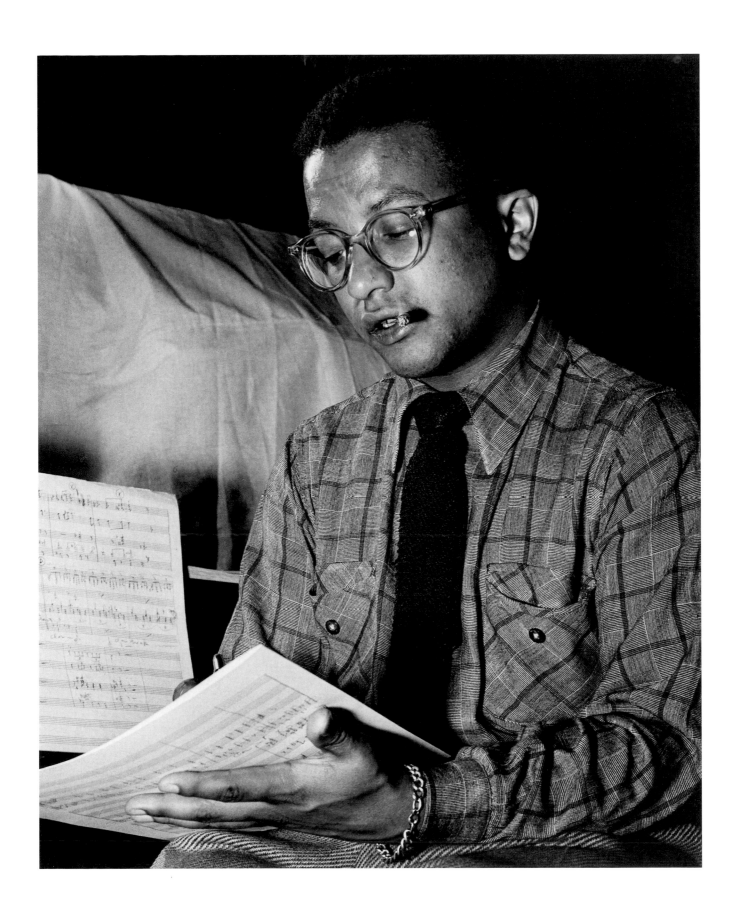

PLATE 49 | **Billy Strayhorn** WILLIAM P. GOTTLIEB C. 1945

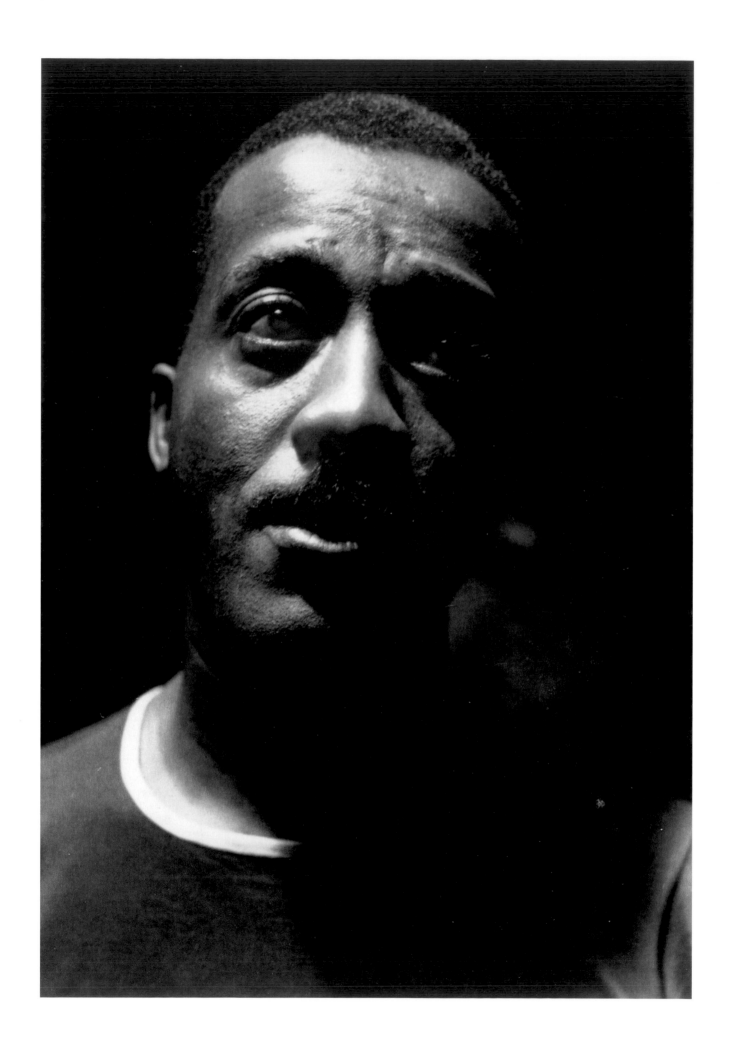

PLATE 50 | **Norman Lewis** ALEX JOHN 1946

PLATE 51 | **Felrath Hines** N. JAY JAFFEE 1948

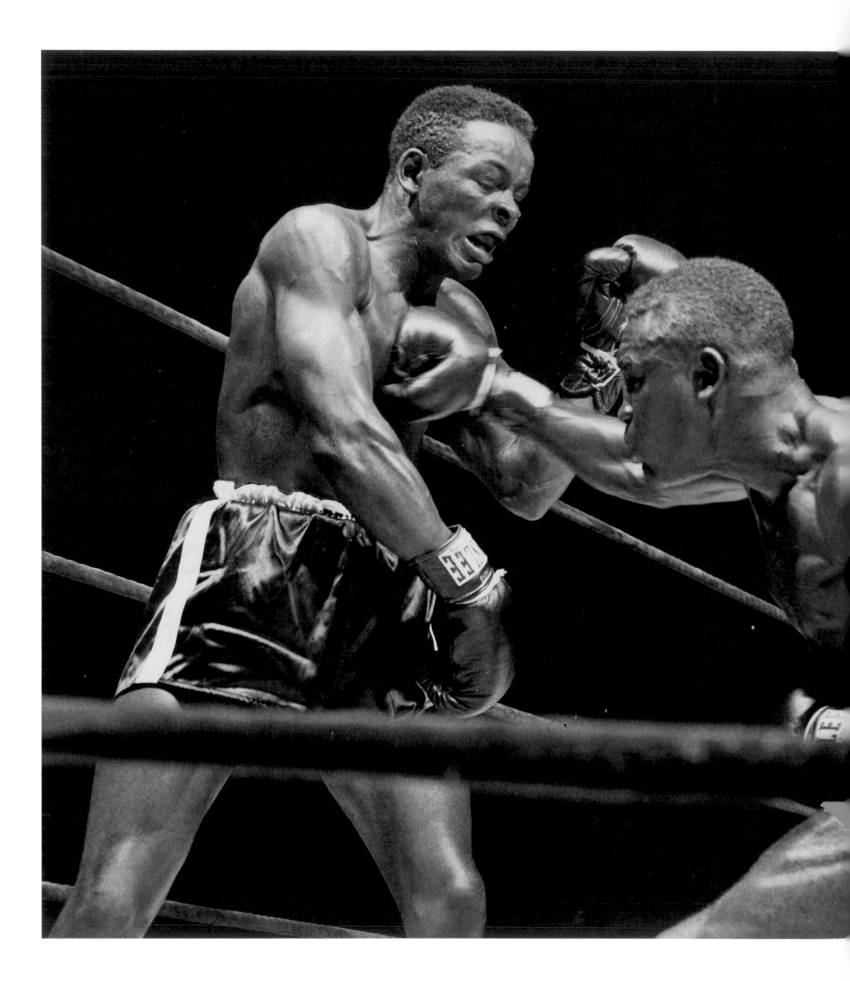

PLATE 52 | **James "Jimmy" Carter and George Araujo** CHARLES HOFF 1953

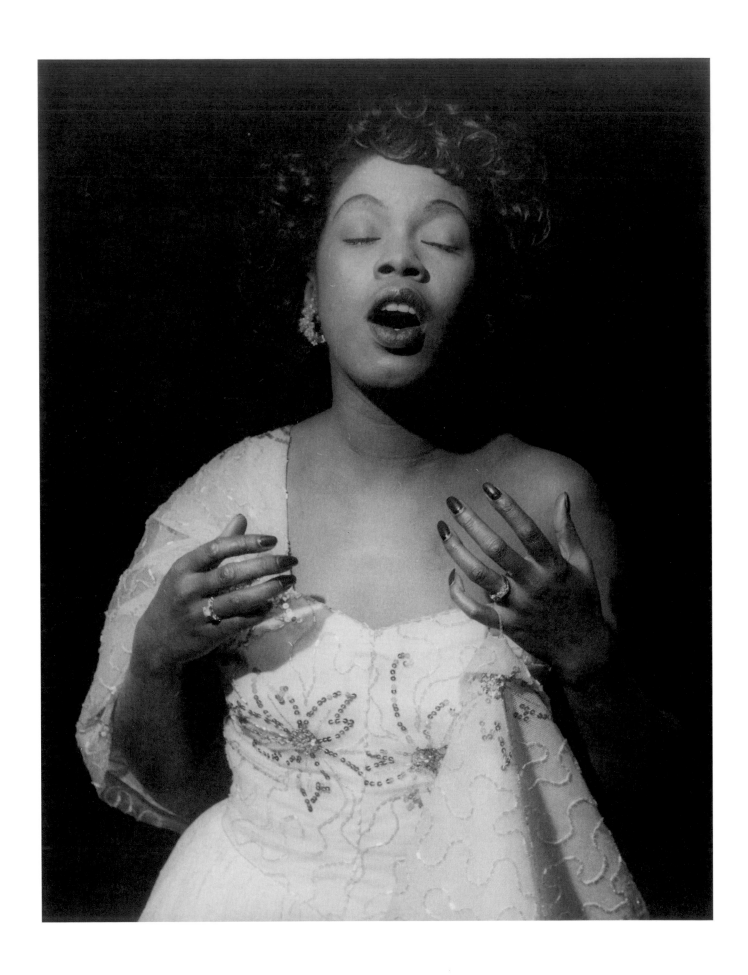

PLATE 53 | **Sarah Vaughan** JOSEF BREITENBACH 1950

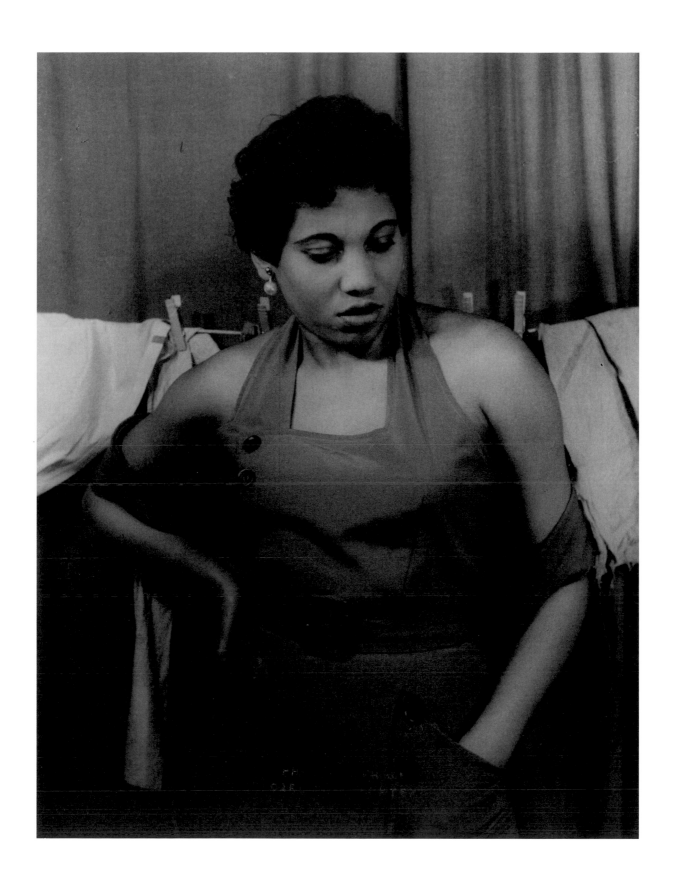

PLATE 54 | **Leontyne Price** CARL VAN VECHTEN 1953

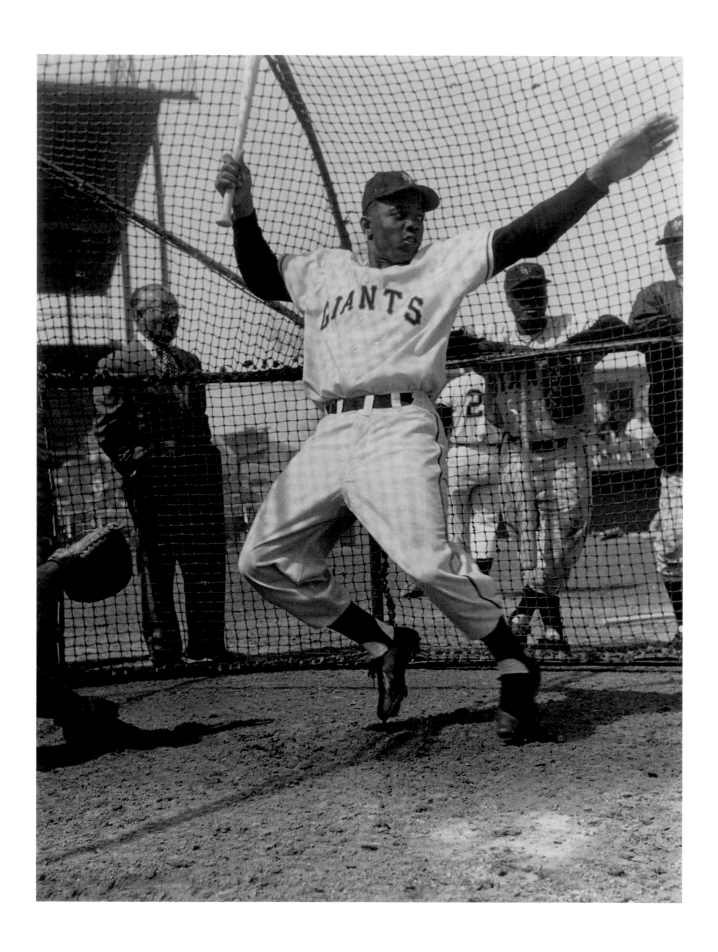

PLATE 55 | **Willie Mays** LOOMIS DEAN 1954

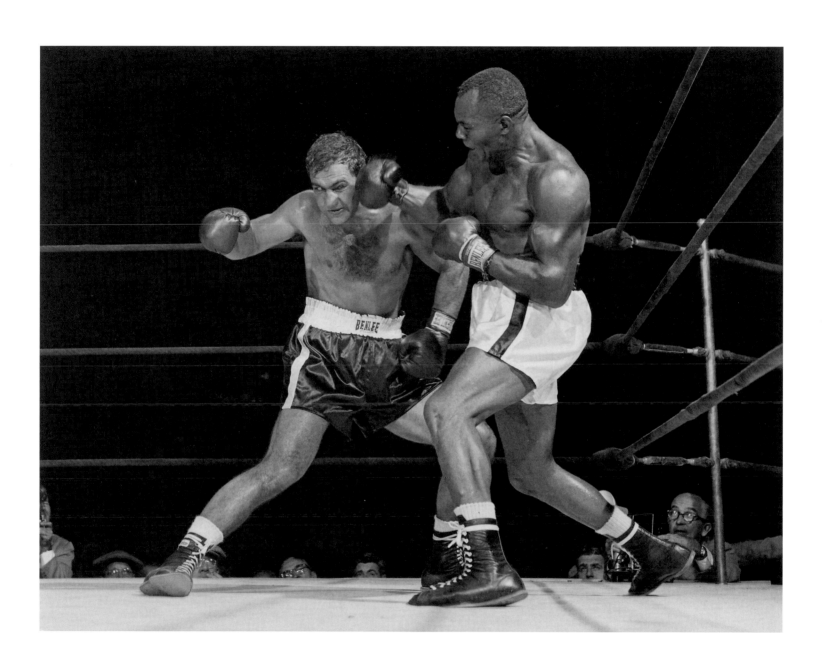

PLATE 56 | **Jersey Joe Walcott with Rocky Marciano** CHARLES HOFF 1952

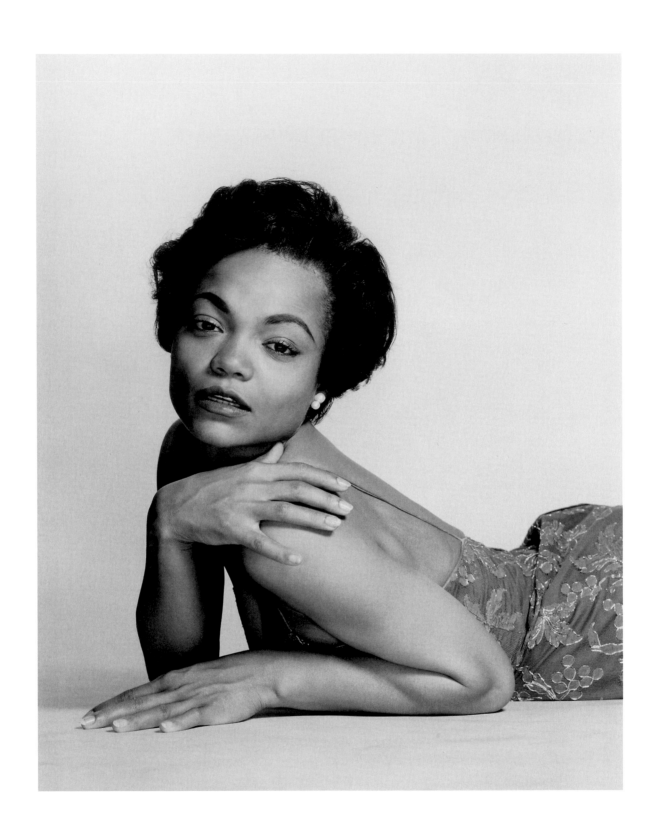

PLATE 57 | **Eartha Kitt** PHILIPPE HALSMAN 1954

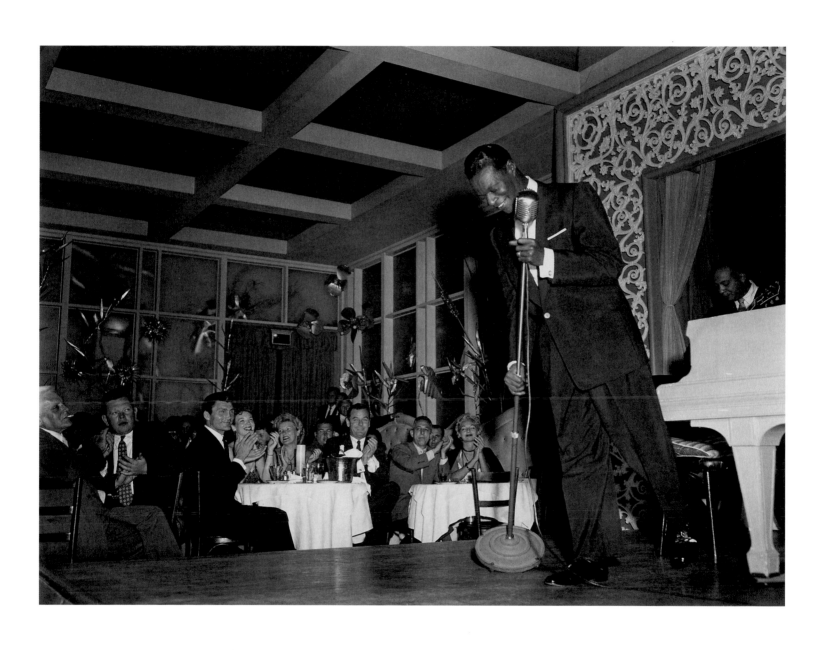

PLATE 58 | **Nat "King" Cole** SID AVERY 1954

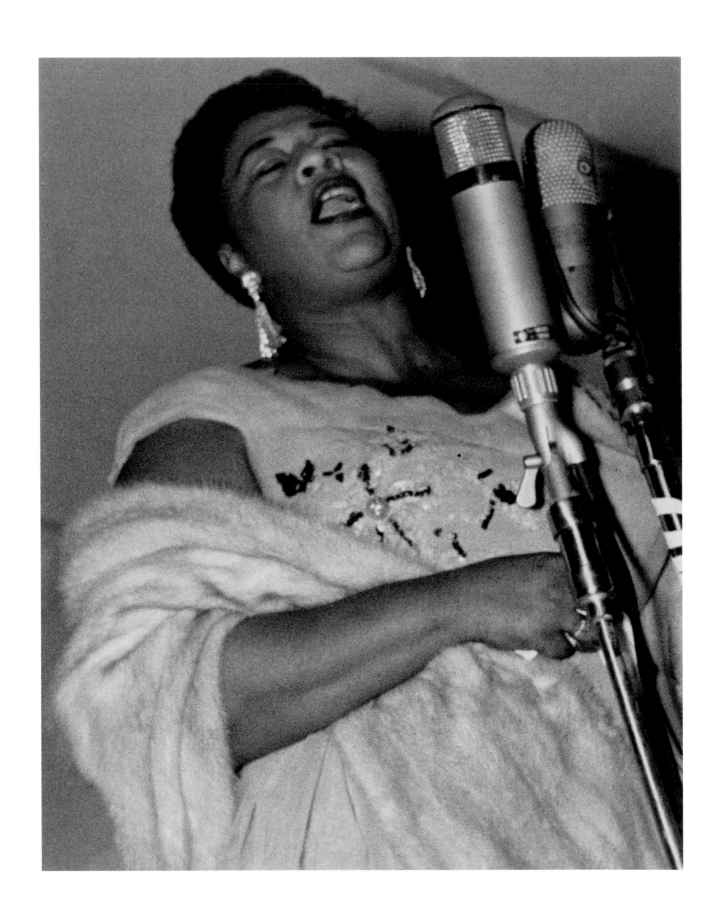

PLATE 59 **Ella Fitzgerald** LISETTE MODEL C. 1954

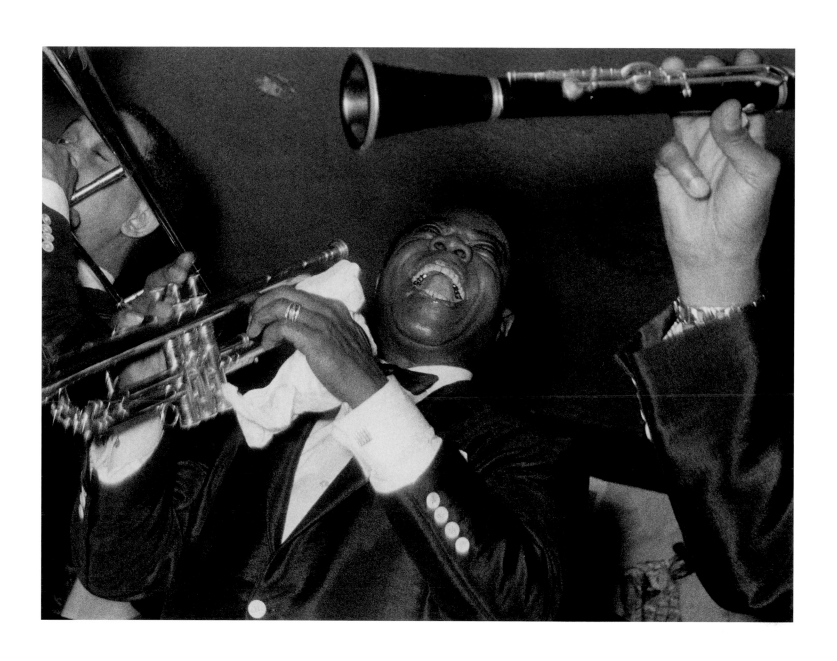

PLATE 60 | **Louis Armstrong** LISETTE MODEL C. 1956

PLATE 61 | **Odetta** BOB WILLOUGHBY 1954

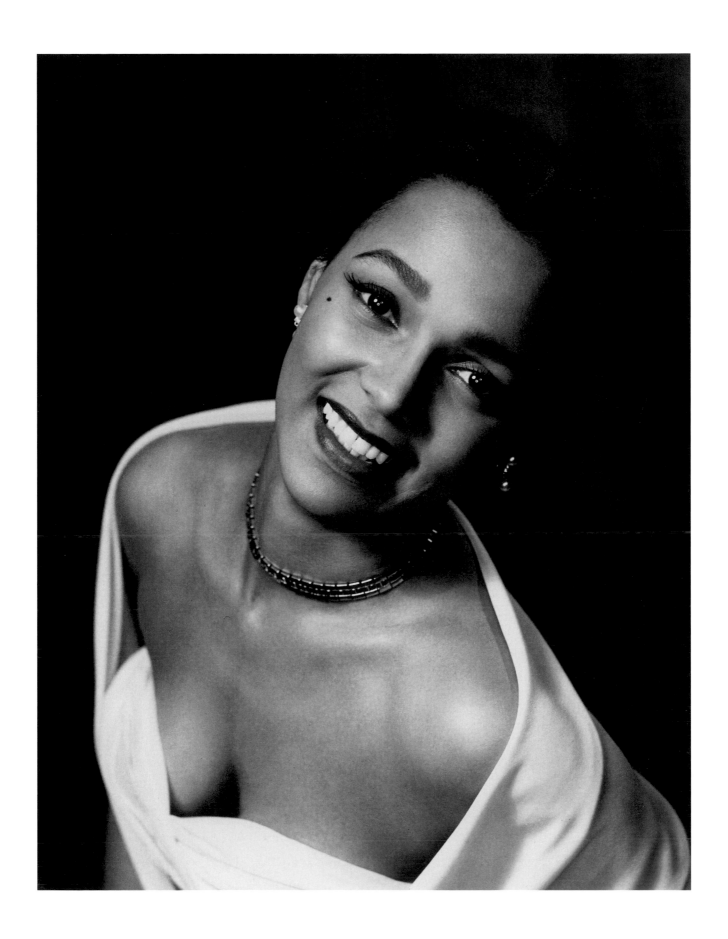

PLATE 62 | **Dorothy Dandridge** PHILIPPE HALSMAN 1953

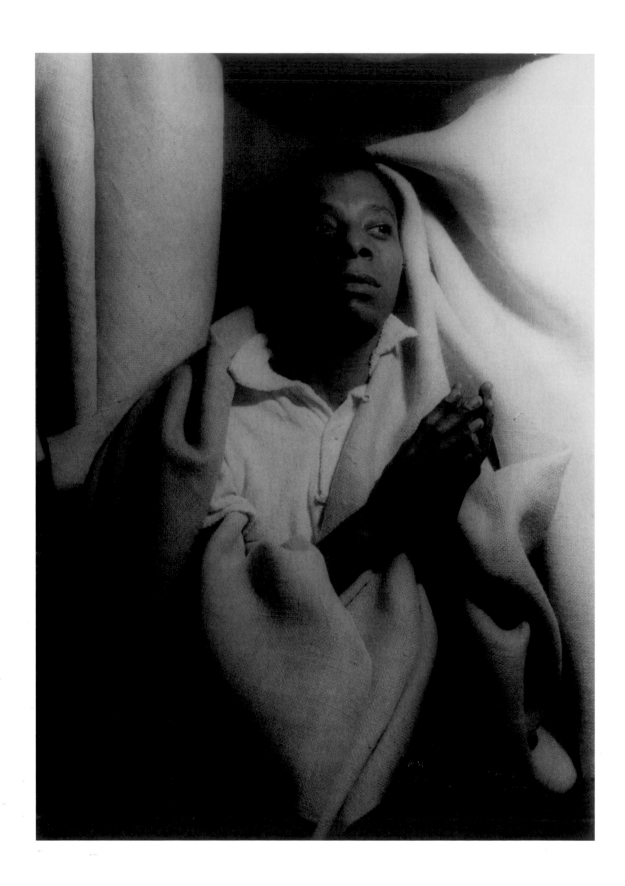

PLATE 63 | **James Baldwin** CARL VAN VECHTEN 1955

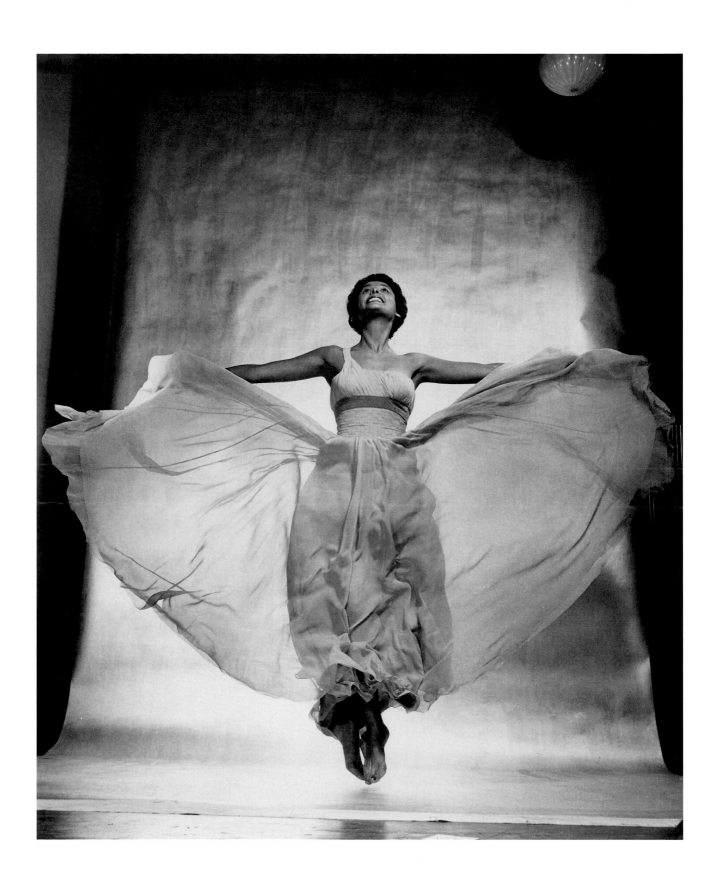

PLATE 64 | **Lena Horne** PHILIPPE HALSMAN 1954

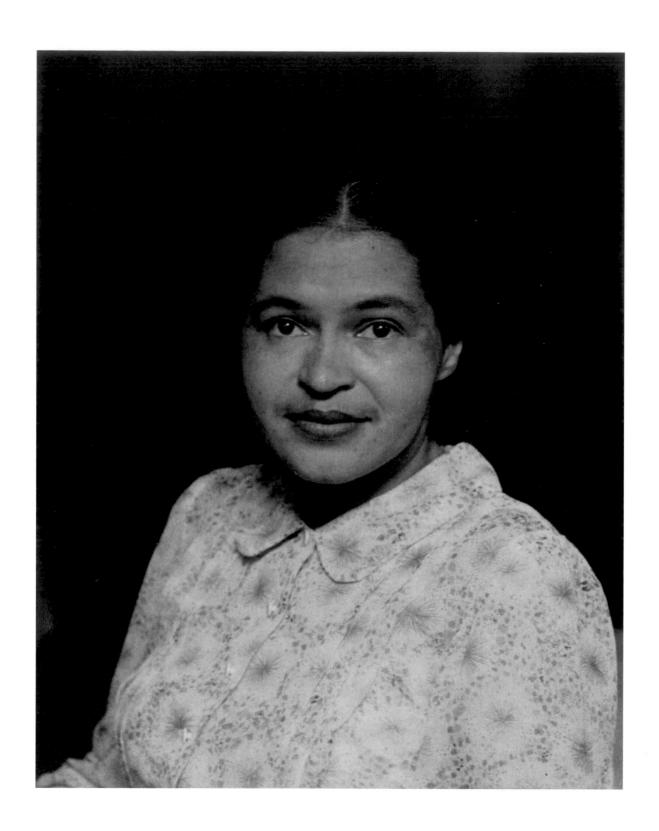

PLATE 65 | **Rosa Parks** IDA BERMAN 1955

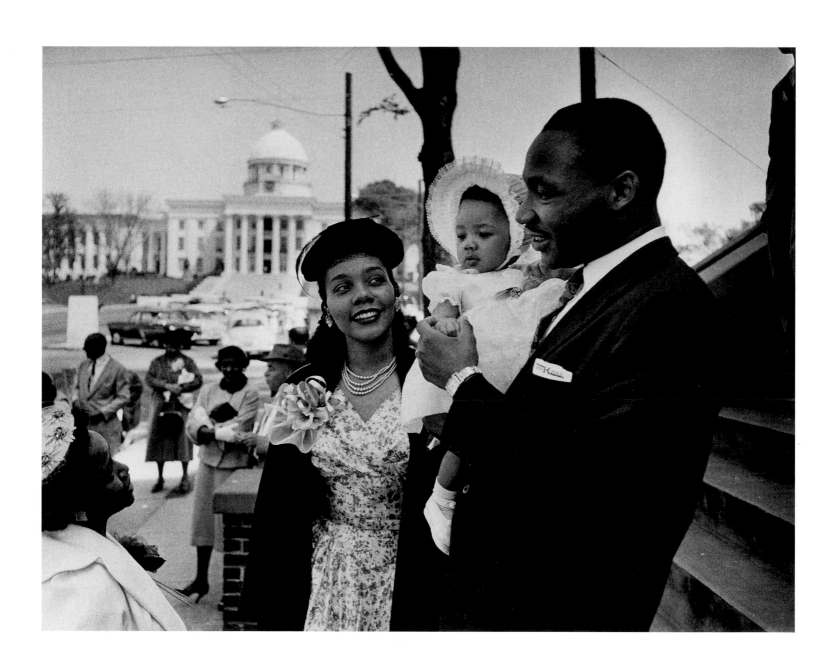

PLATE 66 | **Martin Luther King Jr. with Coretta Scott King and Yolanda Denise King** DAN WEINER 1956

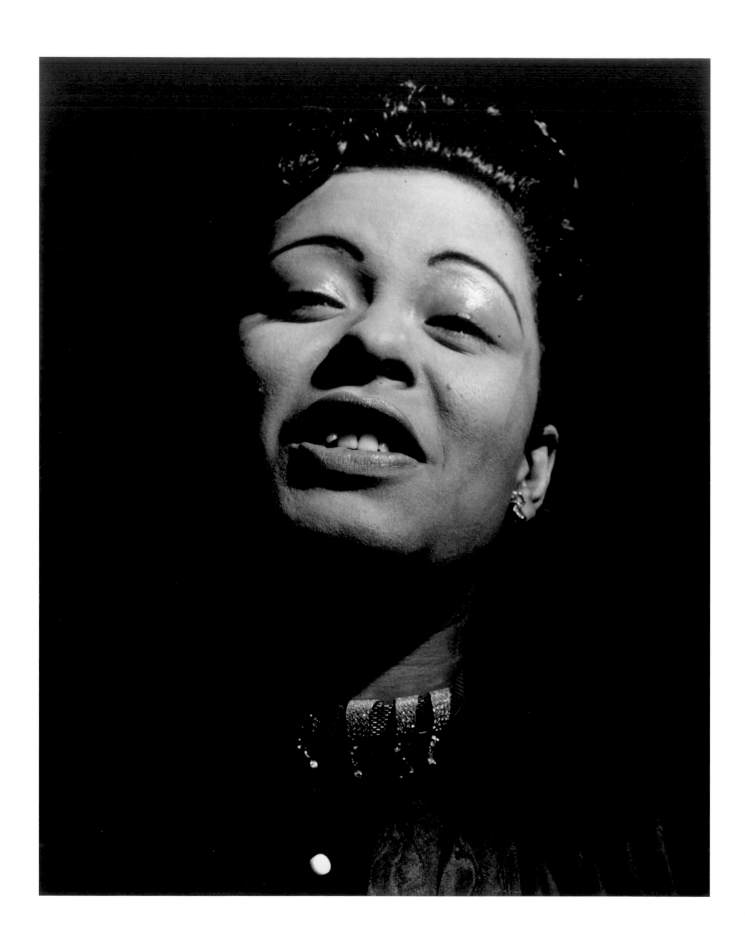

PLATE 67 | **Billie Holiday** SID GROSSMAN C. 1948

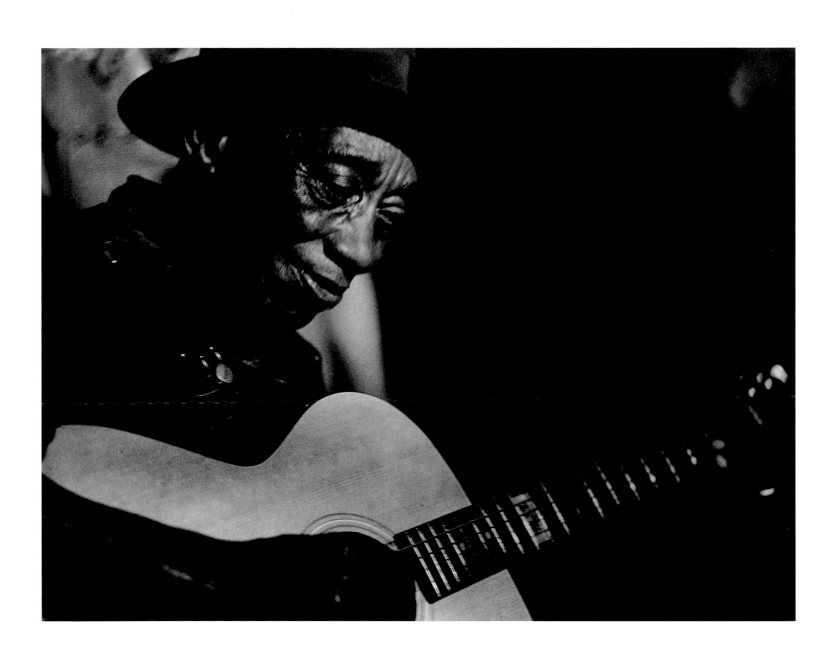

PLATE 68 | **"Mississippi" John Hurt** CHARMIAN READING 1966

PLATE 69 | **Henry "Hank" Aaron** OSVALDO SALAS 1956

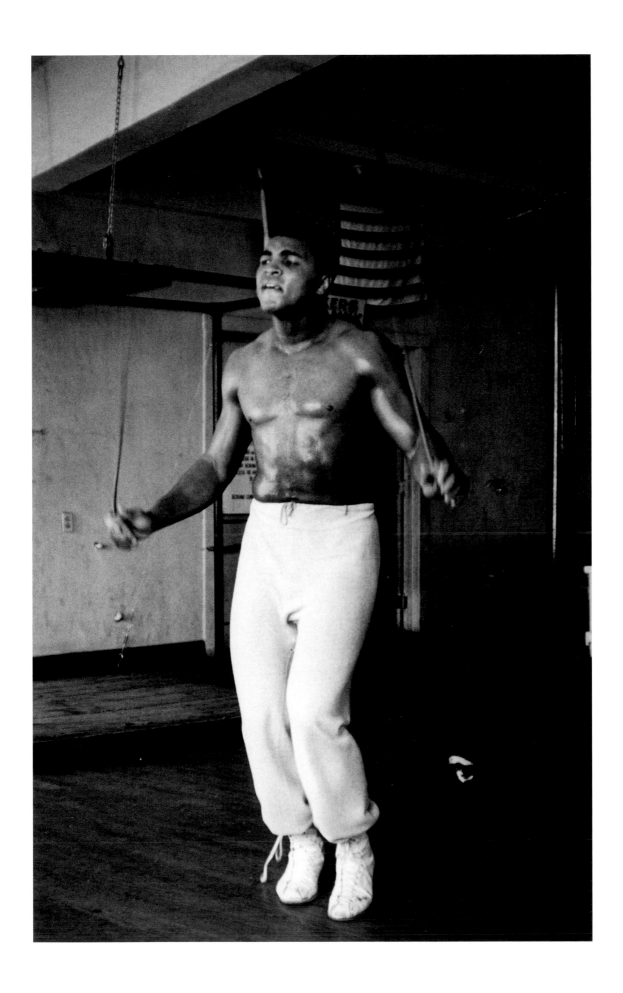

PLATE 70 **Muhammad Ali** GORDON PARKS 1966

ABUELA WATCHES TELEVISION, 1966

You wait for Ricky Ricardo to bloom
in Spanish, your map of the world, your map
to the real, past, beautiful-ugly place, Home,
where you are but you are not, where the lights
go out and the water cuts off. You are here,
Abuelita, in a wheelchair in
your daughter's living room in Washington, D.C.,
laughing hardest when "Amos and Andy" comes on,
who remind you of San Pedro de Macoris.
And then for a few minutes everything stops
when your boxer appears, "Cachoo Clay,"
so beautiful and black. There is never
enough of him, Cachoo Clay, or enough
of the wordless things he makes you feel.

(Muhammad Ali)

MUHAMMAD ALI

Ain't gonna let nobody turn me 'roun'
Turn me 'roun'
Ain't gonna let nobody turn me 'roun'
I'm gonna wait until my change comes

Nothing turned Muhammad Ali around. Not Sonny Liston. Not the threat of losing his championship, not the threat of going to prison.

Nothing.

Ali was twenty-four years old in 1966, when this portrait was taken; he was known then as Cassius Marcellus Clay Jr., an impetuous young fighter with lightning-fast hands and a wit to match. He had become world heavyweight champion two years earlier with a stunning knockout of Charles (Sonny) Liston. After that fight, the "Louisville Lip," as he was called in some circles, announced that he was a member of the Nation of Islam, had shed his "slave name," and was now to be called Muhammad Ali. This was the first in a series of transformations that would change his life, change the way the world viewed him, and change the way a number of young African Americans viewed themselves.

A year after this photo was taken, Ali refused to be inducted into the Army on religious grounds. That one gesture of resistance—refusing to take a step forward, refusing to participate in war—was the most significant act of peaceful resistance many of us had ever seen.

Ali talked about how "pretty" he was. But he was tough. God, was he tough. There was no fighter quite like Ali, a master of the art of fighting while going backward; of inflicting pain while moving backward. He would train for hours, on the ropes, absorbing horrific punishment from sparring partners to prepare his body for the rope-a-dope.

His retreat wasn't really a retreat but an attack you never saw coming. Float like a butterfly, sting like a bee.

Ali regularly endured a torturous training regimen. He would stay on the ropes and absorb a brutal pounding, allowing his opponent to punch himself out.

He taught a generation how to simultaneously float and sting.

Through Muhammad Ali, a generation learned that there are tolls that one must pay along the chosen path of resistance. Ali was convicted for refusing induction into the army. He was stripped of his title and barred from fighting professionally for more than three years.

Don't let nobody turn you 'roun'
Turn you 'roun'
Don't let nobody turn you 'roun'
Wait until your change comes

Ali taught a generation of us that sports, in the right hands, provided another potential weapon in the battle for freedom. In 1970 Ali was allowed to fight again, and in late 1971 the Supreme Court reversed his conviction. Who would have thought that a young African American teenager from Louisville, Kentucky—an athlete, a prizefighter—would become a transformational figure in the river of struggle and resistance?

I say I'm gonna hold out
Hold out, hold out
I say that I'm gonna hold out
Until my change comes

Muhammad Ali floated—like a butterfly.
The great Ali stung—like a bee.
Through hard work and training, Ali set the world on its ear.

William C. Rhoden
Sports Columnist, *The New York Times*
Author, *Forty Million Dollar Slaves: The Rise, Fall,*
and Redemption of the Black Athlete*

NOTE

Negro spiritual, "Ain't Gonna Let Nobody Turn Me 'Roun'," quoted from http://www.negrospirituals.com/news-song/ain_t_gonna_let_nobody_turn_me_roun.htm, accessed March 14, 2007.

PLATE 71 | **Ray Charles** MICHEL SALOU C. 1961

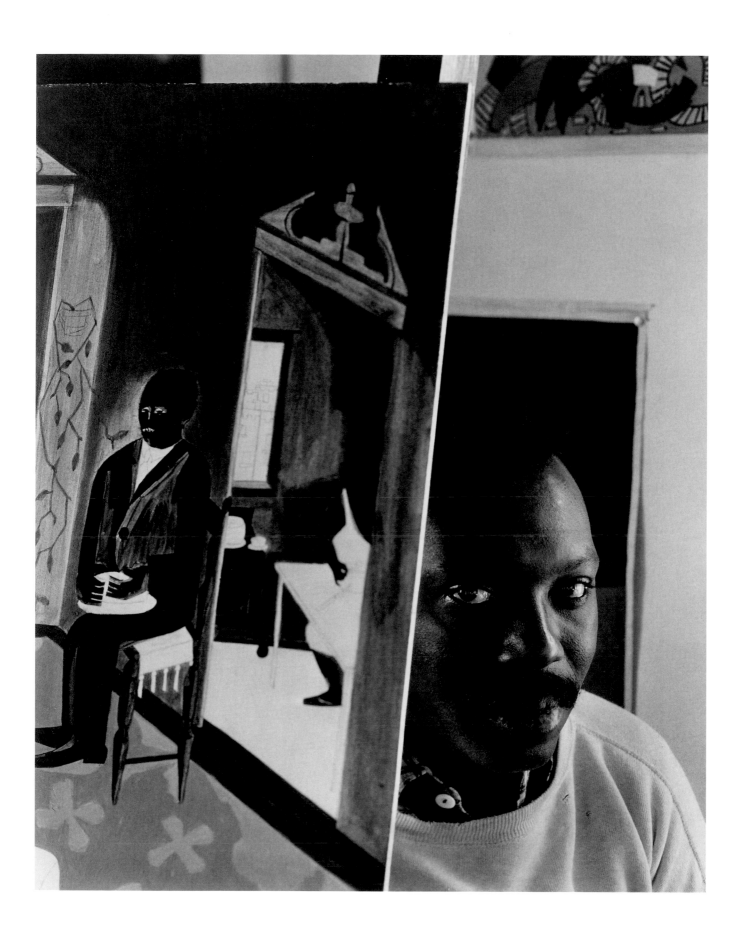

PLATE 72 | **Jacob Lawrence** ARNOLD NEWMAN 1959

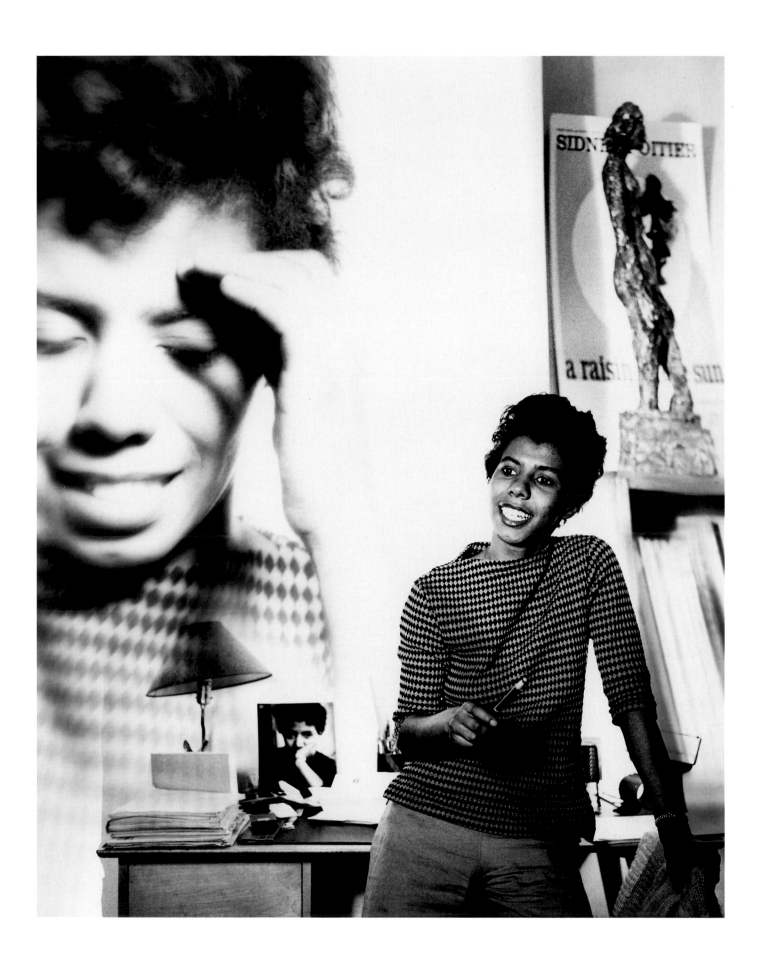

PLATE 73 | **Lorraine Hansberry** DAVID MOSES ATTIE C. 1960

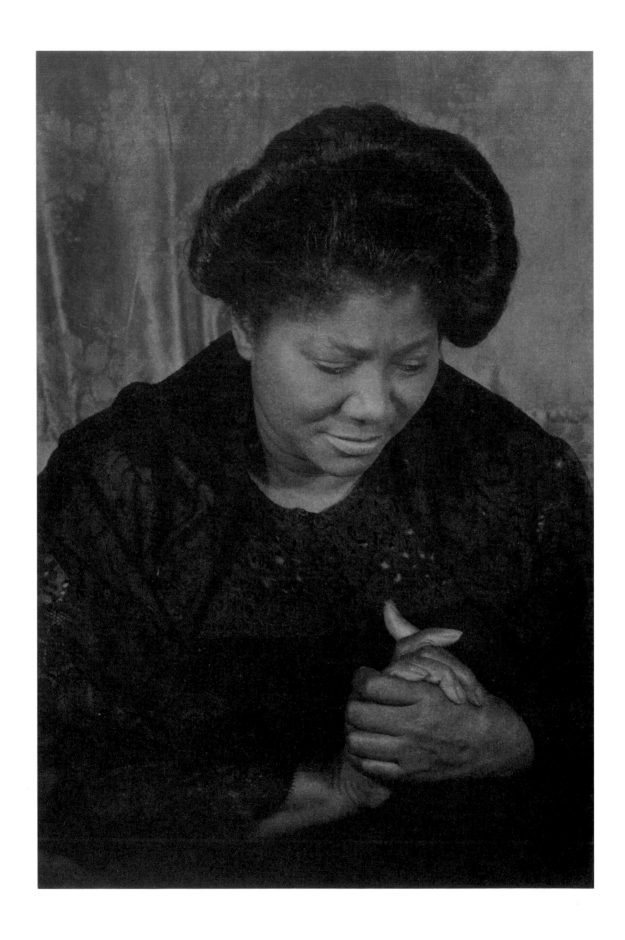

PLATE 74 | **Mahalia Jackson** CARL VAN VECHTEN 1962

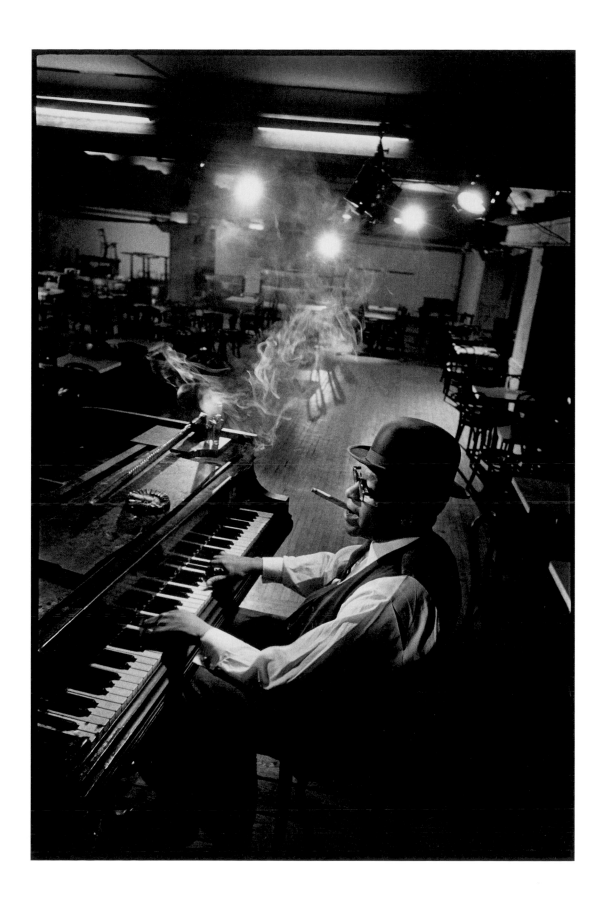

PLATE 75 | **Willie "the Lion" Smith** ARNOLD NEWMAN 1960

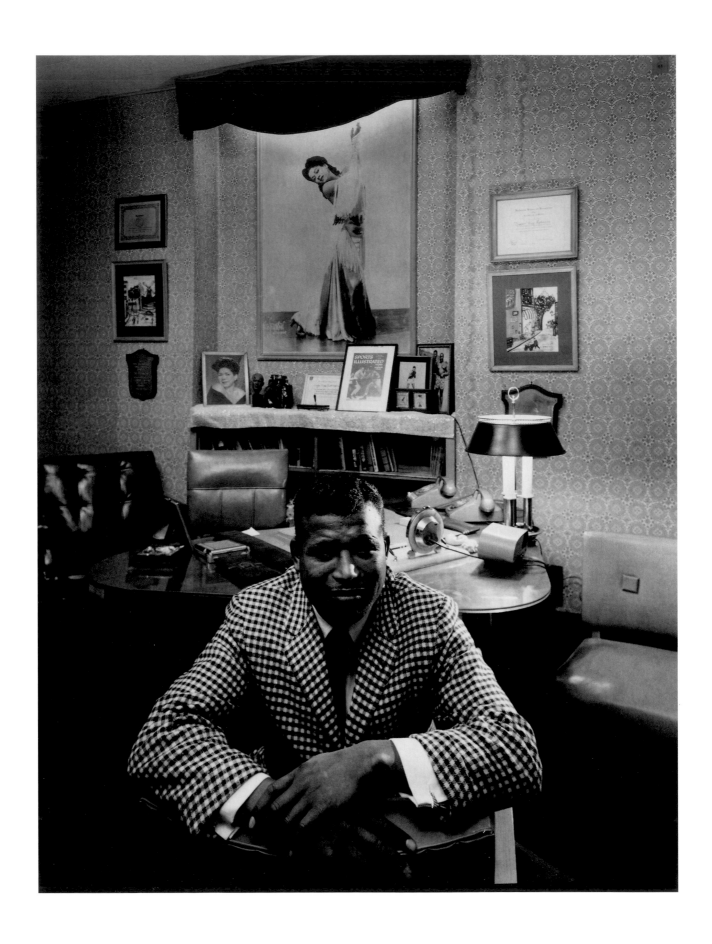

PLATE 76 | **Sugar Ray Robinson** ARNOLD NEWMAN 1960

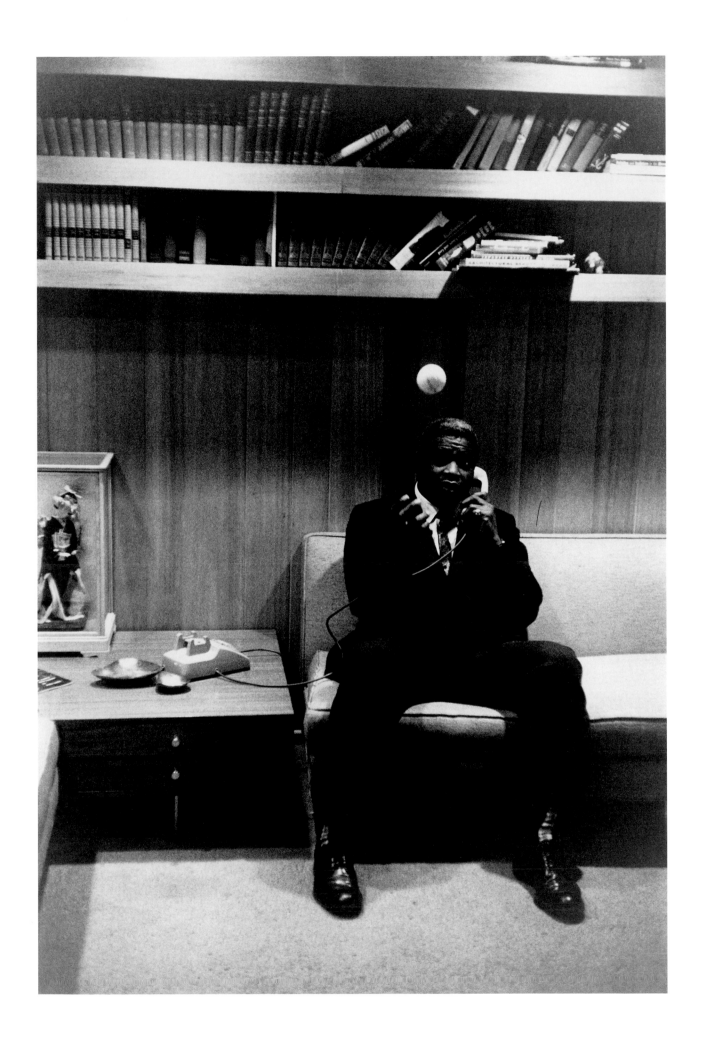

PLATE 77 | **Jackie Robinson** GARRY WINOGRAND 1961

PLATE 78 | **Diana Ross (center) with Mary Wilson and Florence Ballard** BRUCE DAVIDSON 1965

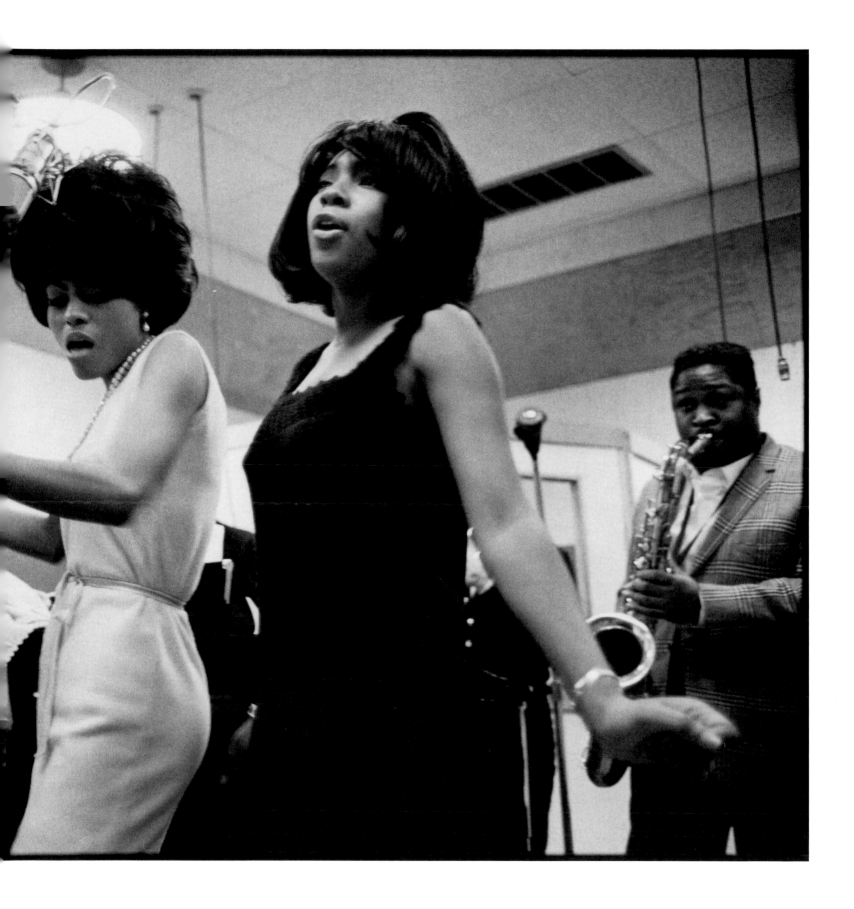

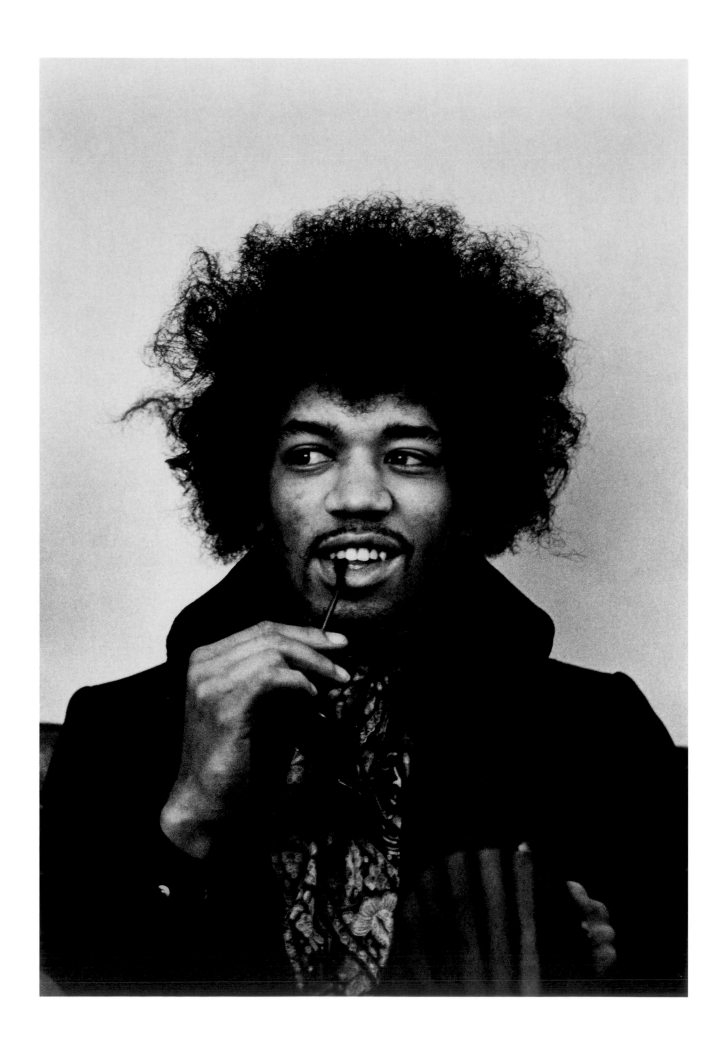

PLATE 79 | **Jimi Hendrix** LINDA MCCARTNEY 1967

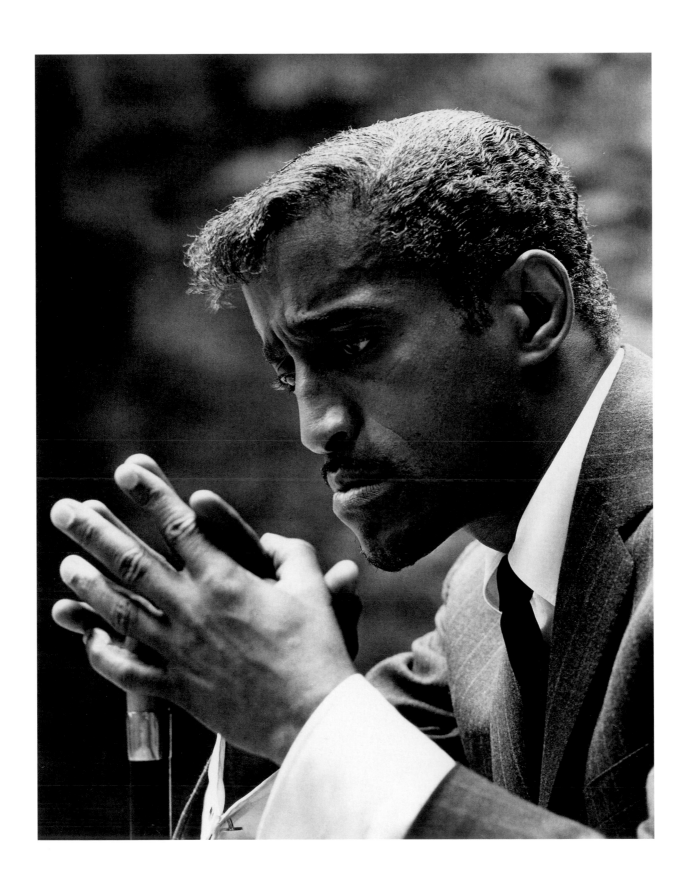

PLATE 80 | **Sammy Davis Jr.** PHILIPPE HALSMAN 1965

Stokely says, Now.
Adam says, Soon.

Stokely says, Straight ahead.
Adam says, To the side.

Stokely says, Black Power.
Adam says, Power.

Stokely says, Global.
Adam says, Harlem is the center of the world.

Stokely: Sweet potatoes.
Adam: Sweet potato pie.

Adam: Don't buy where you can't work.
Stokely: Freedom ride.

Stokely says, yeah.
Adam says, yeah.

Adam says, preach. Stokely says, talk.
Agitate, agitate, agitate.

Adam says, Inside the system.
Stokely says, The system will bite you in the ass.

Adam says, You think I don't know that?
Adam says, Even inside is outside.

Adam and Stokely:
Us black folks got to stick together.

Stokely: We had only the old language of love and
suffering.
Adam: Keep the faith, baby.

Sugar in their eyes, ketchup in their hair, I was burning,
said Stokely Carmichael, witnessing the kids at the
lunch counters.

Why I do what I do. Why I burn.
Why I work, said Adam Clayton Powell. Why I serve.

(Adam Clayton Powell Jr. and Stokely Carmichael)

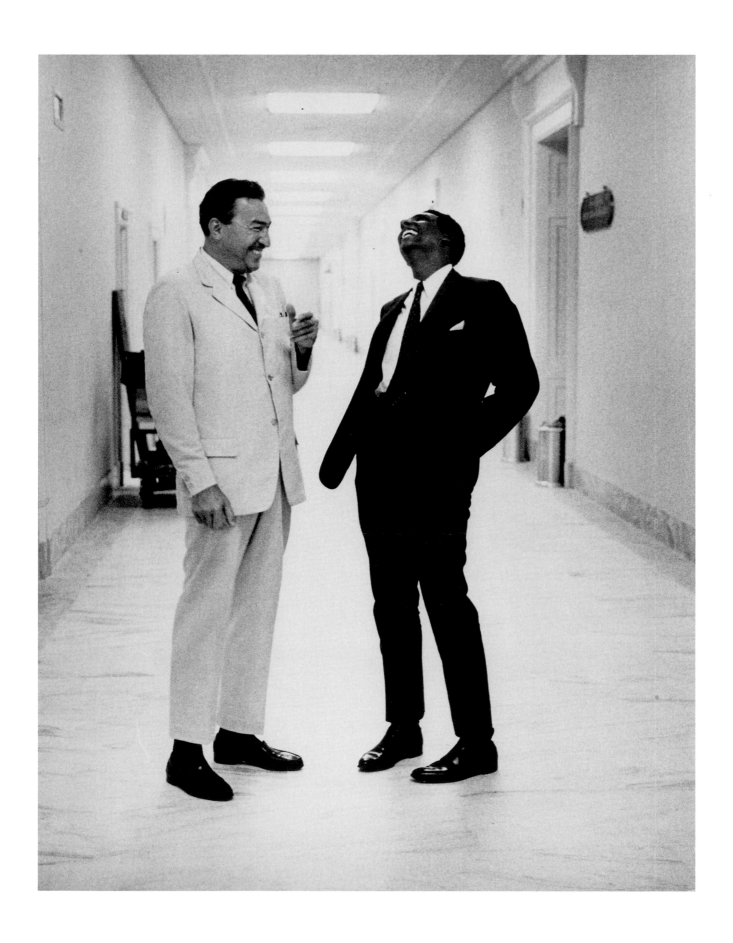

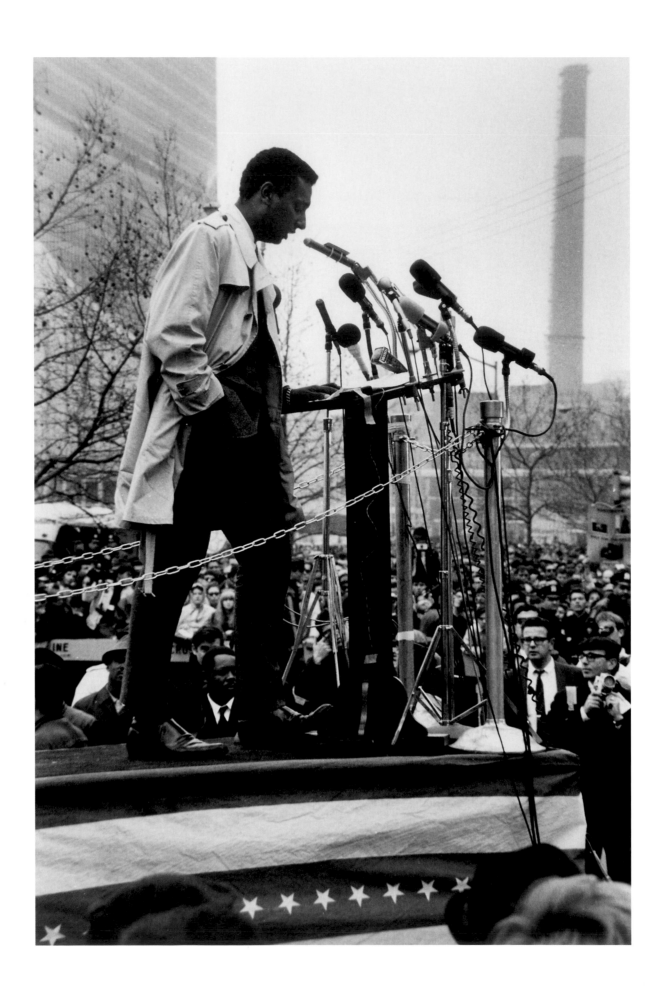

PLATE 82 | **Stokely Carmichael** GORDON PARKS 1967

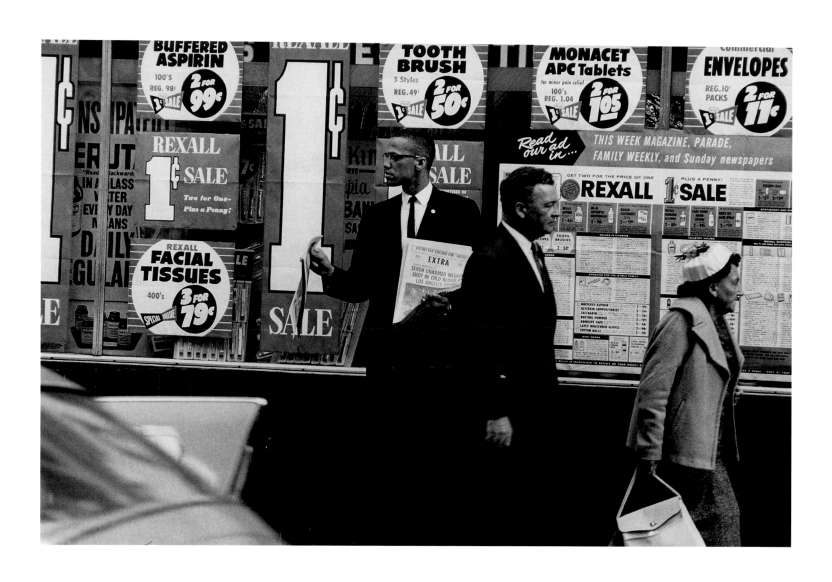

PLATE 83 | **Malcolm X** GORDON PARKS 1963

PLATE 84 | **Martin Luther King Jr.** BENEDICT J. FERNANDEZ 1968

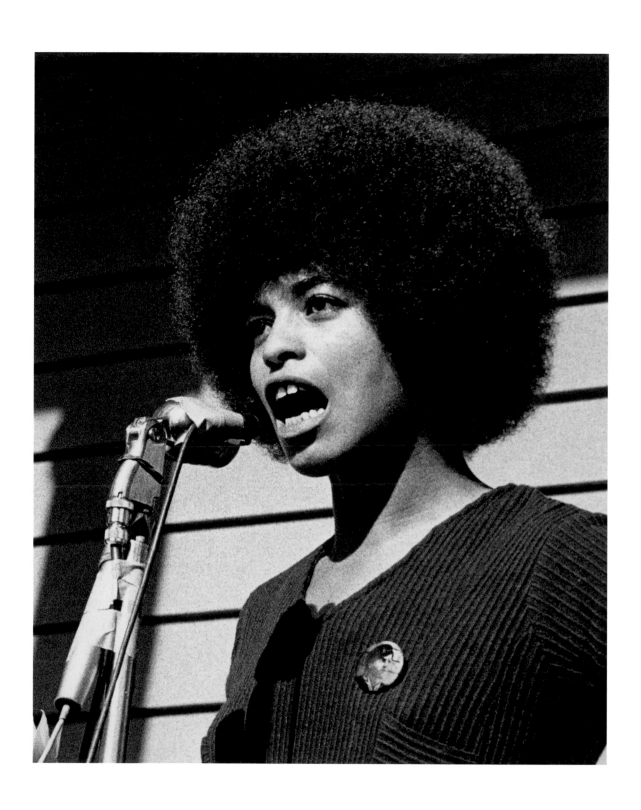

PLATE 85 | **Angela Davis** STEPHEN SHAMES 1969

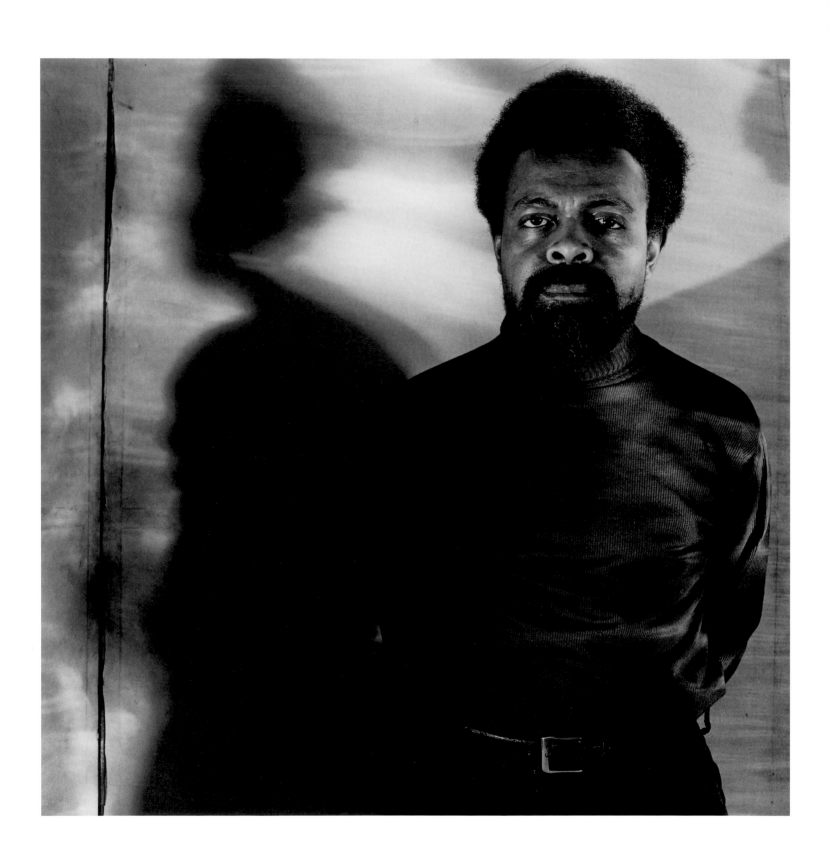

PLATE 86 | **Amiri Baraka** ANTHONY BARBOZA 1976

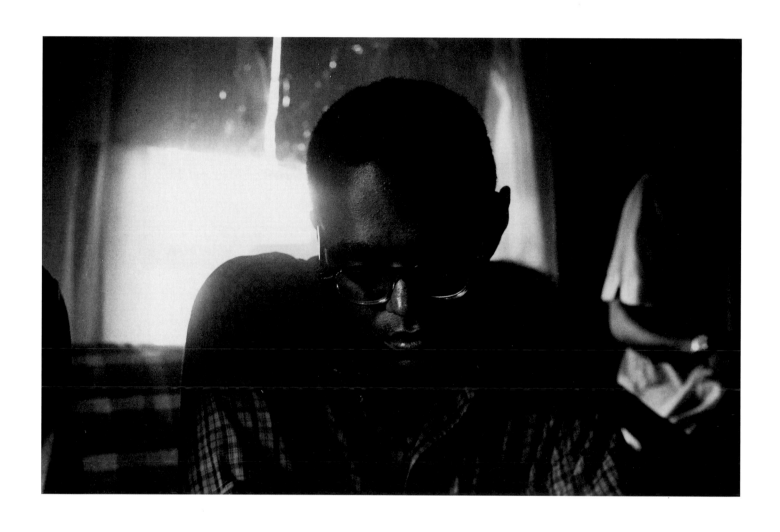

PLATE 87 | **Robert P. "Bob" Moses** DANNY LYON 1962

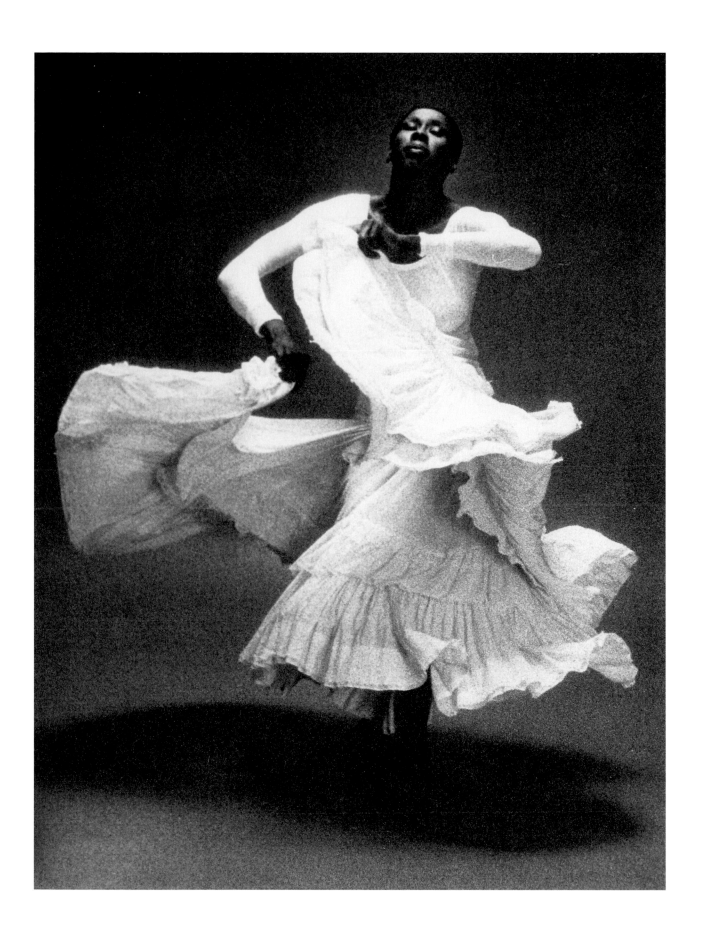

PLATE 88 | **Judith Jamison** MAX WALDMAN 1976

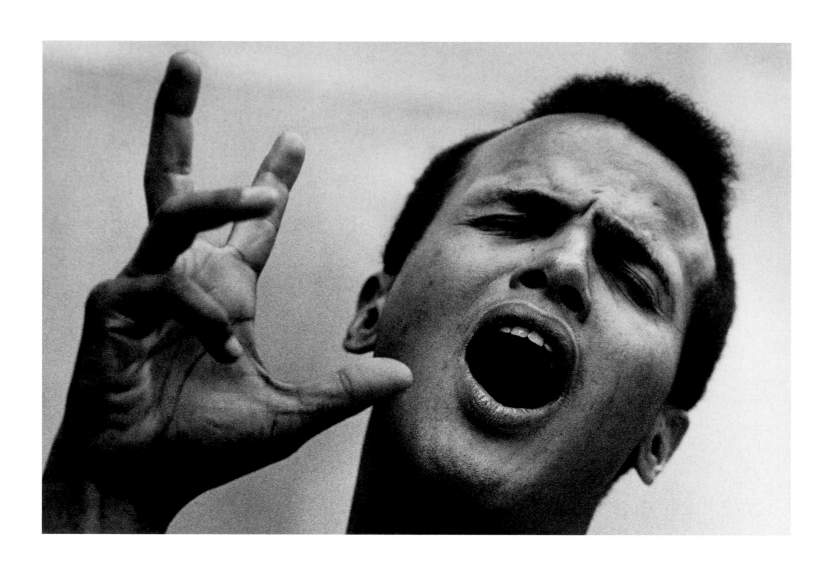

PLATE 89 | **Harry Belafonte** HERSCHEL LEVIT 1960

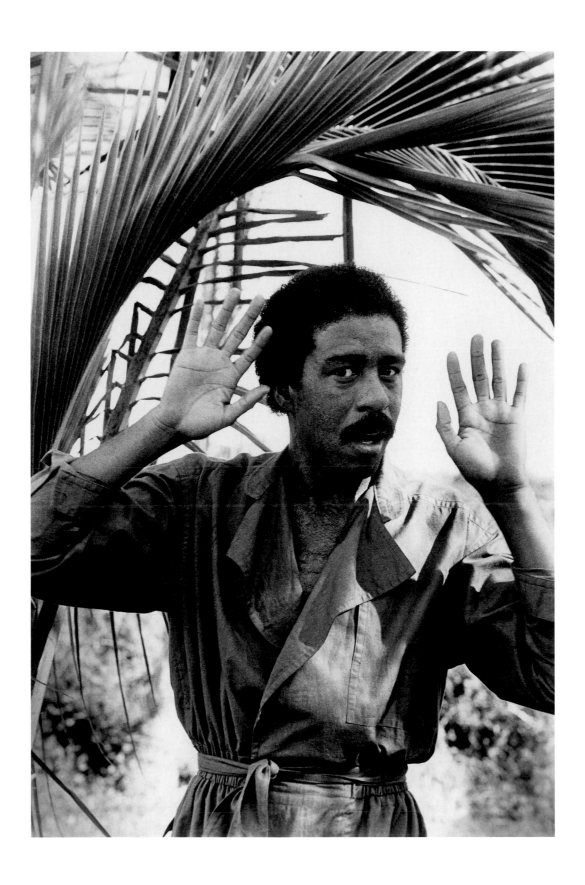

PLATE 90 | **Richard Pryor** STEVE SCHAPIRO 1981

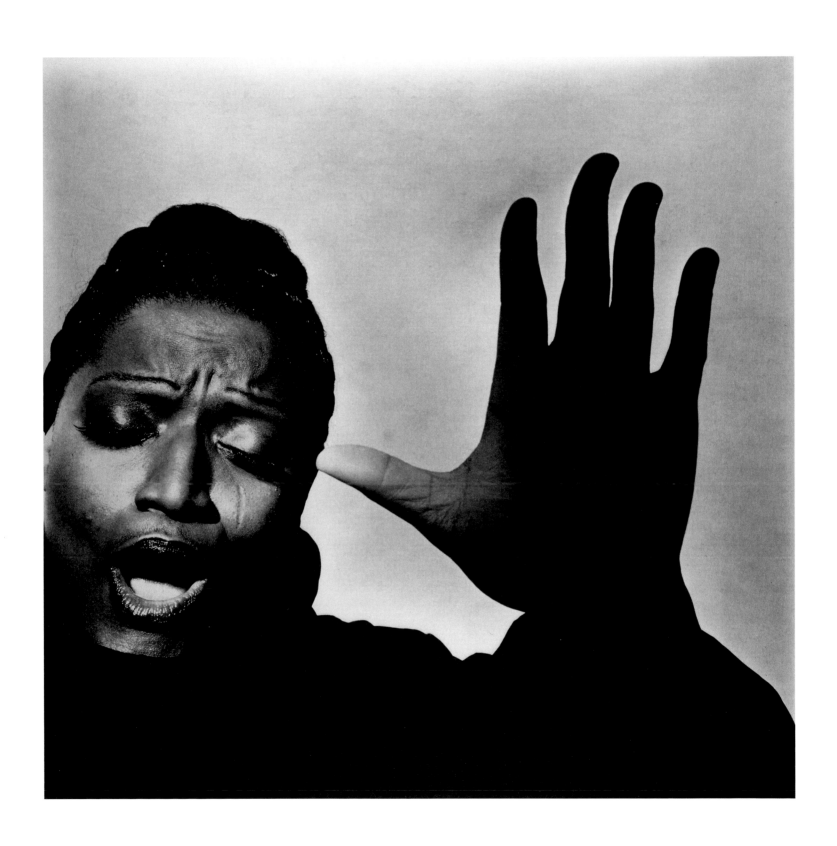

PLATE 91 **Jessye Norman, New York, 1983** IRVING PENN 1983

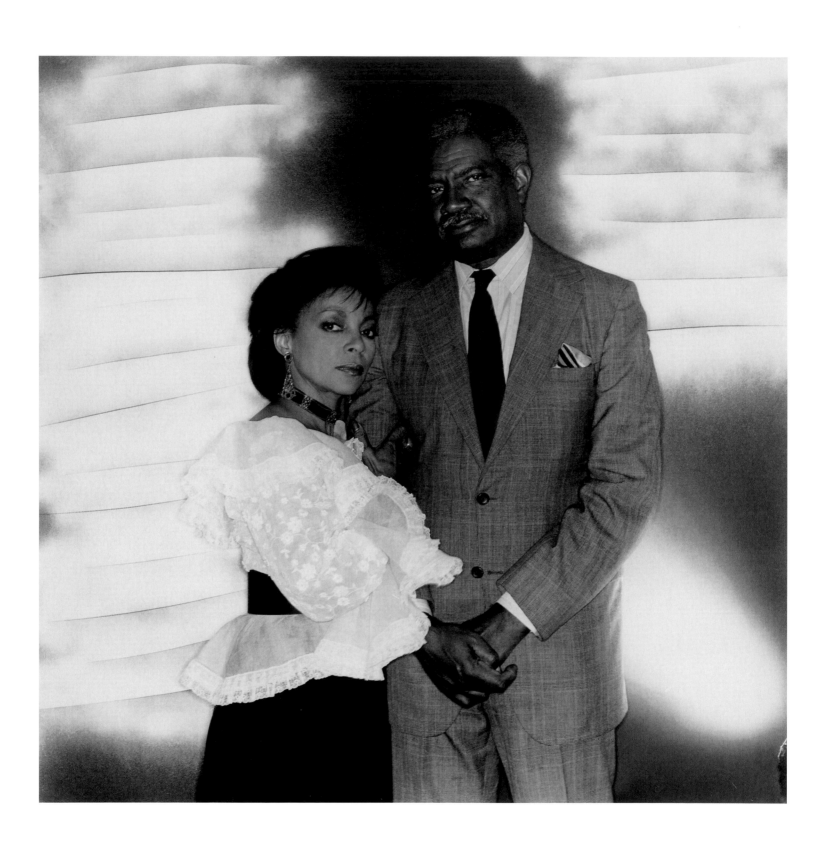

PLATE 92 | **Ruby Dee and Ossie Davis** ANTHONY BARBOZA 1977

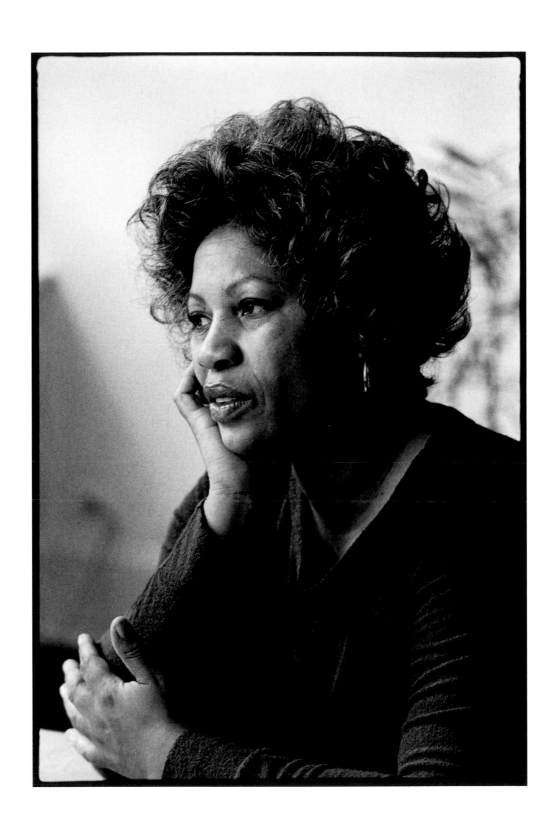

PLATE 93 | **Toni Morrison** HELEN MARCUS 1978

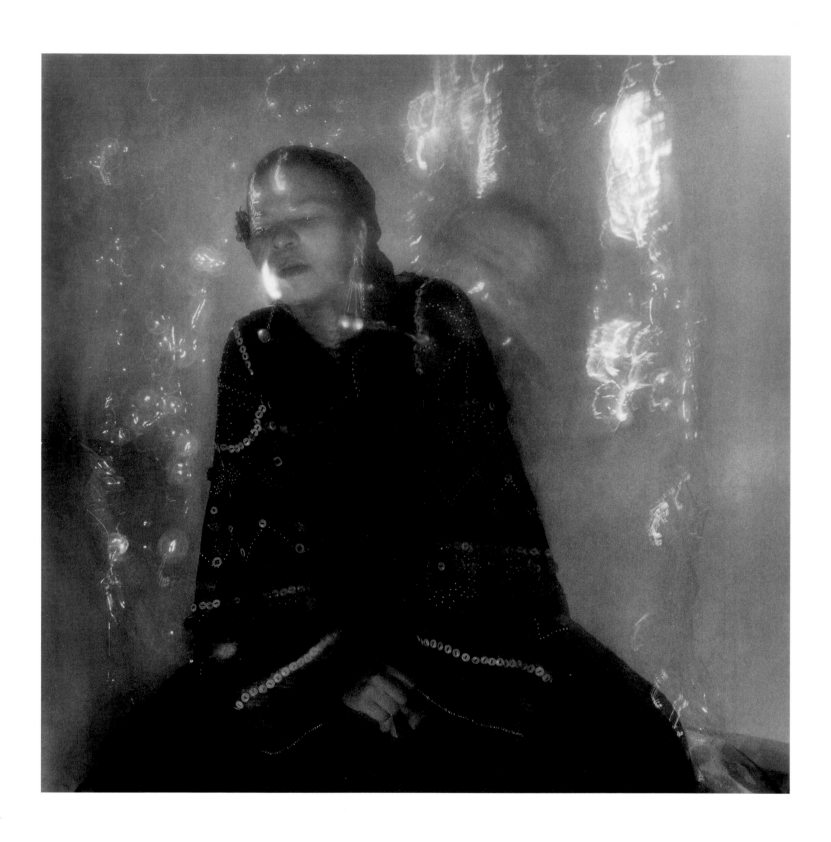

PLATE 94 | **Ntozake Shange** ANTHONY BARBOZA 1977

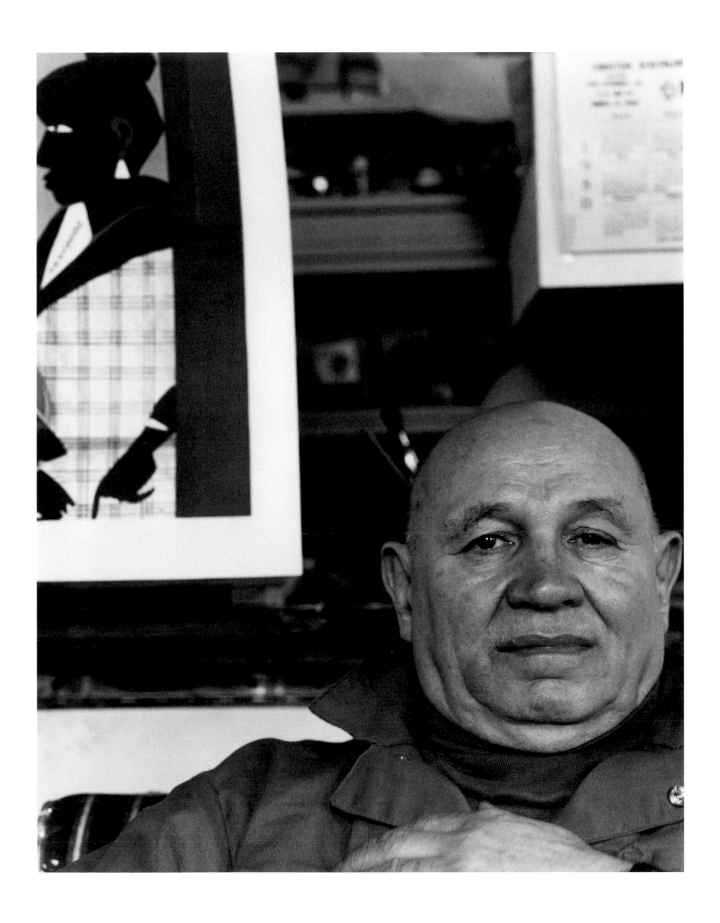

PLATE 95 | **Romare Bearden** ARTHUR MONES 1980

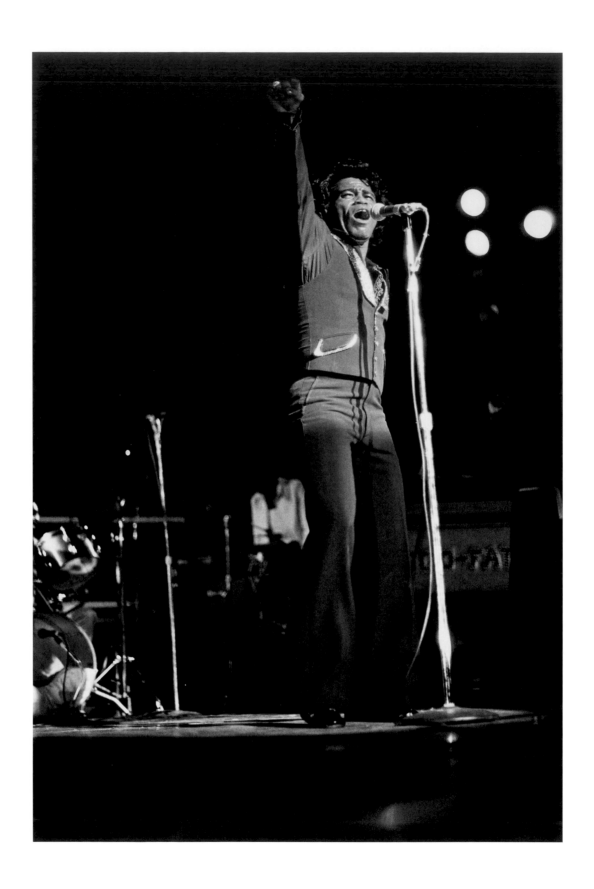

PLATE 96 | **James Brown** MILTON WILLIAMS 1980

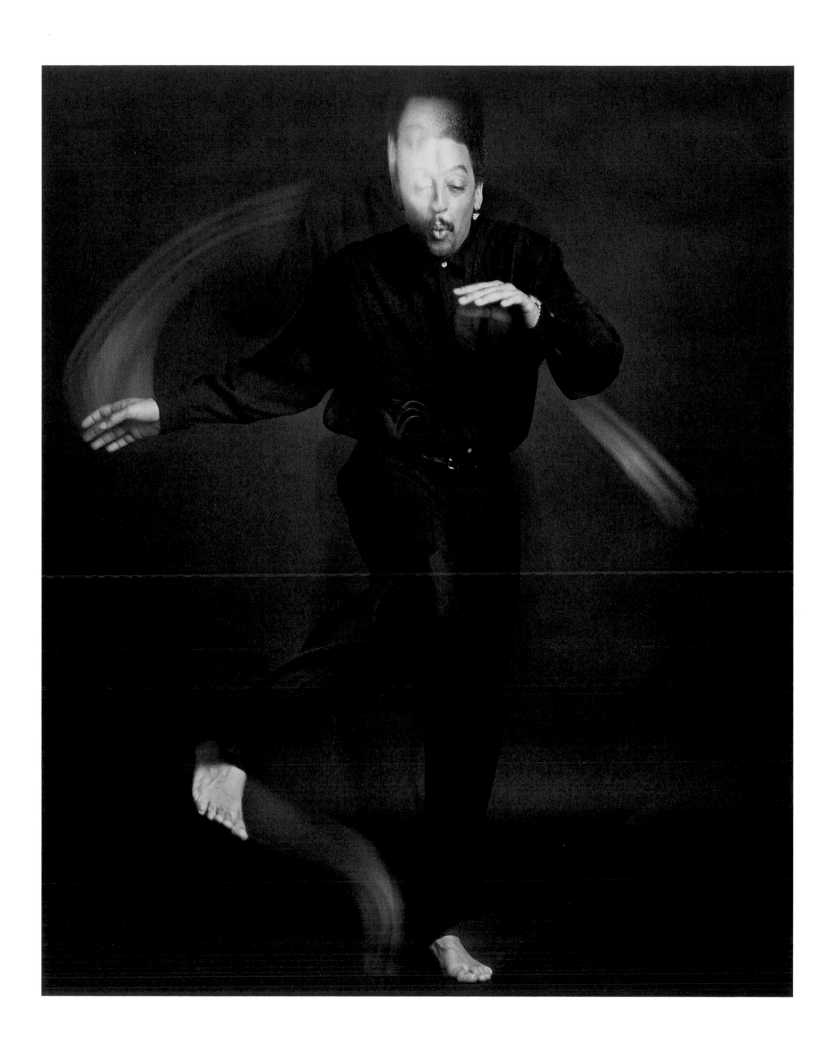

PLATE 97 | **Gregory Hines** ROBERT MAPPLETHORPE 1985

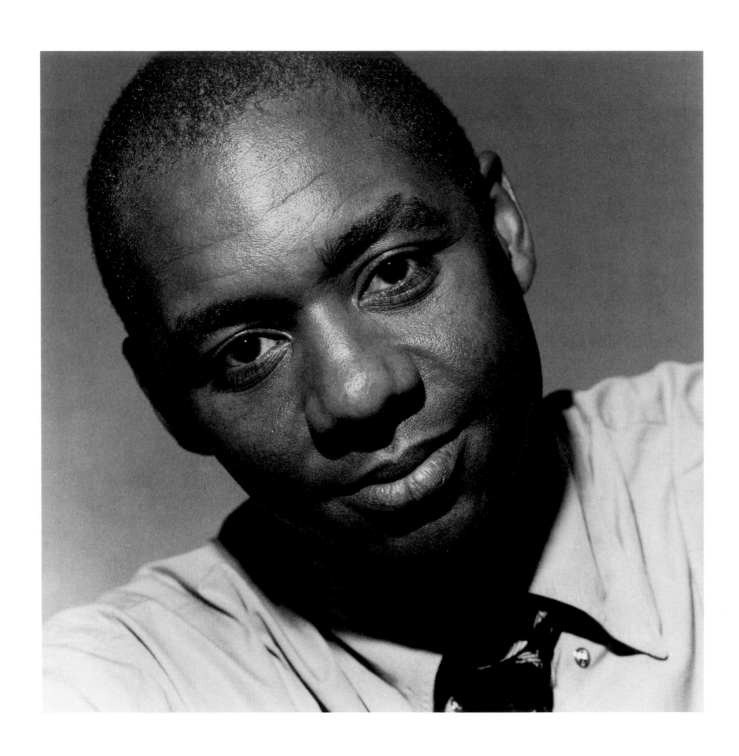

PLATE 98 | **Branford Marsalis** PHILIPPE LÉVY-STAB 1996

1.
Jazz Funeral (February 1, 1999)

The Chicken Man is dead.
Sip a little gin. Remember him.
Twirl that umbrella down Dumaine.
Help the Chicken Man cross over.

The brass band plays:
A Closer Walk with Thee,
Will the Circle Be Unbroken,
This Little Light of Mine.
The mourners warble, HOLLER,
let it shine let it shine,
drink that gin, libate enough

so he don't come back.

The first name he was given was Fred Staten.
"He was straight-up weird,
but he was always smiling,"
said Elvorn Tate, 67.
"He was a beautiful brother,"
said Freddie Thomas
who had known the Chicken Man for years.

You got to do it right,
take a man across that river,
call a man by his name.

2.

Postcard (June 2006)

Please drive me around so I can see what happened,
I asked the cab driver. You mean the disaster? he said.
I will show you the disaster. You need to see the disaster.
He was Haitian, number seven of twelve children,
five of whom died, the only surviving son.

At the levee he said, "They all die.
The great big wave came and wash them. They all die."
"No dogs. Found fish." on one house.
Government search party x's and o's.

Everyone I touched with a fingertip told me stories:
I think my next door neighbor's 'bout to crack.
All my friends are drinking way too much.
The next storm is coming.
We taught school in Houston every day for four months after the storm
to the children who didn't live anywhere.
I don't like how Nagin made it a black thing.
I'm fixing my roof by myself. I ain't waiting on the government.
My neighbor only eats by herself.
I feel at sea without my friends.

Sign on the Superdome,
"We are rebuilding!"
Raze that charnel house.

P.S. A little white boy traveled alone on the plane
to New Orleans. Two elderly black ladies sat next to him
and chatted with him, kept an eye out.
When we landed, they called him to the front.
He pushed his way past the grownups—who was waiting for him
on the other end?—and one of the ladies called out,
"Say excuse me, Baby. Touch the people and then say excuse me."

3.

Memorial

By the nondescript side of the highway
some one or ones wrapped live and plastic
flowers 'round an average telephone pole,

eight or nine feet ground to sky, no signs
or words but color, crosses, ribbons
which I take to be memorial:

a car crashed here and someone died
whose blood and tissue mark the pole
invisibly, now covered with these blossoms.

What will be the sacred words? Baraka asked
black people, asked the polis. And now the polis
open-mouthed in grief. What are the words,

what are the words, what are the words and deeds that will mark this space?

(Wynton Marsalis)

All poems by
Elizabeth Alexander
Professor of African American Studies
Yale University

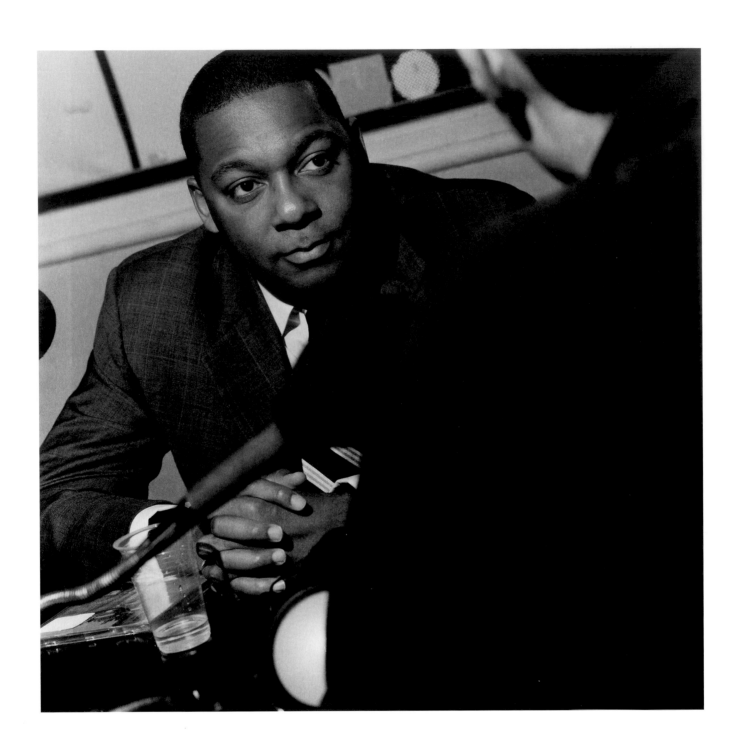

PLATE 99 | **Wynton Marsalis** PHILIPPE LÉVY-STAB 2004

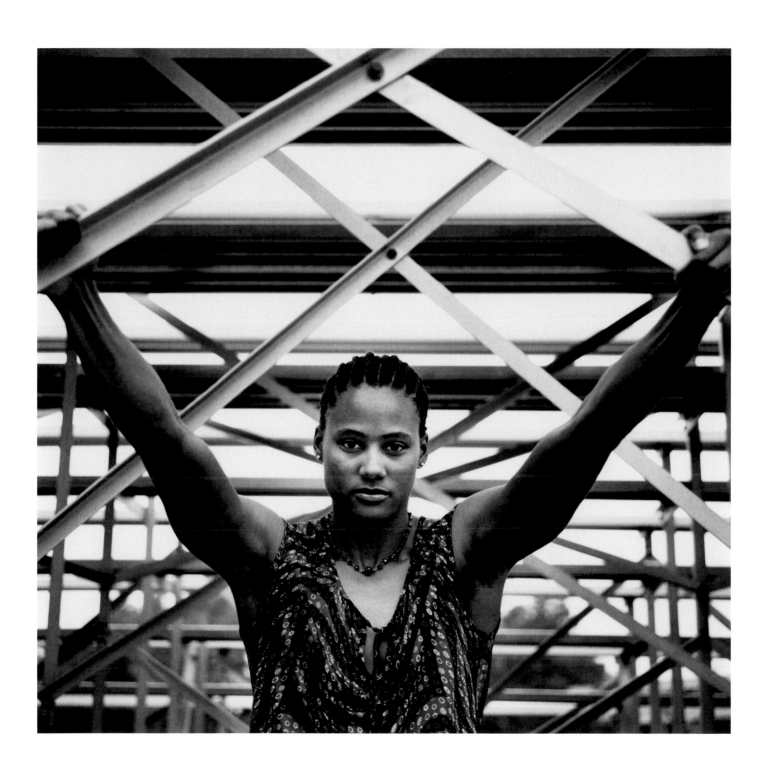

PLATE 100 | **Marion Jones** RICK CHAPMAN 2001

AMERICAN **Idols**

Portraits can portend as much as they portray. Sojourner Truth's prophetic motto, "I sell the shadow to support the substance," printed under her cabinet card portrait (c. 1870), became a statement of the conscious self-offering that characterizes much of African American nineteenth-century portraiture. Her terse phrase also anticipates that some photographs could become complicit in a split between shadow and substance, public image and private self, in the context of America's twentieth- and twenty-first-century cult of celebrity. The television phenomenon *American Idol,* for example, a significant demonstration of our cultural fixation on fame, finds its power in transforming relatively unknown identities into popular images and idols. Yet there is a distinction between an idol and an icon. Idols can be worshiped, consumed, and often discarded. Icons, however, endure.

Icons can survive because of their ability to locate themselves within others; the converse is also true. Sugar Ray Robinson's portrait taken by Arnold Newman in an office, surrounded by framed portraits prominently displayed on the walls and a desk in the background, provides us with this visual reminder. Newman's chosen vantage point revealed that Robinson found his roots and wings in others, as many did in him. The selected pictures of pugilists included in the exhibition construct a narrative arc of transition from the nineteenth through the twenty-first century, from requisite deference to pride. The struggles of Jack Johnson, the first African American to win the heavyweight championship and perhaps the most photographed African American man of the early twentieth century, became an inspiration for others, such as Muhammad Ali, shown in his prime in the 1966 portrait taken by Gordon Parks.

Locating ourselves within icons can be a decidedly physical process; we can adopt poses to approximate positions of power that we feel they convey. However, our constructed images and narratives of our heroes can often be in conflict with the photograph's purpose. Leni Riefenstahl was commissioned by the Third Reich to film and photograph the 1936 Olympic Games in Berlin extensively, causing her work to be denounced initially as National Socialist propaganda. Given the Nazis' ideological stance, one wonders what she, or her photography assistant, must have thought when capturing the images of Jesse Owens's gold medal wins. Within the context of this exhibition, the photograph of Owens can be seen, as it has been seen, despite the photographer's intentions, as a portrait of pride.

Portraits of well-known figures are continually made, even after they are taken. Our best vantage point often begins with a retrospective glance. William Gottlieb's portrait of composer and pianist Billy Strayhorn (c. 1945) looking pensively at a musical score could seem a simple image of contemplation if viewed at midcentury. What subsequently became known of the unique collaborations between Strayhorn and Duke Ellington gives it another constituent layer. This stance became a posture of silent partnership with Ellington, as Strayhorn often composed alone, not always in the Duke's presence; they often communicated by passing compositions back and forth instead. Carl Van Vechten's 1953 portrait of soprano Leontyne Price captures her in a posture of defiance.

Significantly, the photograph was taken before the signature events that resulted in fame—her 1955 television debut in a production of Puccini's *Tosca* and a debut at the San Francisco opera house the following year. Gordon Parks photographed Muhammad Ali in 1966 when both were in their prime. So, too, were contralto Marian Anderson and composer and conductor Leonard Bernstein in 1947. Sid Grossman's portrait of Huddie Ledbetter, known as "Lead Belly," shows him a year before his death. These images may make us look back on sitters' careers and wonder what it takes to create an icon and what the individuals risked to attain that status.

The relationship between photographer and subject in the selected portraits enlarges the significance of many pictures to encompass global narratives. The 1926 photograph of Claude McKay by a young Berenice Abbott marks the early stages of the photographer's career. Abbott had just left Man Ray's portrait studio in Montparnasse, opened her own, and received her first solo gallery show that year. McKay also met Henri Cartier-Bresson, whom McKay later entertained while living in Paris.[1] A poet, novelist, and journalist of the Harlem Renaissance, McKay spent between 1923 and 1933 in Paris, a haven to which other African American artists also emigrated to escape from racism in the United States. His engagement with Cartier-Bresson and Abbott is an illustration of the interracial interactions that artists enjoyed in their temporary home abroad.

Opening a year after the assassination of Martin Luther King Jr., the 1969 exhibition *Harlem on My Mind,* organized by the Metropolitan Museum of Art, exalted the function of African American portraiture to that of metonym, standing in for collective achievement. The show was intended by the museum's director, Thomas Hoving, to celebrate the cultural distinctiveness of African American identities in New York. In the multimedia environmental exhibition, photographs of well-known figures were installed next to documentation of their accomplishments. A portrait of Ellington, for example, was displayed above a record cover, an index of his cultural currency. A two-way channel projected images of museumgoers to pedestrians at selected places on 125th Street, and vice versa. The Black Emergency Cultural Coalition protested the exhibition over two main issues: its reductive approach and the lack of input by the black community in the exhibition's organization. A sign held up during the protest asked the critical question "Whose Image of Whom?," which not only framed the terms of the debate but introduced a question that this exhibition addresses.

The structure of the Jacob Lawrence, Romare Bearden, and Elizabeth Catlett portraits serve as visual reminders of increased control in African Americans' visual self-representation. In a 1980 portrait by Arthur Mones, Bearden leans against a wall in his studio, where two of his collage paintings hang. The image is cropped to include a profiled figure of a black woman in one collage, a conjure woman, a central meditative figure of his oeuvre. In this composition, her index finger delicately points to her creator beneath the frame.

"As African Americans, we often see ourselves as a fragmented people. I prefer to see us as a layered people," Toni Morrison explained during her keynote speech for the symposium on Bearden held at Columbia University in October 2005. Lorraine Hansberry's 1960 portrait by David Moses Attie reflects the relevance of Morrison's perspective. Ontological layering allows for the multiple identifications of gender, sexuality, and class that comprise the heterogeneity of black identities. The multiple planes within the picture constitute her myriad strata. Hansberry stands leaning against her desk, giving a lecture, engaged with the audience. Behind her is a projection of her headshot, left hand gently resting over her shut eyes—a picture of her playfully shielding herself

from her surroundings. In between the two, on her desk, is a framed portrait of the playwright. On the right is a precariously hung poster of *A Raisin in the Sun,* her first play, faithful to the lives of African Americans who otherwise were often shown on the stage in the one-dimensionality of illustrative caricature. Van Vechten's 1955 portrait of James Baldwin, in which he is offering a prayer surrounded by layers of fabric, conveys his perpetual growth. Taken early in Baldwin's career, the image of the writer in proverbial swaddling clothes anticipates that this period would become known as his nascent stage. His defining polemical essays had yet to come. Unwittingly, portraits can portend as much as they portray.

In Baldwin's short essay "The Creative Process," he states, "A society must assume that it is stable, but the artist must know, and he must let us know, that there is nothing stable under heaven."[2] The changed reading of these portraits shows the criticality of instability. Seen over time, these images create a conjunction between the circumstantial constraints at the moment of their making and the partial freedom from them that comes with retrospective reading.

SARAH ELIZABETH LEWIS
CURATORIAL ASSISTANT
DEPARTMENT OF PHOTOGRAPHY
THE MUSEUM OF MODERN ART

Notes

1. Wayne F. Cooper, *Claude McKay: Rebel Sojourner in the Harlem Renaissance,* New York: Schocken Books, 1987, 277.

2. James Baldwin, "The Creative Process," in *The Price of the Ticket,* New York: St. Martin's Press, 1985, 316.

Modern memory is, above all, archival. It relies on the materiality of the trace, the immediacy of the recording, the visibility of the image.[1]

PIERRE NORA

Visual records at times display a power too difficult to bear at points within the unfolding of memory.[2]

BARBIE ZELIZER

Control of a society's memory largely conditions the hierarchy of power.[3]

PAUL CONNERTON

I.

Lot 118.

(Blacks). Tintypes. Fine album containing 50 ⅙ plate tintype portraits of black men, women, and children, possibly compiled by the studio photographer himself. Thick 8vo, contemporary embossed morocco, brass clasps, minor wear; all edges gilt. 1870s (?)

Estimate $500–$750.

In early 1991, I came across this item in the spring auction catalogue of photographs at Swann Galleries in New York. Curious about what it might be, I went to preview it before determining whether I might place a bid. Tucked away in a glass case usually reserved for the most prized works offered for sale, it appeared to be a precious object with a secret to reveal. When the auction room attendant handed it to me, I held it close for a few moments before opening the brass clasp that secured the gilt-edged, leather-bound album. It resembled a small bible except along the spine, where the word "Photographs" embossed in gold gave away its contents. Inside, there were, as the description indicated, "50 ⅙ plate tintypes," all "portraits of black men, women, and children." Although it appeared to be a family album, I had never before seen anything like it, even in my own family's collection of personal photographs dating to the late nineteenth century. Instead, these were heavy, antiquated metallic photographs of babies, children, adults, and older people—proud, happy, confident, strong, funny, stylish, and beautiful. They were weighty for sure, but not because of the sheer physical mass of the iron plates on which the visages appeared. Somehow, rather, it was the mystery hidden inside—the anonymity of the sitters, their relationship to one another and to the photographer(s)—that captivated me. Nowhere were

the names of the sitters or the occasions of the photographs given. I wondered how such a precious object had slipped from memory into forgetfulness. What happened to the people who were pictured there in front of stock studio backdrops, propped up in velvet chairs, standing alone before cascading velvet draperies? What kinds of lives did they lead as free people? Who were their children and their children's children, and why didn't they have this album now? Did they go to an agricultural and technical college in the South, or perhaps attend one of the first historically black colleges or universities such as Tuskegee or Hampton or Howard? Had their lives been cut short by racial violence or disease? Whom did they love and admire? As I turned each page, I persisted with the central question: how had this album ended up a mere commodity? Of course, the obvious analogy between slaves on the auction block and the people pictured in this album now for sale in a twentieth-century auction was never far from my mind. Surely, some of the sitters, only ten years removed from slavery, had experienced the sting and separation of the auction block. Trying, even if only metaphorically, to prevent such a wrong from happening again, I acted out of the same sense of loyalty as those freed people who would have bought their own kin on the auction block, and decided to bid on the album, performing a symbolic rescue mission.

II.

The appearance of this anonymous yet strangely familiar album in an auction made me consider the relationship of photography to memory for the first time. The portraits, filled with unknown secrets and ambiguity, forced me to question the connection of photography *and* memory to power relations and identity formation. I wondered what factors led to its appearance on the auction block and how the study of photography and memory might reveal some clues, at least for the meaning the album might have had in its own time and for the understanding it can bring to us today.

From the beginning of photography, the concept of memory has played a significant role in determining the uses and development of the medium. The early popular slogan "a mirror with a memory" quite literally staked a claim for photography's unique mnemonic quality; it referred both to how the silvered surface of the daguerreotype carried the viewer's ghostly reflection and to the photographic image itself, forever intertwining the two, past and present. The proliferation of photographic portraiture in the 1840s, '50s, and '60s further solidified photography's symbiotic relationship to memory and led to the invention of inexpensive ways to produce multiple prints, such as the tintype and the *carte-de-visite*. The insatiable desire to have one's likeness forever captured revealed an awareness of an undeniable mortality, not only on the part of the sitter but also of the moment that had passed as the event was recorded before the camera. Death (for the sitter, for a moment that would never return, for the beholder of the image) was certain, indeed guaranteed. The temporal-spatial qualities of both photography and memory in this moment seemed inseparable, and the photograph itself became the only appropriate memorial.

The photograph album, an organizational device resulting from the popularity of the *carte-de-visite,* was another invention of necessity: a way to store, collect, and archive the large numbers of portraits being produced. But the album also was instrumental in honing the narrative function of photography through the careful ordering of images. The album further revealed another dimension of photography's link to memory that is social,

affecting identity formation, power relations, and political determination. As collections of individual photographs, albums possessed a different hold on memory, one that related the single image to the larger collection of images or, in human terms, one that placed the individual before the group in a precise narrative sequence. Family albums in particular, which connected one generation to the next and were closely associated with family bibles—both visually and functionally—held stories that were enacted with the aid of a family member. With each recitation, with each photograph, the storyteller guided the constitution and reconstitution of identity, the formation of the social group in relation to a larger history of humankind.

CHERYL FINLEY
HISTORY OF ART DEPARTMENT
CORNELL UNIVERSITY

Notes

1. Pierre Nora, "Between Memory and History: Les Lieux de Memoire," *Representations* 26 (Spring 1989): 7–24.

2. Barbie Zelizer, "Reading the Past against the Grain: The Shape of Memory Studies," *Critical Studies in Mass Communication* 12 (1995): 204–39.

3. Paul Connerton, *How Societies Remember,* Cambridge: Cambridge University Press, 1989, 1.

BIOGRAPHIES

Henry "Hank" Aaron born 1934 PLATE **69**

A legendary hitter who set records that remain unequaled to this day, Hank Aaron was one of baseball's greatest offensive stars. Other players may have been more flamboyant, but none could match Aaron's power and consistency during his twenty-three years in the majors. After launching his career with the Negro League's Indianapolis Clowns in 1952, Aaron signed with the Milwaukee Braves and joined their roster in 1954. He soon emerged as a tremendous asset to that ball club, and in 1957 his bat drove the Braves to a World Series victory over the Yankees. In the years that followed, Aaron's impressive hitting fueled his assault on the record books, and in 1974 he became the first player to break Babe Ruth's career record of 714 home runs. When Aaron retired from play in 1976, his home run mark stood at 755.

Osvaldo Salas (1914–1993) | Gelatin silver print, 1956
NPG.97.125 | AMS

Muhammad Ali born 1942 PLATE **70**

Few American athletes have ever possessed physical talents comparable to those of boxer Muhammad Ali; none with such abilities has ever equaled him for charisma and bravado. Born Cassius Clay, he first made national headlines after winning gold at the 1960 Olympics. Turning professional, he began his assault on the boxing ranks, attaining the heavyweight crown in 1964. But as powerful as he was in the ring, it was his words and actions outside the ring that made him a larger-than-life figure. His outrageous boasts—often in poetic verse—won him a large following. However, when he joined the Nation of Islam in 1964 and changed his name, controversy ensued. His refusal to serve in Vietnam further angered many Americans and led boxing officials to strip him of his crown. After being reinstated, Ali would reclaim the heavyweight crown, lose it, and regain it again before retiring in 1981.

Gordon Parks (1912–2006) | Gelatin silver print, 1966
NPG.98.80 | © Gordon Parks | FHG

Marian Anderson 1897–1993 PLATE **45**

Arturo Toscanini once said that Marian Anderson had a voice that came along "once in a hundred years." But because Anderson was black, her initial prospects as a concert singer in the United States were sharply limited, and her early triumphs took place mostly in European concert halls. Her successes abroad, however, made it difficult for the American musical establishment to ignore her, and when she began touring the United States in 1935, audiences quickly embraced her as the greatest contralto alive. By the time Anderson retired in the mid-1960s, she was regarded as one of the nation's great cultural treasures. Anderson is seen here performing with conductor Leonard Bernstein at a concert in New York in 1947. In response to the thunderous ovation for her performance, she ended up singing five more pieces as an encore.

Ruth Orkin (1921–1985) | Gelatin silver print, 1947
NPG.98.82 | © Ruth Orkin/Hulton Archive/Getty Images | FSV

Louis Armstrong 1901–1971 PLATE **60**

A trumpet virtuoso with a wide smile and an ebullient personality, jazz pioneer Louis Armstrong helped to transform this musical tradition into an international phenomenon, in the process becoming one of America's most beloved twentieth-century entertainers. Raised in New Orleans, Armstrong moved to Chicago in 1922 to join Joe Oliver's Creole Jazz Band. Several years later he formed his own band, billed himself as the "World's Greatest Trumpet Player," and helped to develop the jazz style popularly known as swing. As his contemporary Duke Ellington observed, "Satchmo" became, over his long career, the "epitome of jazz," playing before capacity audiences throughout America and abroad. Well regarded as a leader in the campaign for racial equality, Armstrong was first and foremost a consummate performer. As he explained, "I never tried to prove nothing, just always wanted to give a good show."

Lisette Model (1901–1983) | Gelatin silver print, c. 1956
NPG.82.138 | © The Lisette Model Foundation, Inc. 1983.
Used by permission. | FHG

Josephine Baker 1906–1975 PLATE **19**

From her beginnings in vaudeville, Josephine Baker exhibited a verve and sensuality that stood out even in a chorus line. Having grown up in poverty in St. Louis, she seized the opportunity in 1925 to travel to Paris in the Harlem music and dance ensemble *La Revue Nègre*. With a reputation for daring outfits and a performance style that was at once erotic and comic, Baker became a star. Ernest Hemingway, who frequented the Club Joséphine, where Baker served as "hostess," called her "the most sensational woman anyone ever saw . . . or ever will." After the outbreak of World War II, Baker threw herself behind the Allied cause, working with refugees and performing for the troops. In later years she became a vocal civil rights proponent, insisting on integrated audiences wherever she performed.

Stanislaus J. Walery (1863–1935) | Gelatin silver print, 1926
NPG.95.105 | FHG

James Baldwin 1924–1987 PLATE **63**

Carl Van Vechten's 1955 portrait of James Baldwin was taken the same year the author's *Notes of a Native Son* was published. This collection of primarily autobiographical essays earned generous acclaim from many, including Langston Hughes, who praised it as "thought-provoking, tantalizing, irritating, abusing, and amusing." While physically slight and soft-spoken, Baldwin emerged at midcentury as one of the most passionate and eloquent writers about the problem of race in American society. He did so from abroad, however, having relocated to Paris in 1948 in order to escape intolerance in America. Although he was featured on the cover of *Time* magazine in 1963, Baldwin was reluctant to serve as a leader or a spokesperson in the campaign for civil rights; instead, as he later explained, he wished to "bear witness to the truth."

Carl Van Vechten (1880–1964) | Gelatin silver print, 1955

NPG.91.66 | © Carl Van Vechten Trust | FHG

Edward Mitchell Bannister 1828–1901 PLATE **7**

Edward Mitchell Bannister became one of the first African American painters to gain national recognition when his landscape *Under the Oaks* won a first prize at the Centennial Exposition in Philadelphia (1876). Almost entirely self-taught, Bannister began his career in the 1850s in Boston, where he enjoyed the patronage of that city's substantial black community. He was also a committed abolitionist who continued to advocate for African American rights after the Civil War. When Bannister settled in Providence, Rhode Island, in 1869, his reputation grew as his landscapes and coastal views were exhibited more widely. His name proved unfamiliar, however, to the Centennial Exposition judges, who tried to withhold his prize upon discovering that he was African American. When the other artists threatened to withdraw from the competition if Bannister was denied his medal, the original award was upheld.

Gustine L. Hurd (1833–1910) | Albumen silver print, c. 1880

Gift of Sandra and Jacob Terner | NPG.76.66 | AMS

Amiri Baraka born 1934 PLATE **86**

Born LeRoi Jones, poet and playwright Amiri Baraka has been an important, yet often controversial, voice in African American literary and political circles. Baraka's experience as a student at Howard University and his subsequent service in the Air Force radicalized him. Moving to Greenwich Village in 1957, he began a short-lived association with various Beat writers.

Their ideas about alienation in American society appealed to Baraka, but ultimately his embrace of black nationalism in the 1960s shifted his focus almost exclusively to African American subjects and political concerns. Beaten and arrested in the 1967 Newark race riot, Baraka came to "see art as a weapon of revolution." He helped to initiate the Black Arts movement, and played a lead role in founding theatrical companies in Newark and Harlem. His more recent writings have been devoted to revealing what he calls "the bankruptcy of Western cultures."

Anthony Barboza (born 1944) | Gelatin silver print, 1976

NPG.2005.126 | © Anthony Barboza | FHG

Count Basie 1904–1984 PLATE **36**

This group portrait by *Life* magazine photographer Gjon Mili pictures Count Basie (lower right, in front of the piano) and other members of his band, including celebrated saxophonist Lester Young (center, with black hat). Influenced by the piano styles of Willie "the Lion" Smith and Fats Waller, Basie formed his first group in 1935. For the next forty years, Basie and his musicians performed and recorded with a frequency unmatched by any other big band. In addition to routinely crisscrossing the United States, he led thirty European tours and traveled eight times across the Pacific Ocean to entertain audiences. In 1961 he gave a memorable performance at President John F. Kennedy's inauguration, solidifying his national reputation. Basie's ability to adapt to changing musical tastes, while maintaining the group's artistic integrity, was a hallmark of his extraordinary jazz orchestra.

Gjon Mili (1904–1981) | Gelatin silver print, 1944 | NPG.95.381

© Gjon Mili/Time and Life Pictures/Getty Images | FHG

Romare Bearden 1912–1988 PLATE **95**

While best known for his collages, Romare Bearden chose a variety of different mediums to express himself as an artist. In addition to paintings and drawings, he created murals, tapestries, and posters, and in several instances he composed music to accompany his works. A gregarious man with a passion for jazz, he described art-making as "a kind of divine play." Bearden grew up in Harlem and in Pittsburgh, and studied painting with George Grosz at the Art Students League. Following service in an all-black regiment during World War II, he returned to New York, where he became immersed in a thriving art scene. Bearden's work reflects many influences: the places he lived and traveled, African American history and literature, and religious traditions and community rituals that bound people together.

In 1987 President Ronald Reagan awarded him the National Medal of Arts.

Arthur Mones (1919–1998) | Gelatin silver print, 1980

NPG.93.142 | Gift of the photographer | © 1980 Arthur Mones | FHG

Sidney Bechet 1897–1959 PLATE 38

Arthur Leipzig's portrait shows Sidney Bechet at the legendary New York nightclub Jimmy Ryan's, playing the soprano saxophone, the instrument for which Bechet was most celebrated. Together with Louis Armstrong, he helped to bring New Orleans jazz to the world. Although no less talented, Bechet never attained the popularity that Armstrong achieved in America, in part because of his often bristly personality. Yet critics and fellow musicians recognized his musical genius and respected his commitment to "doing it your own way." As one reviewer wrote in 1919, when Bechet was only twenty-two, his "'own way' is perhaps the highway [on which] the whole world will swing along tomorrow." To Armstrong, his playing was like a "jug full of golden honey." After a lifetime of touring, Bechet moved in 1951 to Paris, where he enjoyed a wide following.

Arthur Leipzig (born 1918) | Gelatin silver print, 1945

NPG.93.11 | © Arthur Leipzig | FHG

Harry Belafonte born 1927 PLATE 89

Harry Belafonte created a sensation in the 1950s when he introduced Americans to the lilting Caribbean rhythms of calypso with his renditions of such songs as "Day-O (Banana Boat Song)." Although trained as an actor, Belafonte achieved his first success in 1949 as a pop music singer before shifting his focus to the American folk songs and traditional West Indian melodies that showcased his talent as a balladeer and reflected his strong social conscience. In 1956 his release of *Calypso*—the first album to sell more than one million copies—launched the craze for this musical genre and established Belafonte as its most popular interpreter. Believing that his music could help bring people together to work for the common good, Belafonte embraced the dual roles of civil rights activist and humanitarian early in his career, and has continued to advocate for those in need.

Herschel Levit (1912–1986) | Gelatin silver print, 1960

T/NPG.98.86 | AMS

James Brown 1933–2006 PLATE 96

One of the most dynamic and innovative figures in American popular music for half a century, "Godfather of Soul" James Brown profoundly influenced a host of musical genres, from rhythm and blues to hip hop. First climbing the R&B charts with hits like "Please, Please, Please" (1956) and "Try Me" (1958), Brown fueled the emergence of soul and funk in the 1960s by melding high-energy gospel with rhythm and blues. His frenetic performances and over-the-top dance moves earned him a huge following among black and white audiences alike, and a string of smash hits—including "Papa's Got a Brand New Bag," "I Got You (I Feel Good)," and "Cold Sweat"—made Brown a staple of Billboard's Top Forty. Equally important, his experimentations with complex, driving rhythms laid the foundation for much of the pop music that followed.

Milton Williams (born 1940) | Gelatin silver print, 1980

S/NPG.96.187 | © Milton Williams 1980 | AMS

Cab Calloway 1907–1994 PLATE 27

Performing one night at Harlem's fabled Cotton Club in the early 1930s, singer, composer, and bandleader Cab Calloway was suddenly unable to remember the lyrics to his own song "Minnie the Moocher." To fill the void, he launched into improvisational scat, singing "hi-de-hi, hi-de-ho." His performance soon had the audience joining in, and his raucous finale, Calloway later recalled, "nearly brought the roof down." Forever after, "hi-de-ho" was an integral part of his identity as one of the Big Band era's most popular and respected figures. As in this instance, much of Calloway's success can be attributed to his own rakishly vibrant style, which injected his band's performances with a festive exuberance. He also had a remarkable gift for recruiting and holding on to good musicians, and among his band members were such jazz greats as Dizzy Gillespie, Milt Hinton, and Cozy Cole.

Carl Van Vechten (1880–1964) | Gelatin silver print, 1933

NPG.90.87 | © Carl Van Vechten Trust | FSV

Stokely Carmichael 1941–1998 PLATE 82

Stokely Carmichael's experience as a civil rights activist began in 1961, when he joined the Freedom Ride campaign to protest discrimination in public transportation facilities. His subsequent work in the South—to organize voter registration drives and to march against racist intimidation—resulted in frequent arrests. It also led him to question the philosophy of nonviolence. In 1966, Carmichael abandoned his association with the Student Nonviolent Coordinating Committee and helped to organize the Black Panthers, a group that promoted black separatism. His embrace of "Black Power," a term that he coined, sparked outrage among many whites and alarmed an older generation of civil rights leaders. Gordon Parks's photograph shows Carmichael

speaking in New York at a demonstration against the Vietnam War. As he exclaimed on this occasion, "Bigotry and death over here is no different from bigotry and death over there."

Gordon Parks (1912–2006) | Gelatin silver print, 1967
NPG.98.79 | © Gordon Parks | FHG

James "Jimmy" Carter 1923–1994 PLATE 52

George Araujo born 1931

Boxer Jimmy Carter (in the light-colored trunks) was the first three-time winner of the world lightweight title. After turning professional in 1946, Carter gradually worked his way up boxing's ranks until he earned the chance to challenge then-champion Ike Williams on May 25, 1951. Although Williams was heavily favored, Carter scored a stunning upset to take his first lightweight boxing championship. Retaining the title would prove more difficult, however. Over the next four years Carter would twice lose and then regain his boxing crown before surrendering it for the final time in 1955. One of Carter's successful lightweight title defenses took place in a nationally televised bout with twenty-two-year-old George Araujo on June 12, 1953. Although the boxers were evenly rated, the hard-hitting Carter prevailed over his fleet-footed challenger to win by a technical knockout in the thirteenth round.

Charles Hoff (1905–1975) | Gelatin silver print, 1953
S/NPG.97.225 | © Charles Hoff/Daily News | AMS

George Washington Carver c. 1864–1943 PLATE 22

Scientist and educator George Washington Carver dedicated his career to improving the lives of impoverished Southern farmers by encouraging the practice of scientific agriculture. Overcoming numerous barriers to secure a master's degree in 1896, Carver accepted Booker T. Washington's invitation to lead the agricultural department at the Tuskegee Institute in rural Alabama. For the next forty-seven years, Carver poured his energy into research and educational efforts designed to improve farm productivity and foster self-sufficiency among African American farmers who were trapped in sharecropping dependency. Advocating crop diversification to restore soil exhausted by cotton, Carver encouraged the cultivation of soil-enriching peanuts and sweet potatoes. To demonstrate their commercial viability, he developed hundreds of new products solely from those crops. Carver's efforts transformed Southern agriculture and earned him international recognition as the "Genius of Tuskegee."

Prentice H. Polk (1898–1985) | Gelatin silver print, c. 1930
NPG.95.89 | © Tuskegee University Archives | AMS

Elizabeth Catlett born 1919 PLATE 47

Described by poet Maya Angelou as the "queen of the arts," Elizabeth Catlett has created, over the course of the last seventy years, paintings, prints, and sculptures that touch upon many important social and political issues. Refused admission to an all-white art school, Catlett studied at Howard University and then with painter Grant Wood at the University of Iowa. Her work for the Public Works Art Project during the 1930s introduced her to Diego Rivera and other socially conscious mural painters. This group influenced the direction of her art; it also introduced her to artistic traditions in Mexico, where she permanently relocated in 1946. She has completed numerous commissions in the United States and Mexico, and to this day she remains committed to the idea that "art is important only to the extent that it helps in the liberation of our people."

Mariana Yampolsky (1925–2002) | Gelatin silver print, c. 1949
(printed c. 1990) | S/NPG.91.74 | © Mariana Yampolsky | FHG

Octavius V. Catto 1839–1871 PLATE 6

Octavius V. Catto was a tireless activist who gave his life in the struggle to secure civil liberties for African Americans. The freeborn son of a clergyman, Catto was raised in Philadelphia and educated at the Colored Youth Institute, where he later served on the faculty. Committed to African American advancement, Catto founded major civic institutions in Philadelphia, including the Banneker Literary Institute, the Equal Rights League, and the Pythian Baseball Club—one of the earliest black baseball teams. During the Civil War, he allied himself with antislavery Republicans and worked with Frederick Douglass to recruit black regiments. A vigorous advocate for the civil rights amendments of the Reconstruction era, Catto was brutally shot to death by a Democratic Party operative on October 10, 1871, as blacks voted in the first Philadelphia election held after ratification of the Fifteenth Amendment.

Broadbent and Phillips (active 1871–74) | Albumen silver print, c. 1871 | NPG.2006.8 | AMS

Ray Charles 1930–2004 PLATE 71

Blinded at five, singer/composer Ray Charles learned the rudiments of his musicianship at a school for the deaf and blind in his native Florida. In his early performing career, he modeled his style largely on singer Nat "King" Cole. By the early 1950s, however, he was developing his own original blend of blues and gospel that would lead to his first major hit recording, "I've Got a Woman," and ultimately make him the "father of soul music." The winner of eleven Grammy Awards and a Kennedy

Center Honors award, Charles had many hits that have long since become classics of pop music, including "Georgia on My Mind" and "Hit the Road, Jack." He also exercised enormous influence on other performers, and many experts number him among the most important American musicians of his time.

Michel Salou (active mid-twentieth century) | Gelatin silver print, c. 1961 | NPG.2000.23 | FSV

Nat "King" Cole 1919–1965 PLATE 58

Nat "King" Cole first made his name in pop music primarily as a pianist with the King Cole jazz trio that he formed in 1939, and some experts consider his keyboard technique, which influenced a number of other noted musicians, his most significant contribution to music. But by 1950, the public at large was coming to know Cole as the crooner whose relaxed manner went hand-in-glove with his caressing voice. As hits such as "Mona Lisa" and "Unforgettable" followed one another, he became one of America's favorite entertainers, and in the fall of 1956, he was the first African American to host a network television show. Cole was sometimes faulted for not being more outspoken in the civil rights cause, but his broad popular appeal was in itself a contribution to the struggle against racism.

Sid Avery (1918–2002) | Gelatin silver print, 1954
Gift of Ronald B. Avery | NPG.96.91 | © 1978 Sid Avery | FSV

Dorothy Dandridge 1922–1965 PLATE 62

A talented singer and actress with beauty to match, Dorothy Dandridge possessed all the attributes of a star. Teamed with her sister, she made her stage debut as a child and later performed with the popular singing trio known as the Dandridge Sisters. In the 1940s she launched her solo career as a nightclub entertainer and began pursuing work in motion pictures. After appearances in several minor films, Dandridge scored a triumph when she was cast as the title character in *Carmen Jones* (1954). Critically acclaimed for her performance, Dandridge became the first black performer in history to be nominated for an Academy Award in a leading role. Despite this stellar beginning, Dandridge spent the remainder of her career trying to overcome the entrenched racial bias that doomed her to secondary roles rather than showcasing her ability as a dramatic actress.

Philippe Halsman (1906–1979) | Gelatin silver print, 1953
NPG.98.41 | © Halsman Estate | AMS

Angela Davis born 1944 PLATE 85

Stephen Shames's portrait shows civil rights activist Angela Davis in 1969, when she became well known for her impassioned activism on behalf of civil rights and freedom of speech. Davis first gained widespread attention that year for winning a lawsuit against the University of California at Los Angeles for its decision to fire her on account of her membership in the Communist Party. Her connection to a gunfight outside a California courthouse a year later made her internationally famous. Although she had not been present at the time, she was alleged to have purchased the guns that killed a judge and three others. Her two-year incarceration and eventual trial became a cause célèbre and prompted outcries from both the political left and right. Davis was ultimately acquitted. Since then, she has continued to champion various social causes, including, most prominently, prison reform.

Stephen Shames (born 1947) | Gelatin silver print, 1969
S/NPG.2001.55 | © 1972 Stephen Shames | FHG

Sammy Davis Jr. 1925–1990 PLATE 80

Sammy Davis Jr. was a consummate showman whose formidable talent propelled him from the vaudeville circuit to the entertainment industry's most glittering venues. Scarcely more than a toddler when he began his career, Davis emerged as a featured singer and dancer with the Will Mastin Trio in the 1930s. Drafted during World War II, he experienced vicious racial attacks while in the army, and returned to civilian life determined to prove his worth by becoming a top-tier entertainer. Progressing rapidly from warm-up act to headliner, Davis attained bona fide stardom in the 1950s with his high-energy nightclub act, popular recordings, and acclaimed performances on stage and screen. In the 1960s he gained notoriety as a member of Hollywood's fast-living "Rat Pack" and subsequently achieved mega-hit status with his memorable renditions of songs such as "Candy Man" and "Mr. Bojangles."

Philippe Halsman (1906–1979) | Gelatin silver print, 1965
NPG.98.42 | © Halsman Estate | AMS

Ruby Dee born 1924 PLATE 92
Ossie Davis 1917–2005

Ruby Dee and Ossie Davis first met while performing in the play *Jeb* in 1946. Although the play flopped, their relationship thrived. Following their marriage in 1948, Dee and Davis gradually built up a reputation in movies, theater, and television as one of American entertainment's most distinguished couples. While experiencing many successes separately, some

of their greatest moments were shared, including their stage performances in *Raisin in the Sun* and *Purlie Victorious,* which Davis also wrote and later turned into a hit musical. The long list of their achievements also included the hit movie *Cotton Comes to Harlem,* which Davis both wrote and directed, and their performances in Spike Lee's film *Do the Right Thing.* In 1989, Dee and Davis became inductees into the NAACP's Image Awards Hall of Fame, and in 2004 they received the Kennedy Center Honors award.

Anthony Barboza (born 1944) | Gelatin silver print, 1977
NPG.2005.127 | © Anthony Barboza | FSV

Father Divine c. 1877–1965 PLATE 21

James VanDerZee's portrait of Father Divine illustrates the charismatic religious leader amid a background of heavenly clouds. The founder of a communal organization later known as the Peace Mission Movement, Father Divine—born George Baker—regarded himself as the incarnation of God. Although some dismissed this sharecropper's son as a charlatan, he amassed a following that looked to him not only for spiritual guidance but for help in finding employment and housing. His free weekly banquets—open to all—drew large crowds and much publicity. Centered in New York City, where he had settled around 1915, his work was especially appreciated during the Great Depression. Father Divine was also committed to social and racial equality and urged his believers to lead positive lives, free of prejudice and selfishness. In 1942 he relocated to a large estate outside Philadelphia, from which he continued to lead his followers.

James VanDerZee (1886–1983) | Gelatin silver print, 1934
NPG.2000.19 | © Donna Mussenden VanDerZee | FHG

Frederick Douglass 1818–1895 PLATE 1

Born in slavery, Frederick Douglass escaped from bondage in 1838 and soon emerged as one of the nation's most powerful advocates for abolition. When his dignity of bearing and brilliance as an orator led some to question whether he had ever been a slave, Douglass risked recapture as a fugitive by recounting the full details of his biography in his *Narrative of the Life of Frederick Douglass* (1845). After an extensive lecture tour in Britain, where supporters raised the funds to purchase his freedom, Douglass returned to the United States in 1847 and expanded his antislavery activism by launching the *North Star* newspaper. When the nation later descended into civil war, Douglass led the call to enlist black troops in the Union army, and in the years following the conflict, he

continued to campaign vigorously for the rights of African Americans.

Unidentified photographer | Ambrotype, 1856
Purchased with funds from an anonymous donor | NPG.74.75 | AMS

W. E. B. Du Bois 1868–1963 PLATE 11

In 1903 William Edward Burghardt Du Bois famously declared that "the problem of the Twentieth Century is the problem of the color line." He uttered this prophetic statement understanding, perhaps better than anyone, the social and political standing of African Americans at the beginning of the new century. Having received a Ph.D. from Harvard in 1895, Du Bois focused his extraordinary intellectual energies on studying the question of race in America. The author of more than twenty books, he was also an activist and helped to found the National Association for the Advancement of Colored People (NAACP) in 1910. Du Bois came to oppose the policy of political conservatism and racial accommodation favored by Booker T. Washington, insisting that African Americans receive full civil and political rights. His activism extended well beyond the United States and prompted him to move permanently to Ghana in 1961.

Addison N. Scurlock (1883–1964) | Gelatin silver print, c. 1911
NPG.92.1 | FHG

William Edmondson 1874–1951 PLATE 26

Around 1930 William Edmondson experienced a life-changing vision. Declaring that "Jesus has planted the seed of carving in me," the former janitor began transforming discarded blocks of limestone into highly original tombstones, human figures, and "critters" that he believed were divinely inspired. With no formal training, Edmondson achieved remarkable effects, using a railroad spike and a worn hammer to chisel each stone. Religious belief often influenced Edmondson's choice of subjects, but memory, nature, popular culture, and African American traditions also informed his art. Unknown outside of his Nashville neighborhood, Edmondson's sculptures came to the attention of the art world when photographer Louise Dahl-Wolfe recorded images of the artist and his work. Impressed by these photographs, Museum of Modern Art director Alfred Barr arranged a solo exhibition of Edmondson's work in 1937—the first time MoMA had so honored an African American artist.

Louise Dahl-Wolfe (1895–1989) | Gelatin silver print, c. 1933–36
NPG.93.71 | © 1989 Center for Creative Photography,
Arizona Board of Regents | AMS

Duke Ellington 1899–1974 PLATE 48

When Duke Ellington was reaching for the ultimate compliment, his phrase of choice was often "beyond category." No one more deserved that description than Ellington himself, whose pre-eminence in the world of jazz is unassailable. As a bandleader, he produced sounds that all admired but none could replicate, and as a composer, he authored what has justly been described as "the single most impressive body of composition in American jazz." Among his more than two thousand original pieces are such classics as "Sophisticated Lady," "Satin Doll," and "Mood Indigo," along with more extended and serious works such as *Liberian Suite* and *Harlem*. The holder of many honors, Ellington received the Presidential Medal of Freedom in 1969; by the time of his death in 1974, many regarded him as America's most important composer.

William P. Gottlieb (born 1917) | Gelatin silver print, c. 1946 (printed 1991) | NPG.92.58 | © William P. Gottlieb, from the Library of Congress collection | FSV

Ella Fitzgerald 1917–1996 PLATE 59

Ella Fitzgerald entered a Harlem talent contest in the mid-1930s, intending to do a dance. On stage, however, her legs froze, and in desperation she launched into song. Her fallback alternative proved good enough to win the contest, and so began a singing career that would make Fitzgerald the "First Lady of Song." Blessed with a voice capable of seamlessly spanning three octaves, Fitzgerald soon perfected her remarkable gifts for vocal improvisation, known as "scat" singing. Her "songbook" recordings of American standards, made from 1956 to 1964, are the definitive tributes to Cole Porter, Duke Ellington, and others. Fitzgerald's respectful understanding of a composer's intentions made these songwriters some of her most ardent fans. "I never knew how good our songs were," lyricist Ira Gershwin once said, "until I heard Ella Fitzgerald sing them."

Lisette Model (1901–1983) | Gelatin silver print, c. 1954 NPG.88.62 | © The Lisette Model Foundation, Inc. 1983. Used by permission | FSV

Henry Highland Garnet 1815–1882 PLATE 8

Clergyman Henry Highland Garnet was well acquainted with the evils of America's "peculiar institution." Born in slavery in Maryland, he escaped from bondage in 1824 and later served as a conductor on the Underground Railroad in Troy, New York. Like many abolitionists, Garnet first hoped that moral persuasion could turn public opinion against slavery, but in 1840 he abandoned this approach in favor of political action. His

stance became still more militant in 1843, when he delivered an impassioned speech at the National Convention of Colored Citizens in Buffalo, New York. In his "Address to the Slaves of the United States of America," Garnet exhorted those in bondage to rise in insurrection against their enslavers. "Strike for your lives and liberties," he proclaimed. "Rather die freemen than live to be slaves. . . . Let your motto be resistance! *Resistance!* RESISTANCE!"

James U. Stead (active c. 1877–?) | Albumen silver print, c. 1881 NPG.89.189 | AMS

Gordon lifedates unknown PLATE 3

In the spring of 1863, a slave known only as Gordon escaped from a Louisiana plantation and, after a harrowing ten-day journey, found security among Union troops stationed at Baton Rouge. Before enlisting in a black regiment, he was examined by military doctors who discovered horrific scarring on his back, the result of a brutal whipping by his former overseer. Two local photographers created this image to document the harsh treatment Gordon had received. A searing indictment of slavery, Gordon's portrait became one of the most powerful images in the abolitionist cause. As a New York journalist wrote, "This Card Photograph should be multiplied by 100,000 and scattered over the States. It tells the story in a way that even Mrs. [Harriet Beecher] Stowe can not approach, because it tells the story to the eye." Gordon fought in several battles, yet nothing is known about his subsequent life.

Mathew Brady Studio (active 1844–94), after William D. McPherson and Mr. Oliver | Albumen silver print, 1863 | NPG.2002.89 | FHG

Lionel Hampton 1908–2002 PLATE 35

Lionel Hampton began his musical career in Les Hite's band as a drummer, but that changed in the early 1930s, when he tried playing a vibraphone during an idle moment at a recording session. The vibraphone was soon his instrument of choice, and over the next several years, his skill on it earned it a significant place in the jazz idiom. In 1940, after playing for four years with the Benny Goodman Quartet, Hampton formed his own band. Claiming a roster of musicians that included such jazz notables as Quincy Jones and Charlie Mingus, the group became one of America's most highly regarded big bands. Hampton's most endearing trait was his high-energy spontaneity that sometimes raised audience enthusiasm to fever pitch. "We got no routine," he once said, "we just act the way the spirit moves us."

André Da Miano (lifedates unknown) | Gelatin silver print, 1937 NPG.99.149 | FSV

W. C. Handy 1873–1958 PLATE **37**

With their African American origins reaching back to the days of slavery, the blues had been around for a long time when W. C. Handy began using them as the basis for his own musical compositions in the early 1900s. But Handy gave the blues a twist that substantially broadened their appeal, and the publication in 1914 of his "St. Louis Blues" marked a watershed in the transformation of blues into one of American music's most important strands. A musician and music publisher as well as a composer, Handy continued to broaden popular appreciation for African American music traditions, and by the 1920s he was widely known as the Father of the Blues. Among the many testimonials paid to him on his sixty-fifth birthday in 1938 was a Hollywood concert featuring fifteen renditions of "St. Louis Blues" by fifteen different bands.

Prentice H. Polk (1898–1985) | Gelatin silver print, 1942
NPG.83.196 | © Polk Estate | FSV

Lorraine Hansberry 1930–1965 PLATE **73**

Lorraine Hansberry never finished several early attempts at playwriting. In 1956, however, she began work on a drama about a black family's attempt to buy a house in a "white" neighborhood that did not want them. This time, fired by memories of how a similar experience had scarred her own family, she completed the play. Titled *A Raisin in the Sun,* it opened on Broadway to glowing reviews in March 1959. The following month, Hansberry became the first African American playwright to win the coveted New York Drama Critics' Circle award. A longtime civil rights activist, Hansberry soon emerged as an outspoken supporter of the movement's increasing militance. Declaring that African Americans had "a great deal to be angry about," she warned that chaos could result if the federal government failed to move decisively to combat racial injustice.

David Moses Attie (1920–1983) | Gelatin silver print, c. 1960
NPG.93.92 | © David Attie | FSV

Richard B. Harrison 1864–1935 PLATE **18**

From childhood on, Richard B. Harrison wanted to be an actor. But after completing several years of study at a drama school, he found that opportunities for black actors in American theater were almost nonexistent, and for most of his career he alternated between giving lectures and readings and teaching elocution and drama. Harrison finally got his theatrical break in 1929, when he was offered the role of God in *Green Pastures,* a production with an all-black cast that was based on Old Testament stories. Opening on Broadway in 1930, the play proved an

enormous hit, and one of its greatest strengths was Harrison's elegantly tempered interpretation of God. His performance, declared one critic, deserved a "place among the classics." In the wake of this stage triumph came many honors, including the NAACP's Spingarn Medal for distinguished achievement.

Doris Ulmann (1882–1934) | Gelatin silver print, c. 1932
NPG.79.113 | © Knight Library Special Collections,
University of Oregon | FSV

Coleman Hawkins 1904–1969 PLATE **34**

Coleman Hawkins transformed the tenor saxophone into one of the signature instruments in jazz. Once regarded as a comic instrument, the saxophone became, in Hawkins's hands, the centerpiece for explorations in this musical tradition. Hawkins first began playing the saxophone at age nine. He moved to New York City in 1923, where he found work with the Fletcher Henderson group. Influenced by trumpeter Louis Armstrong, he pioneered a form of improvisation based on chords rather than melody. By the time he recorded his famous "Body and Soul" in 1939, Hawkins was recognized as the premier saxophonist in jazz and a hero to a new generation of musicians. An international celebrity, he traveled widely in North America and Europe and continued to experiment with his instrument's creative possibilities until his death.

Ronny Jaques (born 1910) | Gelatin silver print, c. 1942
Gift of Dan Okrent | NPG.2002.101 | © Ronny Jaques | FHG

Roland Hayes 1887–1976 PLATE **20**

Tenor Roland Hayes was the first African American singer to earn an international reputation on the concert stage. Hayes studied at Fisk University and later trained in Boston, where he marked his professional debut in 1917 with a recital of operatic arias, continental art songs, and African American spirituals. After touring with some success at home, Hayes traveled to Europe in 1921 for a series of concert engagements that earned him glowing notices and marked a turning point in his career. Back in the United States, he was greeted with great enthusiasm by American concert audiences, who responded to the poignancy and emotional power of his singing. Mindful of his role in breaking barriers that had prevented black Americans from pursuing concert careers, Hayes observed, "I live to encourage my race and see them rise from the bondage of centuries."

Attributed to Johan Hagemeyer (1884–1962)
Gelatin silver print, 1934 | NPG.84.17 | AMS

Jimi Hendrix 1942–1970 PLATE 79

Jimi Hendrix transformed the creative possibilities of the electric guitar during a short-lived yet influential music career. His use of sound distortion and ear-splitting amplification—together with outrageous showmanship—set him apart from most guitarists of the 1960s. Having taught himself to play by listening to the records of blues guitarists he admired, he formed his first band, the Jimi Hendrix Experience, in London in 1966. Returning to the States a year later, he became an overnight sensation with his debut album, *Are You Experienced*. On stage, Hendrix displayed extraordinary energy and a frank sexuality that both attracted and unsettled audiences. Yet it was his unconventional rendition of "The Star-Spangled Banner" at the close of the now-legendary Woodstock Festival in 1969 for which he is best remembered today. Hendrix died of a drug overdose a year later, at age twenty-seven.

Linda McCartney (1942–1998) | Platinum print, 1967 (printed 1995) Gift of the photographer | NPG.96.26 © Estate of Linda McCartney | FHG

Earl "Fatha" Hines 1905–1983 PLATE 42

Earl Hines was given the nickname "Fatha" by a Chicago disc jockey in part because of his genial, fatherly personality, but also in tribute to Hines as the progenitor of modern jazz piano. Playing hornlike lines with one hand and chords with the other, Hines elevated the role of the piano as a solo instrument and, in the process, became the most influential jazz pianist of his generation. A church organist as a child, he resettled in 1924 in Chicago, where his playing partners included trumpeter Louis Armstrong. Shortly thereafter he formed his own big band, which performed regularly at the Grand Terrace Ballroom and toured throughout North America and later Europe and the Soviet Union. During the 1940s, when bebop was transforming jazz with its fast tempos and improvisation, Hines's band continued to grow, nurturing new talent that included trumpeter Dizzy Gillespie and saxophonist Charlie Parker.

Ronny Jaques (born 1910) | Gelatin silver print, c. 1942 NPG.2002.102 | © Ronny Jaques | FHG

Felrath Hines 1913–1993 PLATE 51

A painter whose artistic journey took him from youthful experimentations with cubism and abstract expressionism to the cerebral, geometric compositions of his mature period, Felrath Hines strove to create works that offered "visual as well as spiritual pleasure." Trained at the School of the Art Institute of Chicago, Hines moved to New York in 1946, where

he joined an activist circle of African American writers, artists, and performers that included James Baldwin, Harry Belafonte, and Billy Strayhorn. Achieving moderate success in one-person exhibitions and group shows throughout the 1950s and 1960s, Hines embarked on a second career in fine art conservation in 1962, and later served as chief conservator at the Smithsonian's National Portrait Gallery and the Hirshhorn Museum. Hines never abandoned painting, however, and experienced his most productive period of art-making during the final decade of his life.

N. Jay Jaffee (1921–1998) | Toned selenium print, 1948 Gift of N. Jay Jaffee and Paula Walter Hackeling S/NPG.94.51 | © 2007 N. Jay Jaffee Trust | AMS

Gregory Hines 1946–2003 PLATE 97

The greatest tap dancer of his day, Gregory Hines revitalized this creative tradition and inspired a new generation of performers. Hines's dancing career began when he was a child, performing with his brother and his father in an act billed as Hines, Hines, and Dad. As he later recalled, "I don't remember not dancing. When I realized I was alive . . . and I could walk and talk, I could dance." Beginning in the late 1970s, Hines emerged as a Broadway star, headlining such shows as *Eubie, Sophisticated Ladies,* and *Jelly's Last Jam,* for which he received the 1992 Tony Award for Best Actor. He also enjoyed a successful movie career, starring in *The Cotton Club* and alongside Mikhail Baryshnikov in *White Nights*. Robert Mapplethorpe's portrait shows the thirty-nine-year-old performer showing off his defining moves.

Robert Mapplethorpe (1946–1989) | Gelatin silver print, 1985 NPG.2004.29 | © 1985 The Robert Mapplethorpe Foundation, Inc. | FHG

Billie Holiday 1915–1959 PLATE 67

Renowned for making songs her own, Billie Holiday once explained, "I hate straight singing. I have to change a tune to my own way of doing it. That's all I know." This attitude characterized not only her singing style but her life as well. Having endured a difficult childhood, Holiday moved to New York City in 1927. Intent on fashioning a musical career, she began performing to supplement her meager income as a housemaid. Success onstage led to recording opportunities and, beginning in 1937, a close working relationship with Count Basie's band. Holiday later joined the Artie Shaw Orchestra, becoming one of the first African American singers to headline an all-white band. Despite the stardom she achieved, Holiday

suffered various personal crises during the last two decades of her life, several of which were the result of drug and alcohol abuse.

Sid Grossman (1913–1955) | Gelatin silver print, c. 1948

NPG.87.44 | National Portrait Gallery, Smithsonian Institution

© Miriam Grossman Cohen, courtesy Howard Greenberg Gallery | FHG

Lena Horne born 1917 PLATE 64

Combining talent, beauty, and steely determination, singer and actress Lena Horne challenged racial barriers to emerge as one of the most popular entertainers of her generation. Following her debut as a dancer at Harlem's Cotton Club, Horne found work as a big-band vocalist. Her subsequent success as a nightclub singer led to a Hollywood audition, and she became the first African American to secure a long-term contract when she signed with Metro-Goldwyn-Mayer in 1942. After starring in the all-black musicals *Cabin in the Sky* and *Stormy Weather,* Horne found her screen opportunities limited when she refused to accept stereotypical roles. Blacklisted during the McCarthy era, she succeeded in rebuilding her career and went on to take an active part in the civil rights movement. Horne's crowning achievement came in 1981, when her critically acclaimed one-woman show earned a special Tony Award.

Philippe Halsman (1906–1979) | Gelatin silver print, 1954

NPG.98.43 | © Halsman Estate | AMS

Langston Hughes 1902–1967 PLATE 24

Poet, novelist, playwright, and songwriter Langston Hughes was one of the most prolific and versatile writers in the history of African American letters. With the publication in 1926 of his first volume of verse, *The Weary Blues and Other Poems,* he emerged as a figure of national prominence. Although at times faulted for his use of dialect and for dwelling on the negative aspects of his race's experience in America—a Chicago critic once labeled him the "poet 'low-rate' of Harlem"—Hughes created moving works that transcended the unpleasant realities he portrayed. Born into humble circumstances, he identified with "low-down folks" and praised them for maintaining "their individuality in the face of American standardizations." Yet his work also showed the influence of literary modernism, a tradition to which he contributed. This portrait was created in California on the occasion of a reading at the artists' colony in Carmel.

Edward Weston (1886–1958) | Gelatin silver print, 1932

NPG.77.264 | © 1981 Center for Creative Photography,

Arizona Board of Regents | FHG

"Mississippi" John Hurt 1893–1966 PLATE 68

Charmian Reading's portrait of "Mississippi" John Hurt pictures the celebrated blues guitarist performing in 1966, in conjunction with the March Against Fear, a 220-mile march from Memphis to Jackson, Mississippi, to champion civil rights reform. Hurt spent most of his life in a small town not far from the marchers' route, and, when he learned of their presence, he came out to lend his support. Prior to appearing at the Newport Folk Festival in 1963, an event that led to widespread acclaim, Hurt lived in relative obscurity in Mississippi, playing occasionally for local audiences. Although he had recorded a selection of songs back in 1928, he worked principally as a farmer and a laborer, supporting his wife and fourteen children. His "rediscovery" in the 1960s led to new opportunities to record and to perform, and prompted a nationwide blues revival.

Charmian Reading (born 1930) | Gelatin silver print, 1966

(printed later) | NPG.2004.52 | © 1966 Charmian Reading | FHG

Mahalia Jackson 1911–1972 PLATE 74

Singer Mahalia Jackson created a worldwide audience for gospel music with her soul-stirring performances and immensely popular recordings. Although influenced in her youth by blues legend Bessie Smith, Jackson was unwavering in her commitment to gospel, and excluded blues and jazz from her repertoire. Church choirs served as the first showcase for her talent, but her majestic voice soon marked her for a solo career. Touring widely throughout the 1930s, Jackson thrilled audiences as she performed gospel favorites in storefront churches, tent shows, and revival meetings. Her breakthrough came in 1947, when her recording of "Move On Up a Little Higher" sold more than one million copies, confirming her as the "Gospel Queen." A fervent voice for civil rights, Jackson performed numerous benefit concerts in support of the movement and was a favorite of Martin Luther King Jr.

Carl Van Vechten | 1962 (printed 1983) | NPG.83.188.25

National Portrait Gallery, Smithsonian Institution | © Carl Van Vechten

Trust Gravure and Compilation © Eakins Press Foundation | AMS

Judith Jamison born 1944 PLATE 88

This 1976 portrait shows thirty-two-year-old dancer Judith Jamison performing her signature role in *Cry.* The ballet—described as "a hymn to the sufferings and triumphant endurance of generations of black matriarchs"—made Jamison an international celebrity in the world of dance. It also marked a crowning moment in her partnership with Alvin Ailey, who

had first recruited her to his dance company in 1965. About their collaboration, the *New York Times* dance critic raved, "Rarely have a choreographer and a dancer been in such accord." Jamison served as the principal dancer in the Alvin Ailey American Dance Theater until 1980, when she left to perform with Gregory Hines in the Broadway musical *Sophisticated Ladies.* In 1989, just prior to Ailey's untimely death, Jamison was appointed the artistic director of his company, a position she holds to this day.

Max Waldman (1919–1981) | Gelatin silver print, 1976

Gift of Carol Greunke, Max Waldman Archives

NPG.2002.395 | © 1976 Max Waldman | FHG

Jack Johnson 1878–1946 PLATE 12

Jack Johnson became the first African American to earn boxing's heavyweight title when he defeated reigning champion Tommy Burns of Canada in 1908. Johnson's victory made him a hero to the black community but sparked outrage among many whites, who found it impossible to accept a black man as the heavyweight champ. Boxing promoters scrambled to find a "white hope" capable of wresting the crown from Johnson, but he continued his dominance by besting all of his challengers. Outside of the ring, however, Johnson's personal conduct and run-ins with the law severely damaged his reputation, and in 1913 he left the country following his conviction for violation of the Mann Act. After twice defending his title in Europe, Johnson surrendered his crown in Havana in 1915 when white boxer Jess Willard won by a knockout in the twenty-sixth round of their title bout.

Paul Thompson (lifedates unknown) | Gelatin silver print, c. 1910

NPG.97.100 | AMS

James Weldon Johnson 1871–1938 PLATE 13

James Weldon Johnson's influence extended into many spheres of early-twentieth-century African American life. He first achieved acclaim as a lyricist, composing with his brother "Lift Every Voice and Sing," a work that later became known as the Negro National Anthem. As a poet, journalist, and editor, Johnson contributed to and encouraged the growth of the "New Negro" movement, a renaissance in African American cultural expression. His novel *The Autobiography of an Ex-Colored Man* explored the phenomenon of "passing" with a remarkable degree of insight and poignancy. Johnson's contributions were not limited to the literary arena, however. He served as a United States diplomat, first in Venezuela and later in Nicaragua, and in 1917 joined the staff of the NAACP. By 1920 he served as

that organization's chief executive and helped make the NAACP a national leader in civil rights activism.

Doris Ulmann (1882–1934) | Gelatin silver print, c. 1925

NPG.79.114 | © University of Oregon Library

Special Collections and AAA/VRC | FHG

Marion Jones born 1975 PLATE 100

At the 2000 Summer Olympics in Sydney, Australia, Marion Jones became the first female track-and-field athlete to win five medals at a single Olympics. Capturing gold in the 100 and 200 meters, she fulfilled her goal of becoming the world's fastest woman. Jones grew up in Southern California, where she was attracted to other sports and activities besides track, most especially basketball. While in high school, she declined an invitation to join the U.S. 1992 Olympic relay team and opted in 1994 to enroll at the University of North Carolina at Chapel Hill, where she helped the women's basketball team win a national championship in her freshman year. Although Jones failed to medal at the 2004 Olympics and has been accused of using performance-enhancing drugs, she has vowed to make a comeback at the 2008 games.

Rick Chapman (born 1966) | Gelatin silver print, 2001

(printed 2002) | NPG.2003.13 | Gift of Rick Chapman and ESPN

© 2001 Rick Chapman | FHG

Ernest Everett Just 1883–1941 PLATE 16

Arguably the most brilliant African American scientist of his generation, Ernest Everett Just graduated magna cum laude from Dartmouth College in 1907 and earned his doctorate in zoology from the University of Chicago in 1916. After joining the faculty at Howard University, Just played a substantial role in upgrading the quality of training offered at its medical school. His greatest distinction, however, was attained as a marine researcher; his studies in cellular physiology and experimental embryology—conducted principally at the Marine Biological Laboratory in Woods Hole, Massachusetts—yielded a host of groundbreaking discoveries and theories. Because of entrenched racial prejudice, Just was never able to fully join the American scientific community, despite the obvious significance of his research. But European scientists welcomed him; supported by funding from various foundations, he spent much of his later career conducting research abroad.

Unidentified photographer | Gelatin silver print, c. 1920

NPG.96.89 | AMS

Martin Luther King Jr. 1929–1968 PLATE 66

with Coretta Scott King and Yolanda Denise King

Under the inspired leadership of Martin Luther King Jr., nonviolent protest became the defining feature of the civil rights movement. A brilliant strategist, King first demonstrated the efficacy of passive resistance in 1955, when he led the prolonged bus boycott in Montgomery, Alabama, that resulted in the dismantling of bus segregation laws. Fresh from a victory that had brought him national recognition, the charismatic young clergyman helped found the Southern Christian Leadership Conference and took the lead in directing its civil rights initiatives. In a carefully orchestrated campaign of peaceful protest to expose and defeat racial injustice, King awakened the nation's conscience and galvanized support for the landmark civil rights legislation of the 1960s. King's words were as powerful as his deeds, and the moving and eloquent addresses that gave hope to millions continue to inspire people throughout the world.

Dan Weiner (1919–1959) | Gelatin silver print, 1956 | NPG.94.253
© Sandra Weiner | AMS

Martin Luther King Jr. 1929–1968 PLATE 84

On April 4, 1968, Dr. Martin Luther King Jr. was killed by an assassin's bullet in Memphis, Tennessee, where he had gone to organize a march in support of that city's striking sanitation workers. The murder that deprived the nation and the world of an unparalleled champion for civil rights also deprived King's four children of a beloved father. When King lay in state in Atlanta at Sisters Chapel, Spelman College, thousands of mourners paid their respects as they passed his open casket. Photographer Benedict Fernandez was there to record the moment when five-year-old Bernice King, flanked by her older sister Yolanda and brother Martin Luther King III, first caught sight of her father's body. Bernice's shocked expression serves as a reminder that while King's death was a loss for the world, it was a deeply personal tragedy for his young family.

Benedict J. Fernandez (born 1935) | Gelatin silver print, 1968
(printed 1989) | Gift of Eastman Kodak Professional Photography
Division, the Engl Trust, and Benedict J. Fernandez
S/NPG.91.47.11 | © Benedict J. Fernandez | AMS

Eartha Kitt born 1927 PLATE 57

With a voice like a sultry purr, entertainer Eartha Kitt has claimed countless fans, including Orson Welles, who called her "the most exciting woman in the world." Kitt debuted as a featured dancer and vocalist with Katherine Dunham's dance

troupe in 1945, before embarking on an international career as a cabaret singer and actress. Her singing style and provocative stage persona made her a top nightclub attraction, and her early 1950s recordings of "C'est Si Bon" and "Santa Baby" remain popular standards. Kitt's career has included performances on Broadway, in films, and on television, where she scored a hit as the villainous Catwoman on *Batman* (1967). She is also remembered for voicing her opposition to the Vietnam War during a 1968 White House luncheon hosted by Lady Bird Johnson—a move that caused Kitt to be blacklisted professionally for some time.

Philippe Halsman (1906–1979) | Gelatin silver print, 1954
Gift of George R. Rinhart | T/NPG.83.100 | © Halsman Estate | AMS

Jacob Lawrence 1917–2000 PLATE 72

Jacob Lawrence achieved a level of recognition during his lifetime previously unparalleled by an African American artist. This critical attention began early in his career. In 1941, at age twenty-four, he exhibited a series of sixty paintings, *The Migration of the Negro,* at the prestigious Downtown Gallery in New York. Visually chronicling the historic movement of African Americans from the South to the North between the two world wars, these paintings attracted wide notice and helped solidify Lawrence's reputation for creating multi-picture narratives about individuals and episodes in African American history. Other noteworthy series from this period highlighted such figures as Frederick Douglass, Harriet Tubman, and John Brown. To the end of his career, Lawrence remained committed to an aesthetic of bold colors and flat forms and to a subject matter that was sensitive to the varied experiences of African Americans.

Arnold Newman (1918–2006) | Gelatin silver print, 1959
(printed later) | Gift of Arnold Newman
NPG.91.89.73 | © Arnold Newman | FHG

Huddie Ledbetter 1888–1949 PLATE 46

Playing his signature twelve-string guitar, Huddie Ledbetter was instrumental in introducing African American traditional music to national audiences. Known popularly as Lead Belly, a nickname given to him by a prison chaplain, he amassed a vast song repertory that ranged from the blues to early jazz and ragtime. Ironically, although a series of arrests in Louisiana and Texas almost cut short his career, prison gave Ledbetter the break that transformed his life. In 1933, Ledbetter met folklorist John Lomax, who was traveling through the South recording folk songs from inmates—among others—for a music

archive at the Library of Congress. Lomax helped to secure his parole and then accompanied him to New York. There, Ledbetter became a star, performing and recording for large audiences, many of whom had never encountered such music before.

Sid Grossman (1913–1955) | **Gelatin silver print, c. 1946–48**
NPG.94.19 | © **Miriam Grossman Cohen, courtesy Howard Greenberg**
Gallery, New York City | **FHG**

Edmonia Lewis 1844–after 1909 PLATE 4

Edmonia Lewis achieved international recognition as a sculptor during the second half of the nineteenth century. Educated at Oberlin College, she settled first in Boston, where she created portrait busts and medallions of prominent politicians, writers, and abolitionists. In 1865 she relocated to Rome and joined an active community of American and British artists living abroad. Adopting a neoclassical style then widely popular, she found inspiration in stories from the Bible and classical mythology, as well as from African American history. Her sculpture *Forever Free* (1867) depicts an African American couple as they first hear news of the Emancipation Proclamation. The work led one critic to exclaim, "No one, not born subject to the 'Cotton King,' could look upon this piece of sculpture without profound emotion." Although Lewis enjoyed unprecedented success for several decades, she died in obscurity.

Henry Rocher (born 1824) | **Albumen silver print, c. 1870**
NPG.94.95 | **FHG**

Norman Lewis 1909–1979 PLATE 50

Norman Lewis began his artistic career in the 1930s as a social realist, creating paintings that made visible the plight of the poor and the disenfranchised. But like other abstract expressionists who got their start working for the New Deal's Federal Art Program, Lewis later moved away from so-called "social painting" to explore the creative possibilities of abstraction. During this period, he sought to make art that was "above criticism," in the hope that it would not "be discussed in terms of the fact that I'm black." As he explained in 1946—the same year in which his friend Alex John created this portrait—"the excellence of [the African American artist's] work will be the most effective blow against stereotype and the most irrefutable proof of the artificiality of stereotype in general." Lewis was also a well-regarded teacher at various schools, including New York's Art Students League.

Alex John (lifedates unknown) | **Gelatin silver print, 1946**
NPG.99.159 | **FHG**

Alain Locke 1886–1954 PLATE 43

In the African American cultural movement of the 1920s known as the Harlem Renaissance, no one played a larger role than Alain Locke. A leading member of the Howard University faculty throughout most of his career, Locke believed that black artists and writers must look to their own heritage for their inspiration and material. In *The New Negro,* his anthology of essays, fiction, poetry, and art published in 1925, he conveyed that message with a persuasiveness that made the book a shaping influence of the renaissance and, at the same time, convinced many white critics that African American culture was worthy of more serious consideration. In the mid-1930s Locke became involved in producing the "Bronze Booklets," a series that for many years was a basic tool in the teaching of African American history.

Carl Van Vechten (1880–1964) | **Photogravure, 1941 (printed 1983)**
NPG.83.188.30 | © **Carl Van Vechten Trust** | **FSV**

Joe Louis 1914–1981 PLATE 33

After launching his professional boxing career in 1934, Joe Louis made short work of a string of opponents who fell victim to his punishing knockout punch. On his way to winning the heavyweight title in 1937, the heavily favored Louis was staggered by his 1936 defeat at the hands of German boxer Max Schmeling. When the two fighters met in a historic rematch in 1938, the outcome was dramatically different. Buoyed by a tremendous outpouring of support from blacks and whites alike, the "Brown Bomber" KO'd the myth of Aryan supremacy by taking just 124 seconds to pummel Adolf Hitler's champion and retain the world heavyweight crown. A hero to millions for the rest of his life, Louis successfully defended his title for twelve years to become one of the longest-reigning champions in the history of heavyweight boxing.

Underwood & Underwood (active 1880–c. 1950)
Gelatin silver print, c. 1935 | **NPG.80.326** | **AMS**

John Roy Lynch 1847–1939 PLATE 5

One of the leading African American statesmen during Reconstruction, John Roy Lynch was born in slavery and later sold with his mother and siblings to a planter in Natchez, Mississippi. Liberated when Union forces reached Natchez in 1863, Lynch strove to educate himself, and soon developed a passion for politics and parliamentary law. Advocating Republican Party initiatives for the advancement of Southern blacks, Lynch spoke eloquently in support of the new Mississippi constitution, which extended voting rights to black men. Elected to the state legislature in 1869, he served as speaker of the house during

his second term. In 1873, at the age of twenty-six, Lynch became the first African American to represent Mississippi in the U.S. House of Representatives. A champion for human rights legislation, Lynch helped win passage of the Civil Rights Act of 1875, which he termed "an act of simple justice."

Charles Milton Bell (1848–1893) | Albumen silver print, c. 1883
NPG.89.190 | AMS

Branford Marsalis born 1960 PLATE 98

Two-time Grammy Award winner Branford Marsalis is a leading figure in contemporary jazz. Initially overshadowed by his younger brother, Wynton, he has emerged as one of the great saxophonists of his day. Marsalis studied at the Berklee College of Music and began his professional career playing in Art Blakey's Jazz Messengers. In addition to performing with his own group, he has enjoyed successful collaborations with a number of celebrated individuals and groups, including Miles Davis, Sting, and the Grateful Dead. His musical renown has also led him to host a weekly program for National Public Radio, to produce various film scores, and for three years in the early 1990s to conduct *The Tonight Show* band. More recently, he has established a record company, Marsalis Music, for "artists who want to be musicians, not marketing creations."

Philippe Lévy-Stab (born 1967) | Gelatin silver print, 1996
Gift of Philippe Lévy-Stab | S/NPG.2004.133
© 2005 Philippe Lévy-Stab | FHG

Wynton Marsalis born 1961 PLATE 99

Wynton Marsalis is arguably the most accomplished jazz musician of his generation. Born into a musical family, he studied both jazz and classical music as a child. Since moving to New York in 1979—to attend the Juilliard School of Music—Marsalis has built an international reputation as a jazz trumpeter, winning nine Grammy Awards. In 1997 he became the first jazz musician to be awarded a Pulitzer Prize—for *Blood on the Fields,* an oratorio about the experiences of two free Africans who are captured and sold into slavery. In addition to studying the roots of jazz, he has nurtured collaborations with those working in a variety of musical traditions, including European classical and non-Western. Marsalis now serves as the artistic director of Jazz at Lincoln Center and has emerged as a leading—and often outspoken—voice regarding jazz's past, present, and future.

Philippe Lévy-Stab (born 1967) | Gelatin silver print, 2004
Gift of Philippe Lévy-Stab | NPG.2004.132
© 2005 Philippe Lévy-Stab | FHG

Willie Mays born 1931 PLATE 55

Sportswriters routinely reached for superlatives to describe the play of Willie Mays. An All-Star for twenty consecutive seasons, Mays was a marvel of power, speed, and agility, whether he was patrolling the outfield, swinging a bat, or looking for a chance to steal a base. He signed with the New York Giants in 1950, when he was nineteen, and during more than two decades in the major leagues, he accrued records in hitting and fielding that place him among the best all-around players in baseball history. Twice named as the National League's most valuable player, Mays hit 660 home runs and recorded a career batting average of .302. A natural leader, he provided the spark that carried the Giants to many of their most memorable victories, and in 1961 he became the first African American to captain a major league team.

Loomis Dean (1917–2005) | Gelatin silver print, 1954 | NPG.93.96
© Loomis Dean/Time and Life Pictures/Getty Images | AMS

Claude McKay 1889–1848 PLATE 15

Melding lyric poetic forms with the bitter realities of American racism seemed an unlikely combination. But poet/novelist Claude McKay made it work, and *Harlem Shadows,* his collection of poems published in 1922, is regarded as a major catalyst in unleashing the cultural ferment of the Harlem Renaissance. Of the poems in *Shadows,* the best remembered was "If We Must Die." Inspired by the rash of American race riots in 1919, it ended with the lines "Like men we'll face the murderous cowardly pack,/pressed to the wall, dying, but fighting back!" The universality of appeal in those eloquently defiant words made this poem a call to action, not only for the emerging American civil rights movement but also for such figures as Winston Churchill, who used the lines to rally the Allies during World War II.

Berenice Abbott (1898–1991) | Gelatin silver print, 1926
NPG.82.167 | © Berenice Abbott/Commerce Graphics, Ltd., Inc. | FSV

Toni Morrison born 1931 PLATE 93

On being awarded the Nobel Prize for Literature in 1993, Toni Morrison was honored as an author who "in novels characterized by visionary force and poetic import, gives life to an essential aspect of American reality." Drawing upon both her own life and historical accounts, Morrison has crafted stories and essays that speak broadly about such issues as marginality, exclusion, and belonging. A graduate of Howard University, she taught English before becoming an editor at

Random House in 1965. There, Morrison helped to develop the careers of several African American authors while simultaneously beginning to publish her own writings. Helen Marcus created this portrait to help publicize *Song of Solomon,* which was named as a Book-of-the-Month Club selection, the first such distinction given to an African American author since Richard Wright, for *Native Son,* in 1940. Morrison retired in 2006 after seventeen years on the faculty of Princeton University.

Helen Marcus (birth year unknown) | Gelatin silver print, 1978
Gift of Helen Marcus | NPG.2005.107 | © 1978 Helen Marcus
FHG

Robert P. "Bob" Moses born 1935 PLATE 87

Convinced that political action was the key to black empowerment, civil rights activist Bob Moses played a critical role in the effort to register African American voters in the Deep South in the early 1960s. As field secretary for the newly formed Student Nonviolent Coordinating Committee, Moses initiated SNCC's first black voter drive in Mississippi in 1961 and pioneered programs in which adults received tutoring in registration techniques and voting mechanics. Moses's most ambitious undertaking was the Freedom Summer campaign of 1964—a massive voter registration and education initiative that brought to Mississippi hundreds of volunteers, including white college students, who worked to expand black voter rolls; organize a Freedom Democratic Party to counter the state's whites-only Democratic Party; establish Freedom Schools to teach literacy skills, civics, and black history; and open community centers to provide medical services and legal aid.

Danny Lyon (born 1942) | Gelatin silver print, 1962
T/NPG.94.255 | © Danny Lyon/Edwynn Houk Gallery | AMS

Jessye Norman born 1945 PLATE 91

In the course of her career, singer Jessye Norman carefully husbanded her talents and turned down many a choice opera role in the interest of preserving her voice. But choosiness did not hamper the growth of her reputation. From the moment of her debut in 1969 at Deutsche Oper Berlin in *Tannhäuser,* the virtues of her sumptuous voice were never in doubt, and her early years, spent performing mostly in Europe, were marked by a succession of triumphs. In 1974, one critic proclaimed one of her performances to be "as nearly flawless . . . as one could rightly expect." Norman's first appearance at the Metropolitan in 1983 fulfilled the high expectations. Despite her many years of performing experience, at her opening-night entrance, Norman later confessed, she momentarily "turned to jelly."

Irving Penn (born 1917) | Platinum-palladium print, 1983
(printed 1985) | Gift of Irving Penn | S/NPG.88.70.39
Jessye Norman, New York, 1983, Copyright © 1983 by Condé
Nast Publications Inc. | FSV

Odetta born 1930 PLATE 61

Since the early 1950s, Odetta has been recognized as one of folk music's most compelling interpreters. Introduced to this musical genre just as the folk revival was gaining momentum, she wholeheartedly embraced the ballads, work songs, blues, and spirituals that so vividly evoked the experiences of generations of African Americans. Her powerful voice and distinctive guitar playing soon earned her an enthusiastic following that included performers Pete Seeger and Harry Belafonte, who helped to champion her career. The growth of the civil rights movement coincided with Odetta's rising popularity, and as her political engagement grew, her songs became weapons in the struggle for justice. "As I was singing, I was one of those things that was smoldering," Odetta later recalled. In 1963 she joined the March on Washington and rallied the crowd with her moving rendition of the spiritual "Oh Freedom."

Bob Willoughby (born 1927) | Gelatin silver print, 1954
(printed 1977) | Gift of Mr. and Mrs. Bob Willoughby | T/NPG.97.95
© Bob Willoughby | AMS

Jesse Owens 1913–1980 PLATE 32

With his spectacular performance at the 1936 Summer Olympics in Berlin, track-and-field star Jesse Owens extinguished Adolf Hitler's hopes of turning the games of the XI Olympiad into a showcase for supposed Aryan supremacy. An outstanding athlete in high school and later at Ohio State, Owens easily secured a berth on the U.S. Olympic squad by recording first-place finishes in the 100- and 200-meter sprints and the long jump during team-qualifying trials. When Olympic competition got under way in Berlin in August 1936, Owens quickly established his dominance on the track. His assault on the record books began with a victory in the 100-meter sprint and continued with record-breaking performances in the long jump, 200-meter sprint, and 4-by-100-meter relay. Capturing four gold medals in all, Owens was acknowledged as the undisputed hero of the Berlin games.

Leni Riefenstahl (1902–2003) | Gelatin silver print, 1936
NPG.2000.20 | © Leni Riefenstahl Productions | AMS

Gordon Parks 1912–2006 PLATE 39

To Gordon Parks, the camera was "a weapon against poverty, against racism, against all sorts of social wrongs." The youngest of fifteen children and a high school dropout, Parks was a pioneer in the world of photography and filmmaking. In 1948, he became the first African American photographer to be hired at *Life,* the largest circulation magazine of its day. For more than two decades he created compelling images that addressed the important issues of the moment, including the civil rights movement. During this period, he also photographed celebrities and fashion models for *Vogue* and *Glamour.* Beginning in the late 1960s, Parks added filmmaking to his list of creative pursuits, and his 1971 hit movie *Shaft* is regarded as an important prototype in the "blaxploitation" genre. Arnold Eagle pictures Parks at work on a documentary project for Standard Oil.

Arnold Eagle (1909–1992) | Gelatin silver print, 1945

T/NPG.92.168 | © Estate of Arnold Eagle | FHG

Rosa Parks 1913–2005 PLATE 65

With a courageous act of civil disobedience, Rosa Parks sparked a challenge to segregation that culminated in one of the seminal victories of the modern civil rights movement. On December 1, 1955, while traveling home from work on a public bus in Montgomery, Alabama, the soft-spoken seamstress was arrested and jailed for refusing the driver's demand that she surrender her seat in the "colored" section to a white male passenger. Four days later, when Parks was tried and convicted of violating local segregation laws, Montgomery's African American community launched a massive boycott of the city's bus system. Planned as a one-day protest, the boycott expanded with the support of the Montgomery Improvement Association, led by twenty-six-year-old clergyman Martin Luther King Jr. Continuing for an unprecedented 381 days, the boycott ended only after the United States Supreme Court ruled bus segregation unconstitutional.

Ida Berman (born 1911) | Gelatin silver print, 1955 | NPG.99.57

© Ida Berman, courtesy Steven Kasher Gallery, New York | AMS

Horace Pippin 1888–1946 PLATE 40

Horace Pippin took up painting in part to overcome the trauma he endured while serving in France during World War I. As a member of the all-black 369th Infantry, Pippin fought with valor, but sustained a gunshot wound that rendered useless his right shoulder and arm. Upon returning to the United States, he was unable to perform the manual labor that had supported him

before the war. It was then that he turned to painting. Although his first works concerned the experience of trench warfare, he soon embraced other subjects, including his imaginings of African American life in the South and portraits of historic figures such as Abraham Lincoln and John Brown. By 1937 Pippin had begun to sell his paintings locally. Having caught the attention of several prominent collectors and curators, his work was later featured in various exhibitions and publications.

Arnold Newman (1918–2006) | Gelatin silver print, 1945

NPG.91.89.34 | © Arnold Newman | FHG

Adam Clayton Powell Sr. 1865–1953 PLATE 14

with his Abyssinian Baptist Church Sunday school class

A charismatic preacher with superb organizational skills and a strong commitment to social welfare, Reverend Adam Clayton Powell Sr. not only built flourishing congregations but also ministered to the needs of the greater community. In 1908, following a fruitful fifteen-year pastorship at Immanuel Baptist Church in New Haven, Connecticut, Powell assumed charge of New York City's Abyssinian Baptist Church. Under his dynamic leadership, that church's membership swelled from 1,600 to 14,000, making it the largest Protestant congregation in the United States. In 1923 Powell facilitated the church's relocation from midtown to West 138th Street in Harlem, where it immediately became a vital community center, providing a host of services to those in need. Committed to improving race relations, Powell further expanded his ministry by helping to found the National Urban League and serving as an early leader in the NAACP.

James VanDerZee (1886–1983) | Gelatin silver print, 1925

NPG.94.17 | © Donna Mussenden VanDerZee | AMS

Adam Clayton Powell Jr. 1908–1972 PLATE 81

Stokely Carmichael 1941–1998

George Tames's photograph pictures politician Adam Clayton Powell Jr. (left) and civil rights activist Stokely Carmichael laughing together in a congressional office corridor. Born thirty-three years apart, Powell and Carmichael represented two different generations in the campaign for civil rights. Powell— the son of Reverend Adam Clayton Powell Sr.—was New York City's first black congressman, having been elected to that office in 1944. From this position, Powell became famous for fighting segregation in the military, public education, and organized labor. During the 1960s especially, he helped to develop and pass a number of important civil rights bills. Raised in New York City, Carmichael shared Powell's commitment to civil rights. As

the chairman of the Student Nonviolent Coordinating Committee (SNCC) beginning in 1966, Carmichael conducted his work principally in the streets, rather than in the halls of Congress.

George Tames (1919–1994) | Gelatin silver print, c. 1966
Gift of Frances O. Tames | NPG.94.220
© The New York Times/George Tames | FHG

Leontyne Price born 1927 PLATE 54

With a voice that routinely brought audiences to their feet, soprano Leontyne Price was the first African American opera singer to achieve stardom at home and on the international stage. Following vocal studies at the Juilliard School, Price earned glowing reviews in 1952 for her performance as Bess in a popular revival of George Gershwin's *Porgy and Bess.* She followed this success by starring in NBC's 1955 production of *Tosca,* becoming the first black singer to appear in an opera telecast. Her career steadily gained momentum with acclaimed performances in opera venues from San Francisco to Milan. In 1961, when she made her Metropolitan Opera debut as Leonora in Verdi's *Il Trovatore,* Price received a thunderous, forty-two-minute ovation. For years she remained one of the Met's brightest stars, as well as one of the opera world's most admired performers.

Carl Van Vechten (1880–1964) | Gelatin silver print, 1953
NPG.91.67 | © Carl Van Vechten Trust | AMS

Richard Pryor 1940–2005 PLATE 90

As a comedian, actor, and writer, Richard Pryor became famous for defying the boundaries of taste and decency. Beginning in the late 1960s, his irreverent and often foul-mouthed stand-up performances shocked audiences. Yet it was his desire to probe difficult subjects such as race relations, as much as his raunchy language, that made him so unique. Pryor was a prolific entertainer, appearing in more than thirty feature films and recording more than twenty albums. Although his life was marred by arrests, failed marriages, and drug abuse, he attained a level of popularity and influence unmatched by any comedian of his day. In accepting the first-ever Mark Twain Prize for Humor at the Kennedy Center in 1998, Pryor commented that "I am proud that, like Mark Twain, I have been able to use humor to lessen people's hatred."

Steve Schapiro (born 1934) | Gelatin silver print, 1981
(printed 2006) | NPG.2006.22 | © Steve Schapiro,
courtesy Fahey Klein Gallery | FHG

A. Philip Randolph 1889–1979 PLATE 44

Civil rights activist A. Philip Randolph waged a lifelong battle for the economic empowerment of African Americans. In 1925 he accepted the challenge of organizing the Brotherhood of Sleeping Car Porters—the first black labor union chartered by the American Federation of Labor. Continuing his advocacy for African American workers, Randolph called for a march on Washington in 1941 to protest the exclusion of blacks from defense industry jobs. He canceled that march only after President Franklin Roosevelt signed an order mandating an end to discriminatory practices by government contractors. Following World War II, Randolph led the effort to desegregate the nation's armed forces, and waged a civil disobedience campaign against the draft until President Harry Truman ordered an end to segregation in the military in 1948. Randolph crowned his career in 1963 by organizing the celebrated March on Washington for Jobs and Freedom.

Sy Kattelson (born 1923) | Gelatin silver print, 1948
NPG.87.46 | © Sy Kattelson | AMS

Paul Robeson 1898–1976 PLATE 17

Paul Robeson united great talent with commitment to justice in a career that won him celebrity and respect throughout the world. Educated at Rutgers University—where he was class valedictorian and a two-time football All-American—and Columbia Law School, he sought greater opportunity than the legal profession then offered African Americans. In 1925 Robeson established himself as an actor with his starring role in Eugene O'Neill's *The Emperor Jones* and also earned international acclaim for his concert performances of African American spirituals. For more than three decades, he traveled throughout the United States and Europe appearing on stage, in film, and in concert. Robeson became a committed socialist and worked actively against fascism both before and during World War II. But after 1945, growing conservatism at home clashed with his strong support of left-wing political causes to curtail his American performing career.

Doris Ulmann (1882–1934) | Platinum print, c. 1924 | NPG.78.2
© Knight Library Special Collections, University of Oregon | FHG

Bill "Bojangles" Robinson 1878–1949 PLATE 30

Tap-dancing virtuoso Bill "Bojangles" Robinson began earning nickels and dimes for his street-corner routines and beer-garden performances when he was a child, and he was barely in his teens when he joined the chorus of the touring minstrel extravaganza *The South Before the War.* But it was on the vaudeville

circuit and as a popular nightclub entertainer that he earned his reputation as the "World's Greatest Tap Dancer." Combining superb showmanship with a winning personality, Robinson was a hit with audiences for more than half a century. In addition to appearances on Broadway in the all-black revue *Blackbirds of 1928* and *The Hot Mikado* (1939), Robinson earned lasting fame from his performances in movies such as the *Little Colonel* (1935), in which his signature "stair dance" tap routine with Shirley Temple provided the film's most memorable moment.

George Hurrell (1904–1992) | Gelatin silver print, 1935
NPG.89.193 | © George Hurrell | AMS

Jackie Robinson 1919–1972 PLATE 77

In 1947 Jackie Robinson transformed professional sports by breaking baseball's color barrier to become the first African American player in the major leagues. A trailblazer for equal opportunity, Robinson endured torrents of abuse in his first season with the Brooklyn Dodgers. Some of his own teammates mounted an abortive effort to have him dropped from the roster, while bigoted opponents and spectators alike taunted, heckled, and harassed him. Robinson steeled himself and responded with electrifying play that carried the Dodgers to a National League championship and earned him honors as Rookie of the Year. One of the top draws in baseball during ten memorable seasons with the Dodgers, Robinson paved the way for black major leaguers such as Willie Mays and Hank Aaron. After retiring from the game, he remained a staunch advocate for civil rights while building a successful business career.

Garry Winogrand (1928–1984) | Gelatin silver print, 1961
(printed 1983) | NPG.84.19 | © Garry Winogrand, courtesy of
Fraenkel Gallery | AMS

Sugar Ray Robinson 1921–1989 PLATE 76

Growing up in Harlem, boxer Sugar Ray Robinson gained a reputation for style that was as "sweet as sugar." Along with his brilliant footwork, unrivaled hand speed, and superb defensive skills, he had a genius for grasping his opponent's style and adjusting to it. Robinson turned professional shortly before America's entry into World War II. During that conflict, he and Joe Louis traveled together presenting boxing exhibitions for the troops. Over a twenty-five-year career, Robinson amassed one of the most impressive records in boxing history. Having won the world welterweight championship in 1946, he soon moved up to the middleweight division, and between 1951 and 1958 he captured that title five times. At the height of his

career, Robinson won ninety-one consecutive matches, and in more than two hundred fights he was never physically knocked out. Muhammad Ali later called him "the king, the master, my idol."

Arnold Newman (1918–2006) | Gelatin silver print, 1960
(printed later) | NPG.91.89.22 | © Arnold Newman | FHG

Diana Ross born 1944 PLATE 78

with Mary Wilson and Florence Ballard

Diana Ross achieved international stardom as the lead singer of the Supremes. With songs such as "Where Did Our Love Go" and "Stop! In the Name of Love," the Supremes became the most successful female group in pop music history; during the 1960s, only the Beatles sold more records. Bruce Davidson's photograph pictures Ross in 1965 in Detroit's Motown Records studio between the other two members of the famous singing trio—Mary Wilson (left) and Florence Ballard (right). Described as a "total entertainer," Ross electrified audiences with a voice that could put "swerves into the most unsupple lyrics." In 1970 she left the group to pursue a solo career as a singer and an actress. For her portrayal of singer Billie Holiday in the 1972 film *Lady Sings the Blues,* Ross received a Best Actress Oscar nomination.

Bruce Davidson (born 1933) | Gelatin silver print, 1965
(printed 1996) | T/NPG.96.170 | © Bruce Davidson | FHG

Hazel Scott 1920–1981 PLATE 28

A gifted pianist and singer who moved easily between jazz and the classics, Hazel Scott dazzled audiences with her witty, daring, and sophisticated performances. Her prodigious talent was evident at an early age. Only fifteen when she appeared as a soloist with Count Basie and his orchestra in 1935, Scott made her Broadway debut just three years later. In 1940 her Carnegie Hall performance of a "swing" version of Liszt's Second Hungarian Rhapsody created a sensation, delighting her fans and confounding the critics. From 1939 to 1945 (the year in which she married Congressman Adam Clayton Powell Jr.), Scott not only enjoyed star status as a nightclub performer in New York but also appeared in several films and toured extensively. A staunch proponent of equal rights, she maintained a professional contract enabling her to refuse to perform before racially segregated audiences.

James VanDerZee (1886–1983) | Gelatin silver print, 1936
NPG.94.18 | © Donna Mussenden VanDerZee | AMS

Ntozake Shange born 1948 PLATE 94

Ntozake Shange's poetry, plays, and prose reflect her fierce commitment to empowering women of color by telling their stories, honoring their struggles, and celebrating their strength. Reared in a culturally rich but sheltered environment, Shange was shaken by the racism she encountered in society. The anger and alienation that prompted her to attempt suicide at age nineteen would later be channeled into her most compelling work. In the early 1970s, after renouncing her birth, or "slave," name (Paulette Williams) in favor of an African one meaning "she who comes with her own things/she who walks like a lion," Shange began developing a performance piece rooted in the experiences of contemporary black women. When her groundbreaking "choreopoem," *For Colored Girls Who Have Considered Suicide/When the Rainbow Is Enuf,* reached Broadway in 1976, it was hailed for its powerful and passionate storytelling.

Anthony Barboza (born 1944) | Gelatin silver print, 1977

Gift of Danica, Celefio, and Lien Barboza | S/NPG.2005.128

© Anthony Barboza | AMS

Ada "Bricktop" Smith 1894–1984 PLATE 25

In the 1920s and 1930s the flame-haired entertainer known as "Bricktop" reigned as the cabaret queen of Paris, where her chic nightclub attracted the cream of the café society set. Raised in Chicago, Ada Smith got her start in vaudeville and then worked as a saloon singer in the Windy City until 1922, when she moved on to Harlem. Dubbed "Bricktop" by the owner of one of that district's popular nightspots, she performed in Harlem clubs until 1924, when she seized the opportunity to take her career to Paris. Embraced by that city's cadre of American expatriates, she opened her first Chez Bricktop nightclub in 1926. There, she not only charmed a clientele that included Cole Porter, Scott and Zelda Fitzgerald, and Ernest Hemingway, but helped to nurture the careers of such performers as Mabel Mercer and Josephine Baker.

Carl Van Vechten (1880–1964) | Gelatin silver print, 1934

NPG.90.85 | © Carl Van Vechten Trust | AMS

Bessie Smith 1894–1937 PLATE 31

Legendary blues singer Bessie Smith first made a name for herself performing in tent shows and vaudeville theaters, where audiences warmed to her powerful, earthy contralto. Smith's big break came in 1923, when she signed with Columbia and released her debut recording, "Down Hearted Blues." The phenomenal success of that record and those that followed established Smith as the undisputed "Empress of the Blues." Able

to command as much as $2,000 a week at the height of her fame, Smith played to packed houses and recorded with the top jazz musicians of the day. Although her career suffered a sharp decline with the onset of the Depression and the collapse of the recording industry, Smith continued to perform until an automobile accident claimed her life in 1937. Her musical legacy has influenced countless performers, from Billie Holiday to Janis Joplin.

Carl Van Vechten (1880–1964) | Gelatin silver print, 1936

NPG.91.108 | © 1936, Carl Van Vechten Trust | AMS

Willie "the Lion" Smith 1897–1973 PLATE 75

Seen here smoking his omnipresent cigar and wearing his trademark derby hat and red vest, Willie "the Lion" Smith was fond of describing himself as the greatest pianist in the world. If limited to twentieth-century American jazz, the claim may have had some legitimacy. Along with Fats Waller and James Johnson, Smith pioneered the "stride" style of piano playing that ultimately influenced so many jazz musicians, including Count Basie, Art Tatum, and Thelonius Monk. Moreover, his first solo recordings from the late 1930s are widely regarded as some of the finest examples of stride piano. Among Smith's greatest admirers was Duke Ellington, who in 1939 expressed his high regard for Smith with his piece titled "Portrait of the Lion." In 1957 Smith returned the compliment with "Portrait of the Duke."

Arnold Newman (1918–2006) | Gelatin silver print, 1960

(printed later) | Gift of Arnold Newman | NPG.91.89.77

© Arnold Newman | FSV

Billy Strayhorn 1915–1967 PLATE 49

Composer/pianist Billy Strayhorn never achieved the celebrity that some other jazz musicians enjoyed in their lifetimes. Nevertheless, his composing and arranging collaboration with Duke Ellington over three decades yielded many of the most memorable compositions in the history of jazz. In fact, Ellington and Strayhorn worked so closely that it was often difficult to determine where one began and the other left off. As Ellington once put it, "Billy Strayhorn was my right arm, my left arm, all the eyes in the back of my head." Strayhorn enjoyed the benefit of a solid musical education that included thorough grounding in classical music. Doubtless that training contributed to the remarkably sophisticated character of many of his compositions and the echoes in his own music of such composers as Claude Debussy and Maurice Ravel.

William P. Gottlieb (born 1917) | Gelatin silver print, c. 1945

(printed 1979) | NPG.98.87 | © William P. Gottlieb,

from the Library of Congress collection | FSV

Jean Toomer 1894–1967 PLATE 29

Writer and philosopher Jean Toomer was an influential voice in the African American cultural resurgence known as the Harlem Renaissance. Best known for *Cane* (1923), a collection of modernist poems and vignettes that juxtaposed scenes in the urban North with observations about the rural South, Toomer was sensitive to the role that race played in American society. Yet he tried to look beyond race as a category that defined individuals. The grandson of the first U.S. governor of African American descent, he bristled at being described as a "Negro writer." Having "seen the divisions, the separatisms and the antagonisms," he believed optimistically that "a new man was arising in this country—not European, not African, not Asiatic—but American." Toomer's portrait was taken by his wife, Marjorie Content, a well-respected fine art photographer, at about the time of their marriage in 1934.

Marjorie Content (1895–1984) | Gelatin silver print, c. 1934
NPG.93.15 | © Estate of Marjorie Content | FHG

Sojourner Truth c. 1799–1883 PLATE 2

Abolitionist and women's-rights leader Sojourner Truth worked tirelessly for the poor and disenfranchised in mid-nineteenth-century America. Born into slavery, she changed her name to Sojourner Truth in 1843 to reflect her religious conversion and her commitment to reform. Soon after, she was traveling throughout the nation lecturing about the inhumanity of slavery and the rights of African Americans and women. A tall and imposing figure, she fought especially for the poor, who often had no voice in such debates, as she knew from personal experience, asking famously, "And ain't I a woman?" To heighten awareness of her work and to raise funds to support it, Truth sold copies of her autobiography and photographs of herself. As she proclaimed on the mounts of many of these portraits, "I sell the shadow to support the substance."

Randall Studio (active 1865–75?) | Albumen silver print, c. 1870
NPG.79.220 | FHG

Sarah Vaughan 1924–1990 PLATE 53

Known popularly as the "Divine One" and "Sassy," Sarah Vaughan was regarded as one of the premier female vocalists of her day. She was drawn to music from an early age, and as a youth she studied piano and sang in her church choir. When Vaughan was eighteen, she entered an amateur contest at Harlem's Apollo Theater on a dare and won first prize. This success led to frequent invitations to perform alongside the leading figures in contemporary jazz, including Earl "Fatha" Hines, Dizzy

Gillespie, and Billy Eckstein. Adept at bebop improvisation, Vaughan possessed a wonderfully versatile voice that complemented a larger jazz ensemble. By 1950—the year in which Josef Breitenbach created this portrait—she was selling upwards of three million records annually. A poll in *Down Beat* magazine named her the top female singer for six consecutive years.

Josef Breitenbach (1896–1984) | Gelatin silver print, 1950
NPG.99.160 | © The Joseph Breitenbach Trust, New York | FHG

Jersey Joe Walcott 1914–1994 PLATE 56

with Rocky Marciano

In his quest to capture boxing's heavyweight crown, Jersey Joe Walcott endured setbacks that might have discouraged a less determined fighter. Turning pro at the age of sixteen, Walcott boxed intermittently for seventeen years before getting his first shot at the heavyweight title when he took on defending champion Joe Louis in December 1947. Seemingly headed for victory, Walcott suffered a heartbreaking defeat on a split decision after fifteen rounds, and lost again to Louis in the first round of a rematch the following year. After Louis's retirement, Jersey Joe lost two title bouts to Ezzard Charles, but in their third matchup (1951), the thirty-seven-year-old Walcott finally prevailed to win the heavyweight championship. He retained his hard-earned crown until September 23, 1952, when he was felled by a knockout from Rocky Marciano in one of boxing's greatest contests.

Charles Hoff (1905–1975) | Gelatin silver print, 1952
T/NPG.91.72 | © Charles Hoff/Daily News | AMS

Booker T. Washington 1856–1915 PLATE 10

In the face of racial hatred, segregation, and disenfranchisement, it was unrealistic, Booker T. Washington contended, to expect African Americans to gain entry into America's white-collar professions. Instead, he suggested they establish themselves as a skilled and indispensable laboring class. With that accomplished, he believed, racial discrimination would gradually disappear. In 1881 Washington put this theory to the test, becoming the director of the newly created Tuskegee Institute in Alabama. As the school grew, he became viewed as the nation's leading spokesman for African Americans. A magnetic speaker and the author of ten books, including a moving autobiography, *Up from Slavery* (1901), Washington worked closely with such national leaders as Theodore Roosevelt and Andrew Carnegie. Although well respected, he attracted many critics, including W. E. B. Du Bois, who contended that

his "get along" philosophy undermined the quest for racial equality.

Arthur P. Bedou (1882–1966) | Gelatin silver print, 1915
NPG.78.165 | FHG

Ethel Waters 1896–1977 PLATE 23

"A model for those who would shiver the shackles of prejudice, poverty, and despair," Ethel Waters overcame bleak beginnings to emerge as a versatile singer and actress whose talent propelled her from honky-tonk to Hollywood. Beginning as a blues singer on the black vaudeville circuit while still in her teens, Waters later made her way to Harlem, where she entertained at the Cotton Club and other nightspots. From the mid-1920s to early 1930s she appeared in all-black revues before moving to mainstream musicals with her performance in Irving Berlin's *As Thousands Cheer* (1933). Waters became the first African American actress to play a dramatic lead on Broadway with her role in *Mamba's Daughters* (1939). She ultimately appeared in more than a dozen Broadway productions and nine films, including *Cabin in the Sky* (1943) and *The Member of the Wedding* (1952).

Alfredo Valente (1899–1973) | Gelatin silver print, c. 1939
NPG.90.136 | © The Valente Collection | AMS

"Blind Tom" (Thomas Greene Wiggins) PLATE 9

1849–1908

The musical prodigy known as "Blind Tom" was one of the most celebrated African American concert artists of the nineteenth century. Blind from birth and possibly autistic, Tom was only four when he began performing tunes he had heard played on the piano of his owner, James Bethune. Tom made his professional debut as a pianist in 1857 at the age of eight and was soon earning a fortune for Bethune with engagements throughout the country. When the Civil War began, Tom was returned to Georgia and compelled to play benefit concerts for the Confederate cause. To protect his financial interest in Tom, Bethune obtained legal guardianship of the teenager—a move that effectively prevented Tom from ever securing his freedom. After the war, Tom continued his career, performing a demanding repertoire with skill "so startling as to amaze every listener."

George Kendall Warren (1834–1884) | Albumen silver print, c. 1882
NPG.2000.14 | AMS

Mary Lou Williams 1910–1981 PLATE 41 179

Mary Lou Williams began playing the piano at an early age, and by the time she reached her teens, she was performing on the road. Although many jazz musicians disliked working with female musicians, Williams persevered. As part of the Clouds of Joy Orchestra in the 1930s, she was billed as "The Lady Who Swings the Band," and she supplied arrangements to such top musicians as Louis Armstrong and Earl Hines. An early convert to the bebop revolution of the 1940s, Williams also composed symphonic jazz. She retired briefly from her music career in the 1950s, converting to Catholicism and using profits from her record company to support her work helping troubled musicians. Religious themes inspired much of her later work, including the "Music for Peace" mass, which Alvin Ailey choreographed as "Mary Lou's Mass" in 1971.

Gjon Mili (1904–1984) | Gelatin silver print, 1943 | NPG.95.382
© Gjon Mili/Time and Life Pictures/Getty Images | FSV

Malcolm X 1925–1965 PLATE 83

Gordon Parks's photograph shows Malcolm X on a New York sidewalk selling a special issue of *Muhammad Speaks,* the official newspaper of the black separatist group the Nation of Islam. In covering the civil rights movement for *Life* magazine, Parks found Malcolm X "a spellbinding orator of bitter wit, power, and impressive intellect." Jailed for burglary as a youth, the former Malcolm Little rose to a position of authority in the early 1960s as an outspoken critic of Martin Luther King Jr. and others who were, in his words, "begging for integration." "We've shaken up the white man by asking for separation," he said in 1961. Although he would reject the Nation of Islam in 1964 and would reconcile his differences with King before being assassinated in 1965, Malcolm X was instrumental in making the campaign for civil rights more militant and in planting the seeds for the Black Power movement.

Gordon Parks (1912–2006) | Gelatin silver print, 1963
NPG.98.81 | © Gordon Parks | FHG

AFTERWORD

It is a great honor for the National Portrait Gallery to have its collection of photographs of African Americans featured in the first exhibition presented by the National Museum of African American History and Culture. In truth, it is an honor that would not have happened in the Gallery's earliest days almost four decades ago. It has taken years to build a collection of distinguished images of remarkable African Americans, an effort informed by a growing urgency in the national life to make known stories at the core of our history yet too often untold.

These wonderful photographs, powerful because of the people depicted and powerful too because of the artistry of the photographers, have already been sensitively described elsewhere in this scholarly and quite beautiful catalogue. So it is left for me only to add a few words more, about what a portrait is and how important the form may prove to be in helping our nation seize the opportunity to redress a terrible injustice and also celebrate an epic resistance of the human spirit.

All pictures of human beings are not portraits. Very often in a work of art, we do not think of the person presented as real with his or her own history and temperament but rather as the artist's view of the human condition more broadly considered. However, a work of art defined as a portrait is very specific. It gains its power from making us notice this *particular* life, this *particular* journey. And what community among Americans has been challenged more than African Americans by having their identity as individual human beings submerged in sweeping and often unsympathetic categories? We are all of us participants in categories of human existence, and often gain strength from them. But we also have our particular identity as individuals, and it is that precious individuality that has been seized from invisibility by the amazing people and portraitists that we celebrate here.

When I am asked to describe what the mission of the National Portrait Gallery is, I often leap over the description of its broad mandate to remember significant American lives and say, perhaps too simply, to "cheat death." What I mean by that is that we don't want to "lose" remarkable lives. We want to keep them in the company of their fellow Americans. This we do by collecting their portraits, this we do by displaying these in our galleries. And on this great occasion, this we do by cooperating with our Smithsonian colleagues at the National Museum of African American History and Culture in the creation of this important exhibition. Meet here remarkable people who have challenged assumptions about who they are and what they might become. Meet here people who have given us their talent and inspired us with their determination. Meet here people we must not forget.

MARC PACHTER
DIRECTOR
NATIONAL PORTRAIT GALLERY

INDEX OF PHOTOGRAPHERS

Abbott, Berenice (1898–1991) | Plate 15

Attie, David Moses (1920–1983) | Plate 73

Avery, Sid (1918–2002) | Plate 58

Barboza, Anthony (born 1944) | Plates 86, 92, 94

Bedou, Arthur P. (1882–1966) | Plate 10

Bell, Charles Milton (1848–1893) | Plate 5

Berman, Ida (born 1911) | Plate 65

Breitenbach, Josef (1896–1984) | Plate 53

Broadbent and Phillips (active 1871–1874) | Plate 6

Chapman, Rick (born 1966) | Plate 100

Content, Marjorie (1895–1984) | Plate 29

Da Miano, André (lifedates unknown) | Plate 35

Dahl-Wolfe, Louise (1895–1989) | Plate 26

Davidson, Bruce (born 1933) | Plate 78

Dean, Loomis (1917–2005) | Plate 55

Eagle, Arnold (1909–1992) | Plate 39

Fernandez, Benedict J. (born 1935) | Plate 84

Gottlieb, William P. (born 1917) | Plates 48, 49

Grossman, Sid (1913–1955) | Plates 46, 67

Hagemeyer, Johan (1884–1962) | Plate 20

Halsman, Philippe (1906–1979) | Plates 57, 62, 64, 80

Hoff, Charles (1905–1975) | Plates 52, 56

Hurd, Gustine L. (1833–1910) | Plate 7

Hurrell, George (1904–1992) | Plate 30

Jaffee, N. Jay (1921–1998) | Plate 51

Jaques, Ronny (born 1910) | Plates 34, 42

John, Alex (lifedates unknown) | Plate 50

Kattelson, Sy (born 1923) | Plate 44

Leipzig, Arthur (born 1918) | Plate 38

Levit, Herschel (1912–1986) | Plate 89

Lévy-Stab, Philippe (born 1967) | Plates 98, 99

Lyon, Danny (born 1942) | Plate 87

Mapplethorpe, Robert (1946–1989) | Plate 97

Marcus, Helen (birth year unknown) | Plate 93

Mathew Brady Studio (active 1844–1894) | Plate 3

McCartney, Linda (1942–1998) | Plate 79

Mili, Gjon (1904–1984) | Plates 36, 41

Model, Lisette (1901–1983) | Plates 59, 60

Mones, Arthur (1919–1998) | Plate 95

Newman, Arnold (1918–2006) | Plates 40, 72, 75, 76

Orkin, Ruth (1921–1985) | Plate 45

Parks, Gordon (1912–2006) | Plates 70, 82, 83

Penn, Irving (born 1917) | Plate 91

Polk, Prentice H. (1898–1985) | Plate 22, 37

Randall Studio (active 1865–1875?) | Plate 2

Reading, Charmian (born 1930) | Plate 68

Riefenstahl, Leni (1902–2003) | Plate 32

Rocher, Henry (born 1824) | Plate 4

Salas, Osvaldo (1914–1993) | Plate 69

Salou, Michel (active mid-twentieth century) | Plate 71

Schapiro, Steve (born 1934) | Plate 90

Scurlock, Addison N. (1883–1964) | Plate 11

Shames, Stephen (born 1947) | Plate 85

Stead, James U. (active c. 1877–?) | Plate 8

Tames, George (1919–1994) | Plate 81

Thompson, Paul (lifedates unknown) | Plate 12

Ulmann, Doris (1882–1934) | Plates 13, 17, 18

Underwood & Underwood (active 1880–c. 1950) | Plate 33

Unidentified Artists | Plates 1, 16

Valente, Alfredo (1899–1973) | Plate 23

Van Vechten, Carl (1880–1964) | Plates 25, 27, 31, 43, 54, 63, 74

VanDerZee, James (1886–1983) | Plates 14, 21, 28

Waldman, Max (1919–1981) | Plate 88

Walery, Stanislaus J. (1863–1935) | Plate 19

Warren, George Kendall (1834–1884) | Plate 9

Weiner, Dan (1919–1959) | Plate 66

Weston, Edward (1886–1958) | Plate 24

Williams, Milton (born 1940) | Plate 96

Willoughby, Bob (born 1927) | Plate 61

Winogrand, Garry (1928–1984) | Plate 77

Yampolsky, Mariana (1925–2002) | Plate 47

The exhibition, national tour, and catalogue were made possible by a generous grant
from our lead sponsor, MetLife Foundation. Additional support was provided by
the Council of the National Museum of African American History and Culture.

© 2007 Smithsonian Institution. All rights reserved. No part of this publication may be reproduced or transmitted in any form or by any means, electronic or mechanical, including photocopying, recording, or information storage or retrieval system, without permission in writing from the publishers.

Library of Congress Cataloging-in-Publication Data
Willis, Deborah, 1948–
 Let your motto be resistance: African American portraits/ Deborah Willis; introduction, Lonnie G. Bunch III; afterword, Marc Pachter; essays, Cheryl Finley, Sarah Elizabeth Lewis; poems, Elizabeth Alexander; biographies, Frank H. Goodyear III, Ann M. Shumard, Frederick S. Voss; commentaries, Kirsten P. Buick . . . [et al.].
 p. cm.
 "Inaugural exhibition of the National Museum of African American History and Culture in collaboration with the National Portrait Gallery and the International Center of Photography."
 ISBN 978-1-58834-242-3 (hardcover: alk. paper)
 ISBN 978-1-58834-246-1 (softcover: alk. paper)
 1. African Americans—Portraits—Exhibitions. 2. Portrait photography—United States—Exhibitions. 3. African Americans—Biography—Exhibitions. I. National Museum of African American History and Culture (U.S.). II. National Portrait Gallery (Smithsonian Institution). III. International Center of Photography. IV. Title.
E185.96.W574 2007
973'.049607300922—dc22 2007010092

Published by the National Museum of African American History and Culture, Smithsonian Institution
 http://www.nmaahc.si.edu
Distributed by HarperCollins Publishers

Project Director and Editor: Jacquelyn D. Serwer
Editors: Dru Dowdy, Carla Borden, Michèle Gates Moresi
Designer: Jeff Wincapaw
Proofreader: Sherri Schultz
Typesetter: Maggie Lee
Color separations by iocolor, Seattle
Produced by Marquand Books, Inc., Seattle
 www.marquand.com
Printed and bound by CS Graphics Pte., Ltd., Singapore

Front cover: Irving Penn, *Jessye Norman,* New York, 1983, Copyright © 1983 by Condé Nast Publications Inc., plate 91
Page 1: Herschel Levit, *Harry Belafonte,* 1960, detail, plate 89
Pages 2–3: Charles Hoff, *Jersey Joe Walcott with Rocky Marciano,* 1952, detail, plate 56
Page 4: David Moses Attie, *Lorraine Hansberry,* c. 1960, detail, plate 73
Pages 6–7: Charmian Reading, *"Mississippi" John Hurt,* 1966, detail, plate 68
Page 14: Arnold Eagle, *Gordon Parks,* 1945, detail, plate 39
Page 28: George Hurrell, *Bill "Bojangles" Robinson,* 1935, detail, plate 30
Page 150: Sid Grossman, *Billie Holiday,* c. 1948, detail, plate 67
Page 154: Addison N. Scurlock, *W. E. B. Du Bois,* c. 1911, detail, plate 11